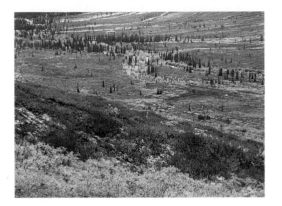

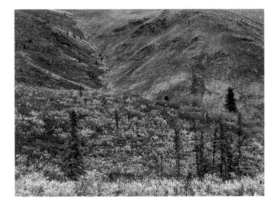

NATIONAL Audubon SOCIETY GUIDE TO

LANDSCAPE PHOTOGRAPHY

SECOND EDITION

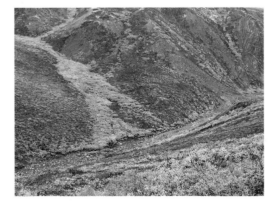

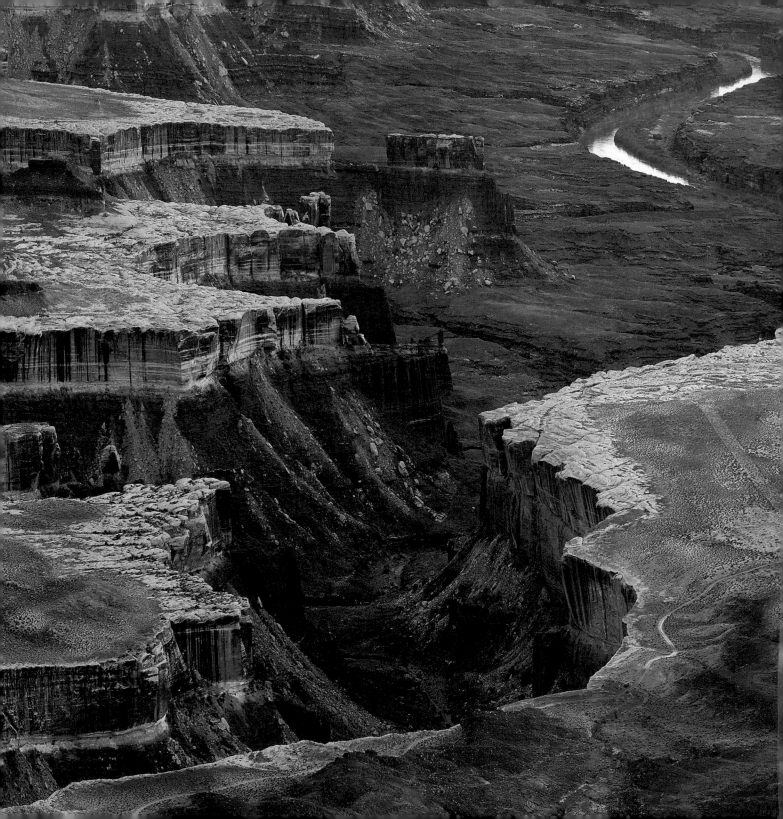

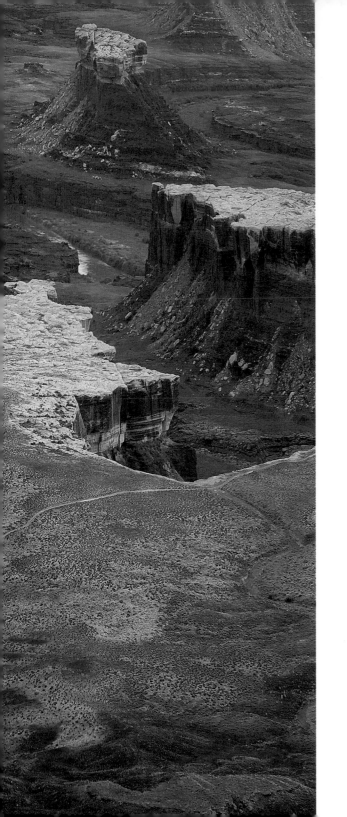

NATIONAL Audubon SOCIETY GUIDE TO
LANDSCAPE PHOTOGRAPHY
SECOND EDITION

Tim Fitzharris

FIREFLY BOOKS

A FIREFLY BOOK

Published by Firefly Books Ltd. 2012

First printing, 2012

Library and Archives Canada Cataloguing in Publication

Fitzharris, Tim, 1948-
National Audubon Society guide to landscape photography / Tim
Fitzharris. -- 2nd ed.
ISBN 978-1-55407-993-3
1. Landscape photography--Handbooks, manuals, etc. 2. Landscapephotography. I. National Audubon
Society II. Title.

TR660.F585 2012 778.9'36 C2011-906292-5

Publisher Cataloging-in-Publication Data (U.S.)

Fitzharris, Tim, 1948-
National Audubon Society guide to landscape photography / Tim Fitzharris.
2nd ed.
[192] p. : col. photos. ; cm.
Summary: A guide to taking professional caliber photographs of the natural landscape. Includes step-by-step lessons, revealing picture grams, information on equipment and examples of professional photographs.
ISBN-13: 978-1-55407-993-3
1. Landscape photography. I. National Audubon Society. II. Guide to landscape photography. III. Title.
778.9 /36 dc22 TR660.F589 2012

Published in Canada by
Firefly Books Ltd.
66 Leek Crescent
Richmond Hill, Ontario L4B 1H1

Published in the United States by
Firefly Books (U.S.) Inc.
P.O. Box 1338, Ellicott Station
Buffalo, New York, 14205

Designed and produced by Tim Fitzharris and Joy Fitzharris

Printed and bound in China

Photo Captions
Half-title Page: Autumn color, Yukon
Full-title Page: Canyonlands National Park, Utah

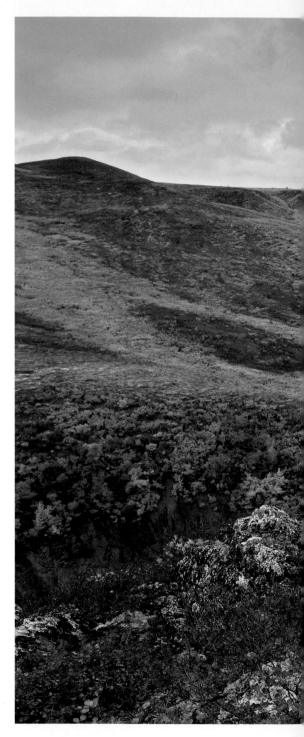

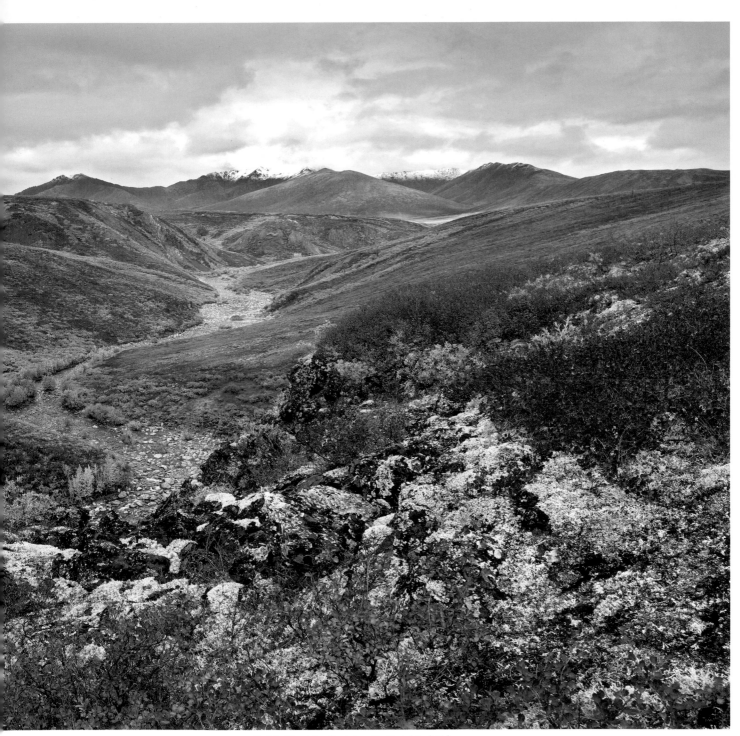

Ogilvie Mountains, Tombstone Territorial Park, Yukon.

For Jesse

Recent Books by Tim Fitzharris

National Audubon Society Guide to Nature Photography
Digital Edition

National Audubon Society Guide to Photographing America's National Parks
Digital Edition

Rocky Mountains: Wilderness Reflections

Virtual Wilderness

Close-up Photography in Nature

Fields of Dreams

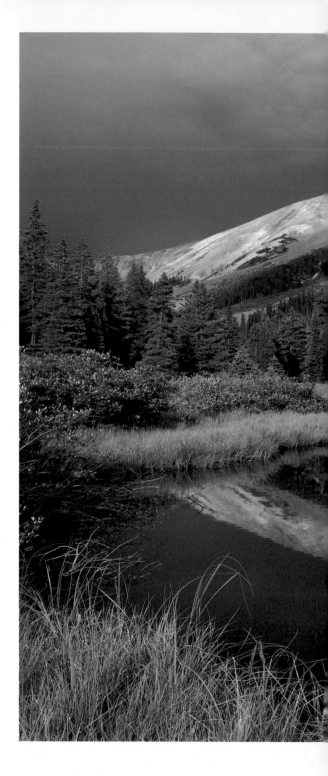

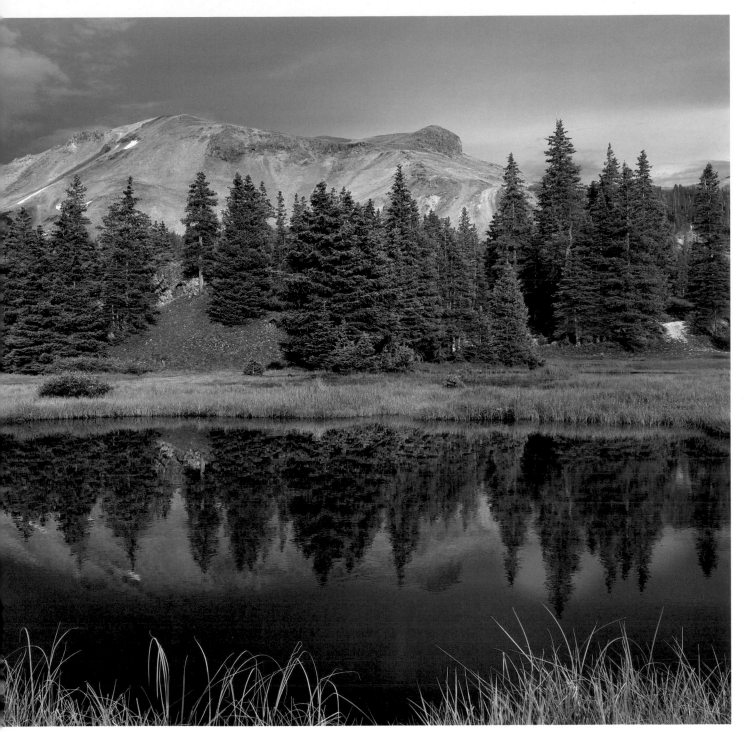

Red Mountain, San Juan Mountains, Colorado.

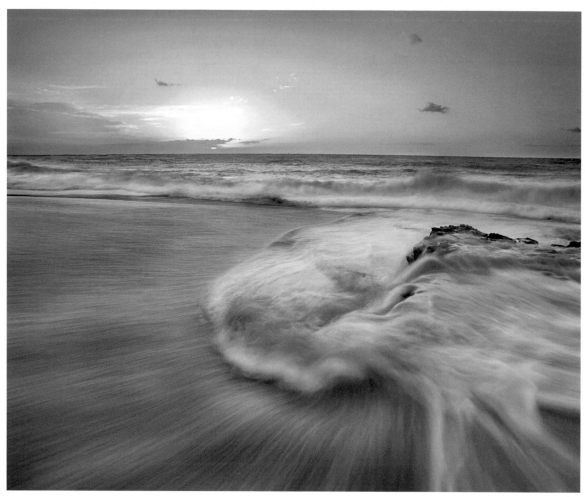

Sandy Beach, Oahu, Hawaii.

NATIONAL Audubon SOCIETY

The Audubon mission is to conserve and restore natural ecosystems, focusing on birds, other wildlife and their habitats for the benefit of humanity and the earth's biological diversity.

Through its education, science and public policy initiatives, Audubon engages people throughout the U.S. and Latin America in conservation. Audubon's Centers and its sanctuaries and education programs are developing the next generation of conservation leaders by providing opportunities for families, students, teachers and others to learn about and enjoy the natural world. The science program is focused on connecting people with nature through projects like Audubon at Home and Great Backyard Bird Count. Audubon's volunteer Citizen Scientists participate in research and conservation action in a variety of ways, from monitoring bird populations and restoring critical wildlife habitat to implementing healthy habitat practices in their own backyards. Audubon's public policy programs are supported by a strong foundation of science, environmental education and grass-roots engagement. Working with a network of state offices, chapters and volunteers, Audubon works to protect and restore our natural heritage.

To learn how you can support Audubon, call (800) 274-4201, visit www.audubon.org or write to Audubon, 225 Varick Street , New York, New York 10014.

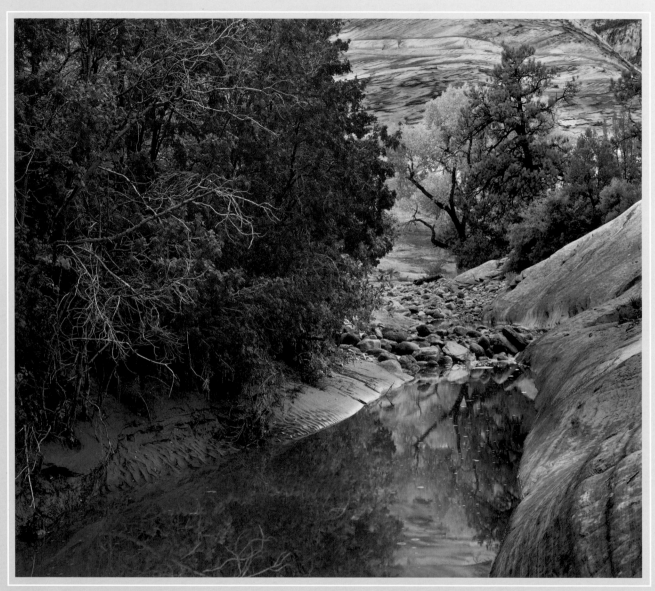

Maples and cottonwoods near Checkerboard Mesa, Zion National Park, Utah.

Contents

Introduction
The Earth, our planet, our home 12

Part One
Outfitting for the Landscape
Camera Systems 17
Professional results from cameras and tripods

Landscape Optics 32
Lenses for scenic subjects and how to use them

Logistics in the Field 42
Transporting, accessing and protecting equipment in the field

Part Two
Shooting Fundamentals
Exposure 57
Making reliable exposures in difficult situations

Aperture and Shutter Speed 64
Controlling image detail with depth of field and exposure time

Part Three
Creating an Image
Illuminating the Scene 73
Proactive lighting techniques

Composition Basics 82
Fundamental principles of picture design

Art of the Possible 90
Adapt your shooting schedule to natural conditions

Expressing Perspective 94
Techniques for recording the third dimension

Photogenic Opportunities 100
Recognizing the potential of a landscape setting

Part Four
Spectacular Settings
Bonfires of Autumn 105
Capturing the rich color of the woodland palette

Cascades and Waterfalls 108
Interpreting the beauty of flowing water

Radiant Reflections 114
Recording mirror-like reflections in lakes and ponds

Dramatic Dunes 118
Procedures for great sand dune photographs

Sunrise and Sunset 124
Seizing opportunities at the magic hour

Oceans of Light 130
Recording the changing moods of the shoreline

Floral Wilderness 134
Capturing the beauty of meadows in bloom

Twilight Time 140
Heavenly light when the sun is below the horizon

Wide View Panoramas 144
Shooting and stitching multiple captures of a scene

Captivating Clouds 148
Dynamic landscape imagery hangs in the air

Part Five
The Digital Landscape
From Field to Studio 153
Hardware for digital field work

The Digital Workflow 156
Step-by step from capture to storage

The LCD Monitor 160
Picture making headquarters in the field

Setting White Balance 166
Get the best color version when shooting JPEG

High Dynamic Range 170
Capturing detailed highlights and shadows

Sharpness Front to Back 174
How to extend depth of field while avoiding diffraction

Preparing Images for Presentation 180
Professional art print, website or print media display

Resources 192

Introduction
The Earth, our planet, our home

Joy Fitzharris

Anne's Land, Prince Edward Island National Park, Prince Edward Island (right). *At this location my attention was attracted to the rhythmic lineup of headlands looming over the beach. The camera position recorded these landforms in an informal S curve, a common design model in photography. Pentax 645, Pentax 45–85 f/4.5 lens, Singh-Ray circular polarizing filter + one-stop split neutral density (ND) filter, digital scan from Fujichrome Velvia, ISO 50, f/16 for ¹/₂ second.*

The Earth, our planet, our home. In its natural state it's difficult to imagine anything more captivating. This book is intended to help photographers capture this beauty for the enjoyment of both themselves and others. The landscape is arguably the most difficult, challenging and fascinating of nature's subjects. It is an elusive target—terrain shimmering in ultraviolet or buffeted by wind one day and twinkling with frost or glinting bronze under a sunset sky the next.

Not only does the landscape change, endlessly offering to the lens new contours, textures and colors depending on weather, light and season, it posts no signs to guide the photographer's approach. It

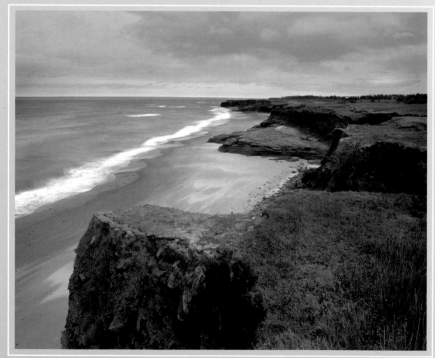

does not encourage you to capture spreading antlers or eyes sparkling with highlights. Its appeal is broad, and as subject it is open to wide avenues of interpretation. It is more concept than thing, more mood or feeling than identity. You cannot take a picture of a mountain and

say, "There, I've got it."
You can only say that
you know a bit of it, that
you've spent some time
near its energy.

If you have an artistic
temperament, this will
appeal to you. No matter
how many times a famous
landform has been photo-
graphed, your encounter
with it will be unique
and will remain so with
every subsequent shoot-
ing session. Pulsing with
light, mother of life, for
the artist a subject both
sublime and mindless,
the land abides in us and
for us. You appreciate this while looking through
the lens, trekking to a shooting site or standing on
a precipice waiting for sunrise. If you're reading
this book, you're already attuned to this. You want
to know more about direct engagement, about
embracing this wonder of Earth through your eyes
and insights, your photography and your art.

This book will help you understand how the
camera and lens depict the land so that you can
make images the way you see and feel. The techni-
cal components of professional-level landscape
photography are all covered here. The emphasis of
the book, however, is on the photographer's actual
interaction with the subject. I've described here the
numerous ways in which I photograph the land-
scape, the particulars of how I proceed to capture a
dune field, ocean sunrise, autumn forest or alpine
reflection. Each setting calls for the application of a
different set of technical and artistic considerations.
I've outlined the general procedures I use when
working in the field, the focus being to enjoy the
process while maximizing the quality of imagery.

*Alta Lakes reflection, Colorado. In
this setting, my goal was to draw the
viewer's attention to the symmetry
of the mountain and its reflection.
I used a one-stop split ND filter to
darken the terrain, which resulted in
projecting the reflection with greater
brilliance. Pentax 645NII, Pentax
45–85mm f/4.5 lens, polarizing filter,
digital scan from Fujichrome Velvia,
ISO 50, f/16 for 1/30 second.*

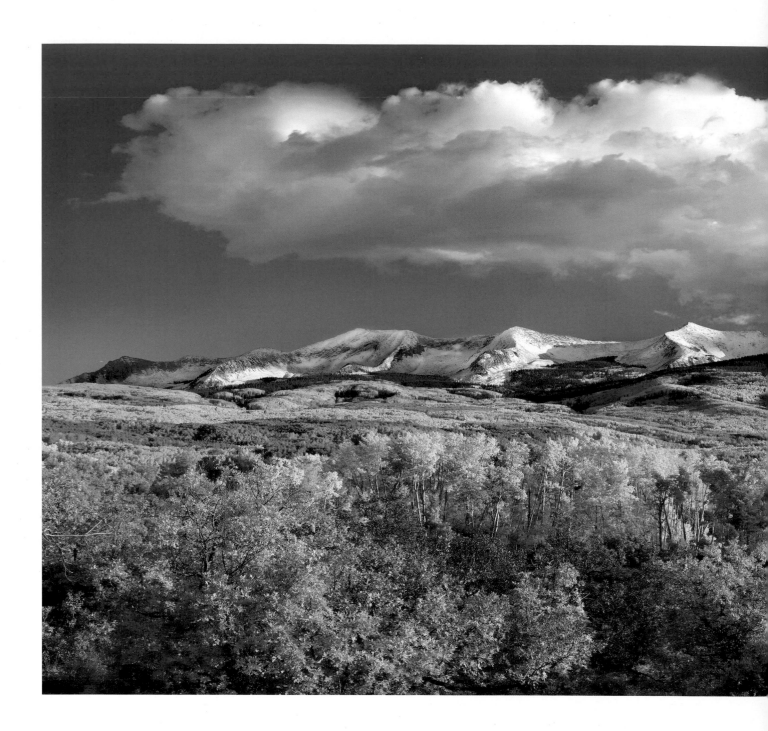

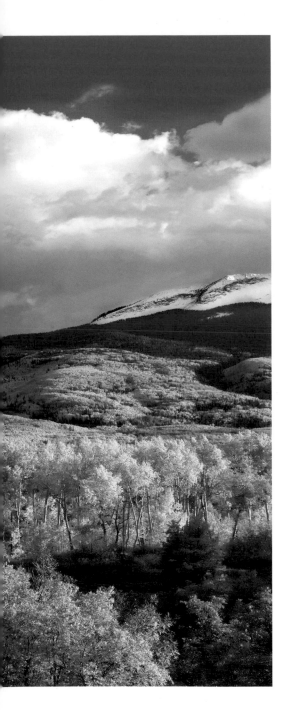

To this end, you will find that keeping things simple—technically, logistically, artistically—brings you closest to the Earth, your subject, allowing the clearest expression of your artistic goals. The working models presented here are the ones that I use and know, but they needn't be the ones that you favor. There are many ways to approach landscape photography, and your art will benefit by considering how others photograph. As you gain experience you will discard some procedures, embrace others and develop new ones of your own.

This second edition addresses the subject of landscape photography as it is practised using digital cameras. This method shares most of film photography's common processes and challenges and hence much of the book remains essentially the same, particularly as it emphasizes the photographer's personal approach to subject matter rather than technical aspects. The text addresses digital photography mostly in terms of field capture but also explains in brief my computer post processing techniques whether the picture files be derived from digital cameras or digital scans of existing film transparencies.

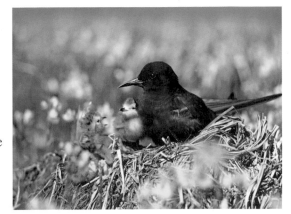

East Beckwith Mountain, Colorado (left). Light softened by a sky filled with clouds allowed the film to record the full range of saturated color of this alpine vista. Pentax 645NII, Pentax 80–160mm f/4.5 lens, polarizing filter, digital scan from Fujichrome Velvia, ISO 50, f/11 for $^1\!/_{15}$ second.

Black tern with young near Priddis, Alberta (above). Taken about 25 years ago, this photo is but a reminder of what once was. The marsh where these birds nested has long since been sacrificed to development.

Part One

Outfitting for the Landscape

Camera Systems

Professional results from cameras and tripods

A digital image is generated by very sophisticated technology. This complexity has moved photography away from the restrictive automation of film-based image making toward a more responsive, hands-on process. Digital technology has added a brush and palette to the pseudo-photocopier that was a film camera. You can now control all stages of the process from initial capture through print production—no need to rely on film manufacturers, film processors or commercial fine art printmakers to do your thinking for you. Digital technology brings the photographer face-to-face with the full measure of philosophical, conceptual and practical challenges that confront the artist.

PIXELS

A digital image is recorded by millions of individual picture elements (pixels) that are components of the camera's sensor. More pixels means greater detail capture. Larger pixels result in better image quality. Digital sensors are measured in millions of pixels (megapixels, MP). Professional cameras have sensors ranging from 10 to 80 MP and higher.

THE LCD MONITOR

The most significant improvement that digital cameras bring to image making is the LCD monitor

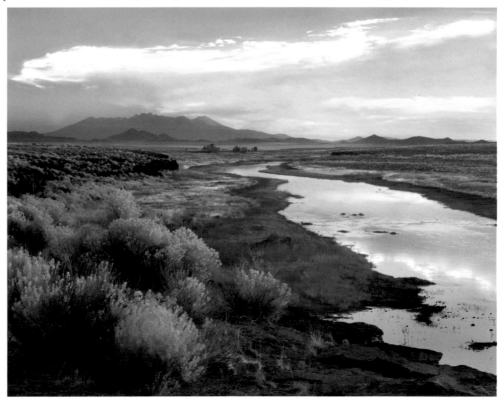

Rio Grande and Sangre De Cristo Mountains, Colorado. *The best digital cameras produce images superior to comparable film cameras. Mamiya 645 AFD with Phase One P 25 digital back, Mamiya-Sekor 55–110mm f/4.5 lens, polarizing filter + one-stop split ND filter, ISO 100, f/22 for 1 second.*

Caprock Canyons State Park, Texas (right). Due to weak light and intermittent breeze, I changed ISO speed momentarily to allow the use of a faster shutter speed to catch the flowers for the brief moment when they were still. Such ISO versatility is not possible with film. Mamiya 645 AFD with Phase One P 25 digital back, Hartblei Super-Rotator 45mm f/3.5 lens, polarizing filter + one-stop split ND filter, ISO 100, f/22 for ¹/₂ second.

Typical appearance of noise (below). Current SLR digital cameras are noise-free at ISO speeds up to 400+. Future models are likely to get even better.

located on the back of the camera. This feature is your picture making headquarters. It provides instant feedback of your shooting efforts. No need to wait for hours or even days to see the developed film and discover too late where you got it wrong or where you got it right. There is more information on using your LCD monitor in Part Five.

LEARNING AND EXPERIMENTATION

Once you have a digital camera, the photos you make are essentially cost free. Add this benefit to the LCD's facility for instant picture review and you have a perfect vehicle for learning the intricacies of photography. You can experiment with effect of shutter speed on flowing water or exposure on the generation of noise. You can measure the changes in depth of field at varied apertures and/or focal distances or compare the perspective effects of different lenses. In addition more seasoned photographers, including professionals, can experiment with new approaches to picture making with minimal expenditure of time and energy.

DIGITAL CONVENIENCE

Although digital photography's main benefits are its low operating cost and facility for instant feedback, it provides additional improvements over traditional film recording.

• Pictures can be ready for transfer, printing or web-posting right from the camera.

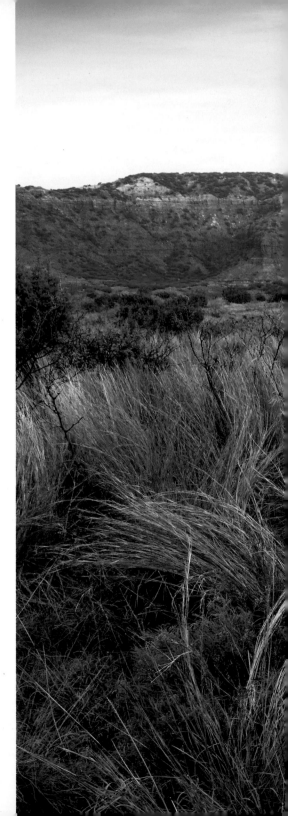

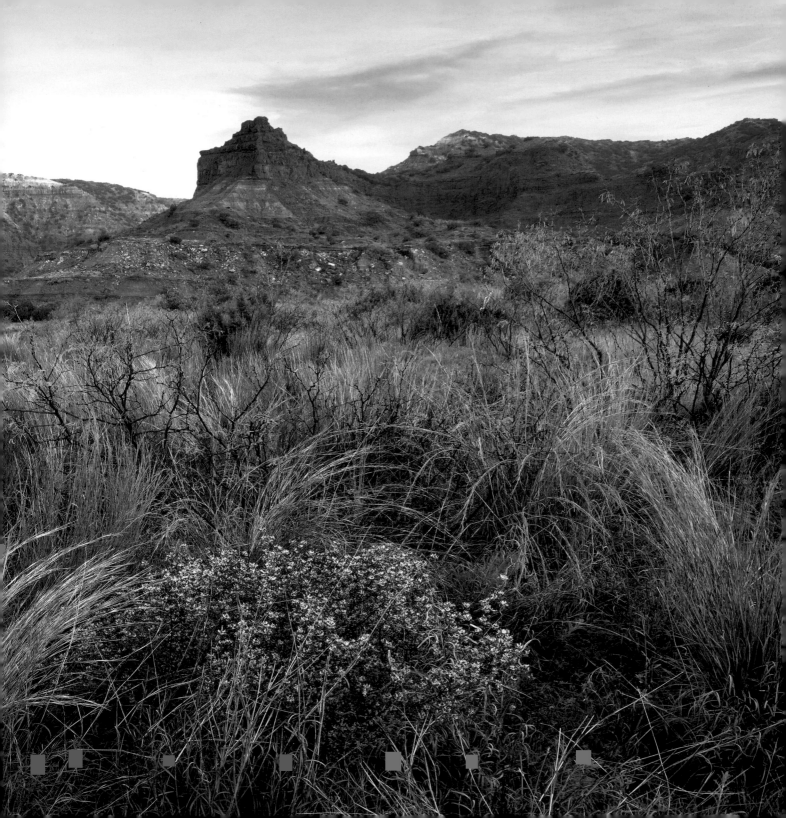

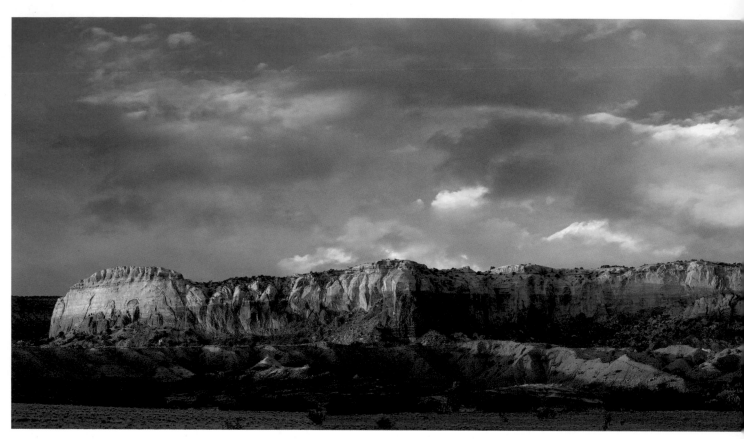

• ISO settings (light sensitivity of the sensor) can be changed at any time to suit circumstances, even for just a single frame.

• Digital cameras are more sensitive to light than film and so allow high quality picture taking in very dim conditions.

• You can capture thousands of frames on one compact storage card, a device smaller than a book of matches.

• Unlike film, captured images are not affected by security screening devices at airports.

• You can delete images in the camera as you go to maximize storage capacity and reduce editing time on the computer.

• Post capture computer manipulation and recomposing in applications like Photoshop provide the photographer the tools to modify the image in any way imaginable.

THE SINGLE-LENS-REFLEX CAMERA

The most efficient, professional quality camera for landscapes is the single-lens-reflex

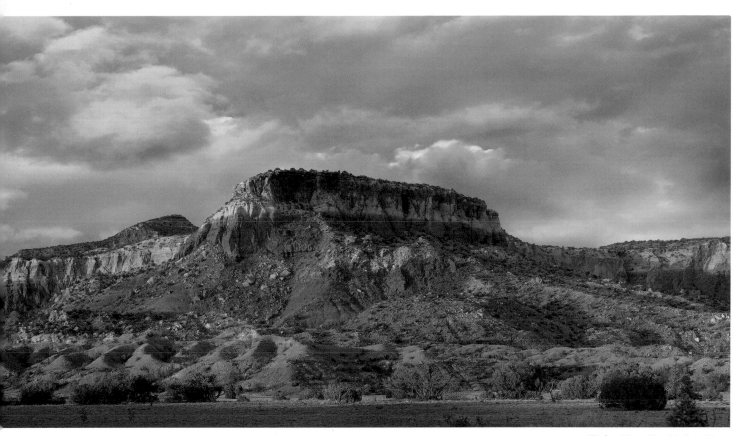

(SLR) camera. Such cameras are characterized by through-the-lens (TTL) viewing which assures precise correlation of what is seen in the viewfinder with what is recorded by the sensor and makes lens interchange possible. Access to a variety of lenses allows for varied pictorial effects, particularly those related to subject magnification and perspective control.

KEY SLR FEATURES FOR LANDSCAPES
• Interchangeable lenses. For landscape subjects,

the wide to normal (20–50mm) focal lengths are most important. Lenses with small maximum apertures are preferred as usually you will be shooting in the f/11 to f/22 range. Such lenses are less expensive, more portable and often sharper than their large aperture cousins.

Zoom lenses are ideal for making the most effective use of picture space by allowing precise framing and magnification of the scene. You won't need a telephoto lens longer than about 200mm. (More on lenses in the following chapter.)

Kitchen Mesa, New Mexico. This panorama was assembled on the computer from three separate high resolution digital captures (see page 144 for more information). Mamiya 645 AFD with Phase One P 25 digital back, Mamiya-Sekor 105–210mm f/4.5 lens, polarizing filter, ISO 100, f/11 for 1/15 second.

Agave and Casa Grande, Big Bend National Park, Texas (below). High resolution (to 80 MP) digital backs for medium and large format cameras have made film obsolete, even for fine art and commercial landscape photographers. This image was made with a 22 MP digital back on a Mamiya AFD 645 SLR with a 45mm tilt/shift lens.

• Remote cable release connection so that the shutter can be activated without causing camera shake and a loss of sharpness.

• Depth-of-field preview for judging the extent of the scene that is rendered sharply.

• A sensor in the 10–25 MP range is generally adequate for commercial and fine art production of images up to wall calendar size.

MEMORY CARDS

Miniature drives that fit into your camera to store the images that you have captured are called memory cards. CF (compact flash) type memory cards are used in most cameras intended for professional and advanced amateur landscape photography. They are smaller than a book of matches and can hold hundreds of hi-resolution images. You should use cards in the 2 to 8 gigabyte (1,000,000,000 bytes—GB) range. Smaller cards fill up faster and require more frequent changing. However, storing your photos on more than one card reduces the risk of sacrificing an entire shoot due to card failure (very rare) or losing or damaging the card. Card speed of most brands is normally adequate for even professional still photography use.

DIGITAL CAMERA FORMATS

Digital cameras come in all shapes and sizes, from the mini-snap shooter in your cell phone to large, special application studio cameras with giant sensors. For advanced

Tilt and Shift Bliss

Large format view cameras using 4 x 5 inch sheet film were long the favored instrument of fine art and professional landscape photographers. The wooden Tachihara, for example, is inexpensive, rugged, relatively lightweight and, like all 4 x 5 cameras, produces Velvia transparencies that can mesmerize when viewed on a light table. View cameras also provide front and rear movements for controlling perspective and depth of field. However, digital imaging quality caught up with

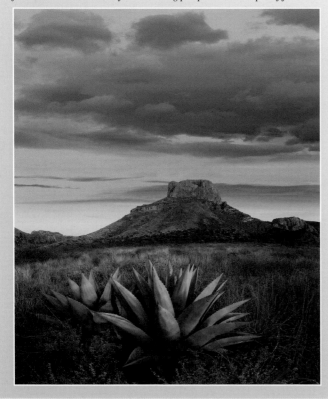

the development of very high resolution (80 MP) digital backs for medium and large format cameras. For most professionals film is a thing of the past. Although digital backs currently cost about 40 times more than a new Tachihara camera, the savings in film cost and processing, scanning and duplicating fees make digital a bargain. Throw into the equation the inevitable reduction in the price of high-end digital backs, the speed and convenience of working with an SLR and the adoption by publishers and picture buyers of full scale digital production, including online image research and editing, and it's no surprise film use has all but vanished.

Fine art photographers bent on the highest quality reproduction should consider a large format view camera for wilderness landscapes. You will enjoy the many benefits of digital imaging and may even save enough in film costs to justify the exhorbitant cost.

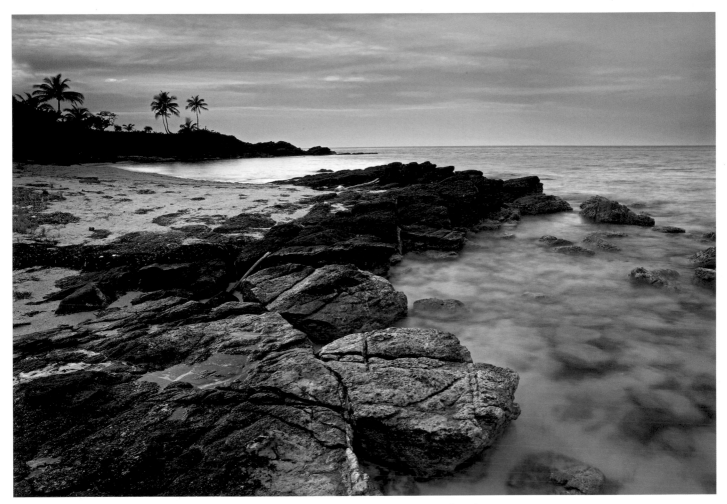

amateur and professional landscape photography, two digital camera formats are generally used. They are based on sensor sizes derived from earlier film cameras—35mm and 645 medium format.

FULL FRAME 35MM FORMAT

This format uses a sensor approximately the size of a frame of 35mm film (referred to as a 'full-frame' sensor). Some models pack 25 million pixels into the sensor. Such cameras produce high quality images suitable for reproduction in postcards, books, magazines and wall calendars as well as internet publication. The advantages of this format are its relatively small size and weight,

Wilkes Point, Roatan Island, Honduras (above). Digital imaging allows for easy correction of minor but common flaws such as keeping the horizon of a seaside view horizontal. Mamiya 645 AFD with Phase One P 25 digital back, Mamiya-Sekor 35mm f/3.5 lens, polarizing filter, ISO 100, f/22 for 1/8 second.

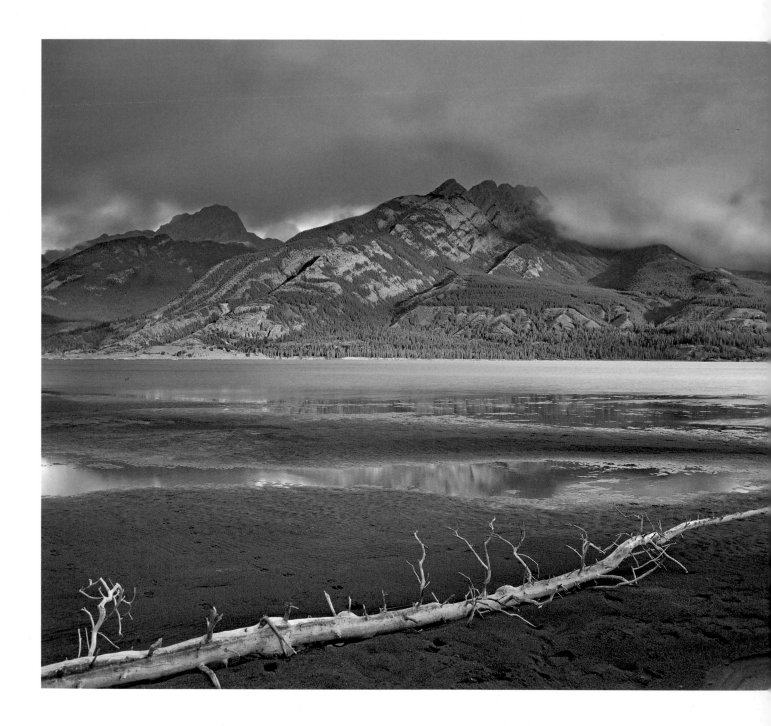

rapid handling, wide selection of lenses and system accessories and suitability to a range of subjects.

REDUCED FRAME (APS-C) 35MM FORMAT

These cameras are similar in features, lens use and size to full frame models but the sensor is smaller and generally has less pixels, producing images with less detail. The smaller sensor uses only a central portion of the data sent to it by the lens so the actual image is cropped and thus magnified in-camera (magnification factor). Depending on the actual sensor size, a 400mm telephoto lens works like a 600mm, a 50mm lens like a 75mm lens and so on. This increase in focal length is advantageous to wildlife and sports shooters who cannot approach the subject closely. However, it handicaps landscape photographers who generally prefer to capture a grand view of the scene, forcing them to use a lower quality ultra wide-angle lens to achieve the perspective and magnification effects of a normal or standard wide angle lens.

MEDIUM FORMAT DIGITAL

Medium format film cameras used film that was much larger than that used in 35mm cameras, resulting in greater detail and increased color tonality. In today's digital world, medium format

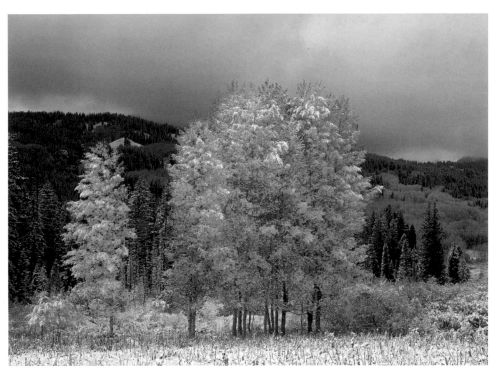

cameras also boast larger sensors, more megapixels (80+), larger pixels and generally higher quality imagery than standard, full frame digital SLRs. These sensors are usually loaded in a jumbo SLR pentaprism package of standard design and operation. For professional landscape specialists, they represent the ultimate in quality but they are generally unwieldy and too slow in operation for wildlife, close-up subjects, sports and travel. However, they have much the same handling and viewing advantages of smaller SLRs including adequate selections of zoom lenses. But high quality imagery comes at a price. Popular medium format

Early snow on aspens, Kebbler Pass, Colorado (above). A tripod steadies the camera, making detailed images possible even with telephoto lenses. Pentax 645NII, Pentax 300mm f/5.6 lens, digital scan from Fujichrome Velvia, ISO 50, f/16 for $^{1}/_{2}$ second.

Cloud over Jacques Range, Jasper National Park, Alberta (far left). A tripod slows down the photography process and encourages more carefully considered compositions. Pentax 645NII, Pentax 45–85mm f/4.5 lens, one-stop split ND filter, digital scan Fujichrome Velvia, ISO 50, f/22 for $^{1}/_{4}$ second.

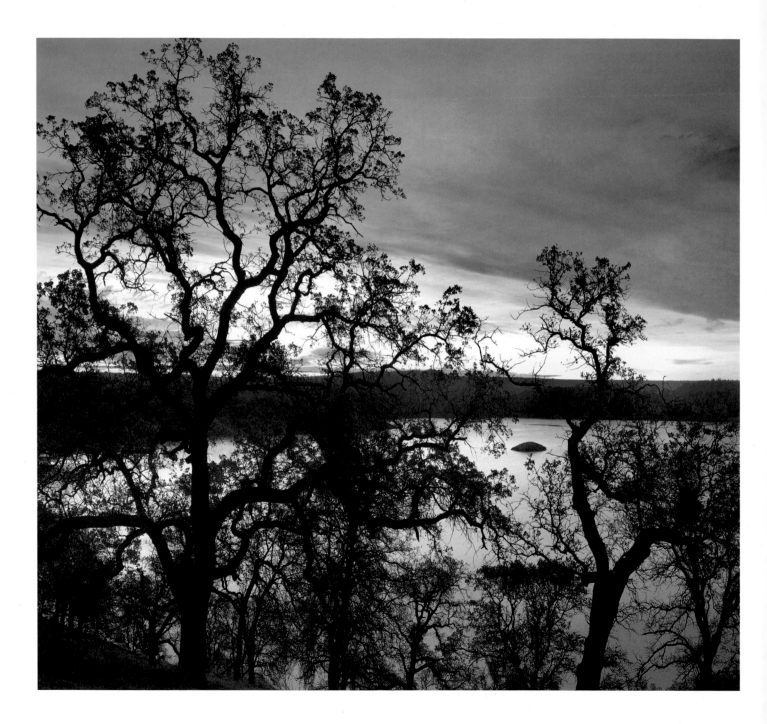

digital brands (Leica, Phase One, Mamiya, Pentax and Hasselblad) can cost many times more than even professional 35mm format digital models.

LARGE FORMAT DIGITAL

Large format cameras (also known as view cameras) provide direct through-the-lens viewing but the scene is presented upside down and reversed. Normally, exposure readings must be made with a separate handheld meter. View cameras allow tilting and shifting of the lens, a feature that affords maximum control in placing depth of field (zone of sharp focus). View cameras are large and slow to operate. More portable versions (called field cameras) are best suited to wilderness landscape photography. Some manufactureres (Leaf, Phase One) produce digital backs with sensors of 80 megapixels that are designed to be plugged onto large format view cameras in place of the film back.

The picture quality of a professional digital camera is determined by the number and size of the pixels captured and how the camera's firmware processes them. Top-of-the-line 35mm full frame digital SLR cameras yield excellent results, are fast and easy to operate and boast the largest selection of accessories and lenses. Medium and large format

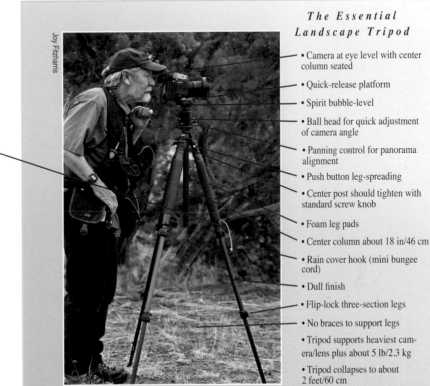

The Essential Landscape Tripod

- Camera at eye level with center column seated
- Quick-release platform
- Spirit bubble-level
- Ball head for quick adjustment of camera angle
- Panning control for panorama alignment
- Push button leg-spreading
- Center post should tighten with standard screw knob
- Foam leg pads
- Center column about 18 in/46 cm
- Rain cover hook (mini bungee cord)
- Dull finish
- Flip-lock three-section legs
- No braces to support legs
- Tripod supports heaviest camera/lens plus about 5 lb/2.3 kg
- Tripod collapses to about 2 feet/60 cm

Tripod shown is Manfrotto Mag Fiber Tripod 055MF3 with Kirk ball head BH1

digital cameras and backs generally capture both more and larger pixels, which results in even higher quality imagery.

CAMERA BRANDS

For landscape photographers there is no clear winner among major camera brands (Nikon, Canon, Pentax, Sony, Olympus, Sigma). All yield imagery of comparable quality and offer systems with similar features. If you wish to combine

Oak groves at sunrise, New Melones Lake, Calaveras County, California (far left). A tripod is essential for shooting in the attractive but weak light of sunrise and sunset. It stabilizes the camera, allowing long exposures without compromising sharpness. Mamiya 645 AFD with Phase One P 25 digital back, Mamiya-Sekor 55–110mm f/4.5 lens, polarizing filter, ISO 100, f/32 for 2 seconds.

Mount Kitchener and Dome Glacier, Jasper National Park, Alberta (right). Flip-lock legs are key to setting up your tripod quickly. This is one of several compositions I was able to make in a short time to take advantage of beautiful but deteriorating light conditions on this autumn morning.

Hillside shooting (below). The tripod center column should be long enough (18 in/46 cm) to bring the camera to eye level when working on sloped terrain (especially common in mountain country and along the edges of lakes and rivers). The camera will remain rock-still on windless days and produce sharp imagery provided you trip the shutter with an electric release, lock up the mirror prior to exposure and stand well clear of the tripod.

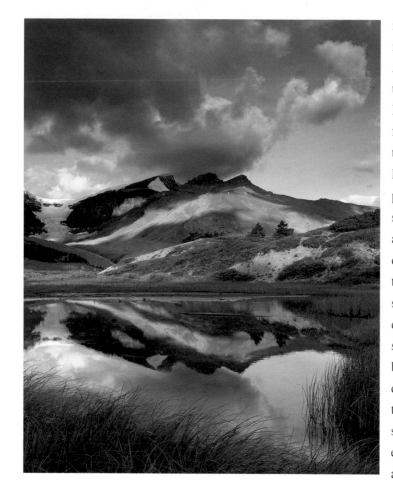

Joy Fitzharris

ments to settings and considered modifications to composition. A rock-steady camera ensures the sharpest possible images. It permits exact replication of framing when it is necessary to bracket settings under tricky lighting situations. It makes possible the extended shutter speeds needed when shooting at small apertures to maximize depth of field. Without a tripod to stabilize the camera for the seconds-long exposures needed during twilight, sunrise and sunset, sharp images would not be possible. During most wilderness shooting sessions, the tripod will be on and off your shoulder many times. It will be extended, collapsed and prodded and likely soaked and muddied.

landscape and wildlife photography, then Canon or Nikon are the brands of choice due to the wide array of telephoto and super telephoto lenses.

THE QUINTESSENTIAL TRIPOD

For landscape photographers, a tripod is nearly as important as the camera and lens. With the camera supported, you can make unhurried adjust-

Its controls will require repeated adjustment, on the whole as much as camera and lens. To capture the often fleeting drama of a landscape scene, your tripod must be precise, quick, sure and reliable. Let's find out what features make this low-tech tool one of your best friends in the field. Professional tripods are normally sold in two parts—legs and head. Here's what to look for.

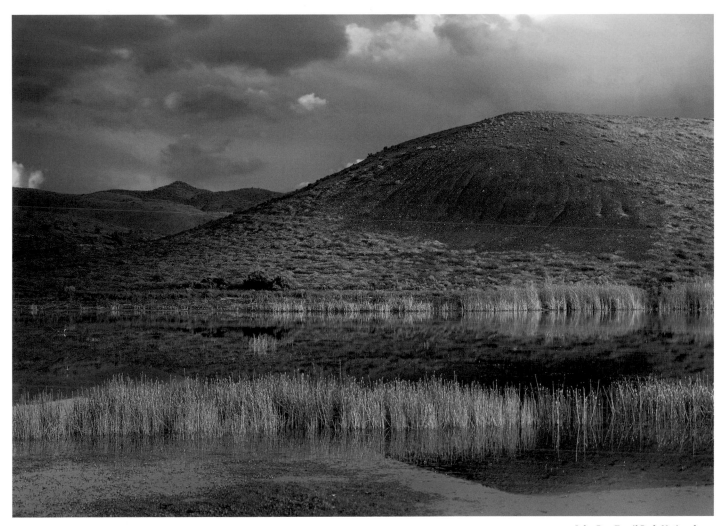

Size Matters

When mounted on a fully extended tripod with center column seated the camera should reach to near eye level (about 5 inches/13 cm below the top of your head). The ball head gives the tripod legs a 6 inch/15 cm boost and the position of the camera's viewfinder adds a further 3 inches/8 cm (or more). Added up, the fully extended tripod with center column retracted and without ball head should be about 14 inches/36 cm less than your height.

The tripod should collapse enough to position the camera well below waist level (to about

John Day Fossil Beds National Monument, Oregon (above). *Use a tripod that will not jam from working in water or mud (avoid concentric leg-locking collars). To get this appealing angle, I had to set up in the marsh.*

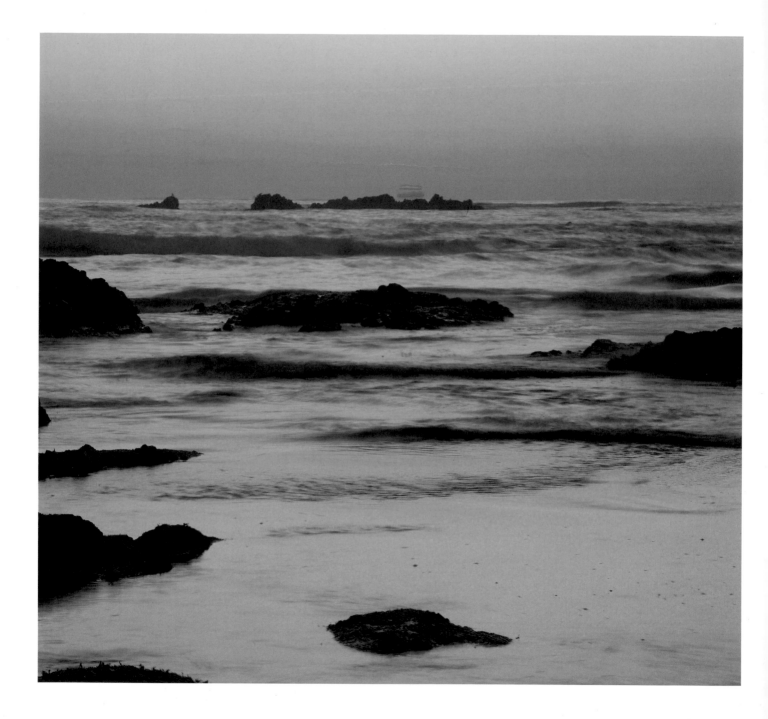

2 feet/60 cm) in order to capture close-up details of foreground landscape elements such as rocks or wildflowers. A long center column (about 18 inches/46 cm) is valuable to bring the camera up to eye level when you are working with the tripod set up on a hillside below you.

LIGHTNESS IS ESSENTIAL

A big, heavy tripod does not mean sharper pictures. If anything it means higher cost, greater fatigue and fewer images. Easy-toting tripods have legs made of carbon fiber. This material is lighter, stiffer and absorbs vibration better than metal.

LEG FEATURES

Three-section legs are stronger and afford quicker setup than four-section models, which are advantageous only when small collapsed size is important (backpacking). Tripod legs should spread independently (no central struts) for easier setup on uneven terrain. The length-locking mechanisms should be clips that snap open and shut rather than concentric twist rings.

BALL HEADS

A compact, lightweight, fast-working ball head with panning capabilities is best for landscape photography. The head should have comfortable knobs for both locking the head and setting the ball's tension. The head should not creep under the camera's weight, even when set in the vertical position. The ball head should have a locking quick-release mechanism for fast camera mounting and dismounting.

Choosing the right tripod is just as important as choosing the right camera. Take your time deciding on each. It will make your shooting more enjoyable and productive.

Beach Two, Olympic National Park Washington (far left). *To ensure sharpness in this telephoto shot, the camera was mounted on a tripod to steady the camera, the mirror was locked up to reduce in-camera vibration and the shutter was activated using an electric cable release to avoid jarring the camera.*

Gull tracks on sand, Gulf Islands National Seashore, Florida (left). *When working on the shoreline, keep a constant eye on your tripod. Incoming waves wash out the sand supporting the legs and can topple your camera into salt water in the wink of an eye.*

Landscape Tripod Recommendations

Tripod Legs
Manfrotto Mag Fiber Tripod 055MF3 (www.manfrotto.com)
Slik PRO 883 CF-D (www.slik.com)
Velbon Camargue Sherpa PRO CF-631EL (www.velbon.com)

Top Ball Head Brands
Kirk (www.kirkphoto.com)
Acratech (www.acratech.net)
Really Right Stuff (www.reallyrightstuff.com)
Numerous others

Landscape Optics

Lenses for scenic subjects and how to use them

Mount Sinopah, Two Medicine Lake, Glacier National Park, Montana (below). *Lens focal length is often essential to achieving the best composition. Here a zoom lens was needed to frame precisely this symmetrical sunrise scene.*

Lenses are key determinants of sharpness, perspective and how much or little of the scene is recorded. The specification of a lens usually consists of two measurements. Focal length determines magnifying power and is measured in millimeters (longer focal lengths produce more magnification). Maximum aperture determines light sensitivity and is measured by an f/number (the smaller the f/number, the larger the aperture). Maximum aperture and focal length are always part of a lens's formal designation (e.g., Nikon 300mm f/4 lens).

IMPORTANT LENS FEATURES

• Getting to beautiful landscape sites usually requires hiking, often over rough terrain. Lightweight lenses (characterized by small maximum apertures) thus are of high value. Small-aperture lenses are also less expensive and often sharper than their big-glass brothers.

• Minimum apertures should reach at least f/16 with 35mm format lenses, f/22 with medium format lenses and f/45 with large format lenses. Small apertures are often necessary to record the scene in complete sharpness.

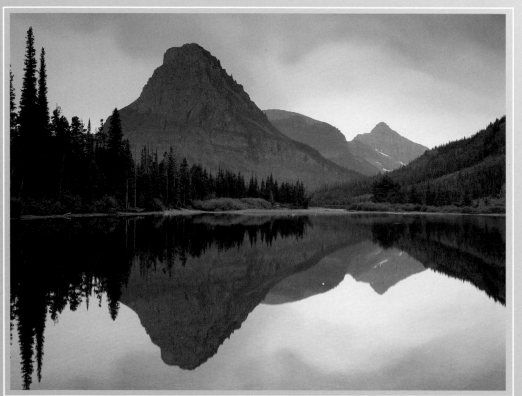

• The lens should yield high quality images at small apertures—the ones you will be using most. Lens performance reports are often available on the relevant manufacturer's website or from *Popular Photography* magazine (www.popphoto.com).

• All lenses should accept the same filter size. This reduces the number of filters you need to carry and makes for quick and simple filter swapping. Inexpensive step-up filter rings can be used to make your system uniform.

• Well-designed zoom lenses are preferred for landscape photography. By affording precise, adjustable framing from any camera position, zoom lenses facilitate the creation of eye-catching compositions and also put every pixel to effective use, minimizing the

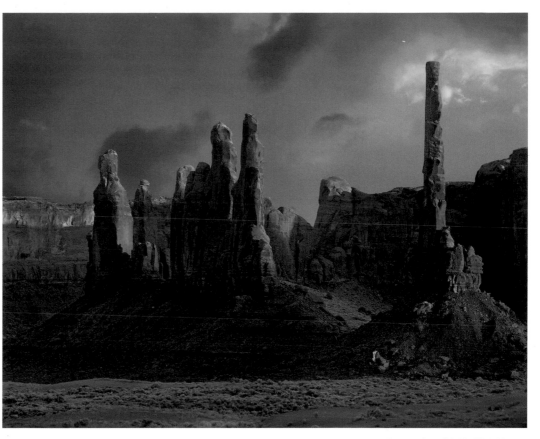

need for resolution-robbing post-shoot cropping.

• The lens should focus internally. This allows focus adjustment without causing the filter to turn, thus retaining settings made when using a polarizer, landscape's most useful filter.

FOCAL LENGTH EFFECTS

Wide-angle, normal and telephoto lenses have characteristics that apply their unique imprints of perspective and magnification to scenic imagery.

Totem Pole and Yei bi Chei, Monument Valley, Arizona (above). A telephoto lens allowed tight framing and produced compressed perspective to create a simple composition emphasizing the warm sidelight on these dramatic rock formations. Pentax 645NII, Pentax 300mm f/5.6 lens, polarizing filter, digial scan from Fujichrome Velvia, ISO 50, f/11 for 1/4 second.

Focal Length Conversion
The focal lengths cited in this chapter refer to the 35mm full-frame digital sensor. If you are using an APS-C or medium format camera, use these multipliers to determine which focal length will yield the same result. Your camera manual will provide exact figures.
Medium Format Sensor: multiply by 1.6
(50mm lens converts to 80mm lens)
APS-C Size Sensor: Multiply by 0.6–0.7
(50mm normal lens converts to 30–35mm lens)

Great Smoky Mountains from Campbell Overlook, Tennessee (above). A zoom lens allows precise framing and is essential for making strong compositions.

Muddy Mountains, Valley of Fire State Park, Nevada (far right). Wide-angle lenses impart an impression of expanded depth to wilderness scenes. Pentax 645NII, Pentax 35mm f/4.5 lens, polarizing filter, digital scan from Fujichrome Velvia, ISO 50, f/22 for ¹/₄ second.

chapter. A zoom lens with focal lengths from wide-angle to normal will be your most useful optic.

WIDE-ANGLE LENSES

Wide-angle lenses (focal lengths less than 50mm) take in more of the scene than normal lenses. They allow you to "get everything in" when space may be restricted by a cliff, rock wall or body of water. Wide-angle lenses are the favorite of landscape photographers due to their expansive presentation of land and sky. The wide-angle lens lets you work closer to the subject while maintaining the

NORMAL LENSES

Normal focal length lenses reproduce the scene more or less as the human eye sees it, taking in a similar angle of view and expressing similar perspective. A lens over 50mm magnifies the scene and one under 50mm makes it smaller. If you are using a digital camera with a less-than-full-frame sensor, check the camera manual for the multiplication factor—usually 1.3 to 1.6—and use this figure to convert the focal lengths cited in this

same magnification of foreground elements you would capture with a longer lens. This yields two benefits. It reduces the amount of atmosphere (fog, mist, dust, haze) between camera and subject, resulting in greater clarity of detail. It also changes perspective by

Wide Is Normal
Less-than-full-frame APS-C sensors turn wide-angle lenses to normal lenses and ultra-wide-angle to wide-angle. For an extreme wide-angle effect you must work with a lens in the 12mm range.

Aspens, Maroon Bells-Snowmass Wilderness, Colorado (far right). *An ultra-wide-angle lens provided this view, captured while lying flat on my back. Near midday overhead sunlight provided the strong illumination needed to set the translucent leaves aglow. No tripod needed.*

Trunks, Maroon Bells-Snowmass Wilderness, Colorado (below). A 300mm telephoto lens compressed perspective of this selective study of aspen trunk patterns.

showing more of the scene behind the subject than would be recorded with a longer lens. The result is an impression of greater depth—a stronger feeling of three dimensions or deep space. By taking in more of the scene, wide-angle lenses add complexity to the image and require extra care in camera placement, shooting angle and composition in general. The smaller sensors of APS-C digital cameras turn moderate wide-angle lenses to normal focal length lenses, and extreme wide-angle lenses to wide-angle focal lengths. To get an extreme wide-angle effect with these cameras you need a lens in the 12mm range.

TELEPHOTO LENSES

Lenses that record a narrower angle of view than a normal lens (focal lengths more than 50 mm) are telephoto lenses. Taking pictures with this optic is like using binoculars—it makes everything look larger.

Telephoto lenses allow you to easily eliminate distracting elements from a composition by small adjustments in camera angle. Tight framing also makes it easy to simplify designs and emphasize main subjects. Unlike wide-angle lenses, which open up space, telephoto lenses compress space, reducing the apparent distance between near and far picture elements and in turn the impression of three dimensions. By flattening perspective, they create abstracted interpretations of landscapes that emphasize color and texture over form and space.

FOUR FAVORITES IN YOUR VEST

The ideal selection of landscape lenses covers all focal lengths between about 18mm and 200mm. Those described below represent the most useful types and should be included in every serious photographer's field kit. If you make the effort to put yourself in the right place at the right time, this optical quartet can extract professional-caliber images from any landscape scenario.

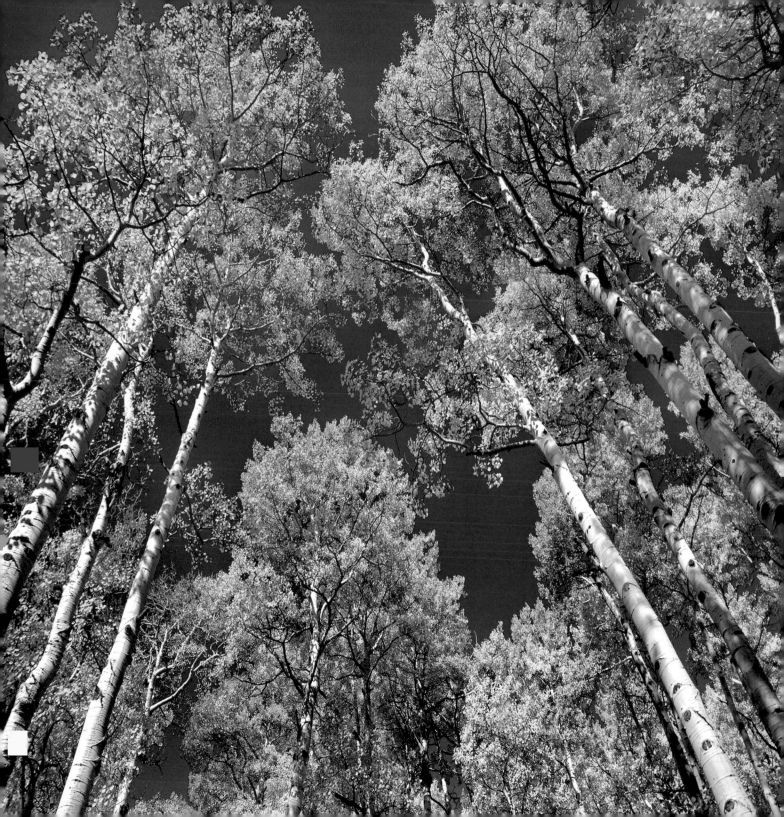

Clingman's Dome, Great Smoky Mountains National Park, Tennesee (above). These overlapping features were compressed with a telephoto lens. To ensure maximum sharpness, lock up the mirror, trigger the shutter with an electric release and shoot at mid-aperture, (f/8 or f/11). Mamiya 645 AFD with Phase One P 25 digital back, Mamiya-Sekor 300mm f/5.6 lens, ISO 100, f/11 for 1/2 second.

Mohave Point, Grand Canyon National Park, Arizona (far right). This ultra-wide-angle lens provided a near aerial view of the canyon. Mamiya 645 AFD with Phase One P 25 digital back, Arsat 30mm f/3.5 fisheye lens, polarizing filter, ISO 100, f/16 for 1/15 second.

WIDE TO MODERATE TELEPHOTO ZOOM LENS

Lenses in the 25–100mm zoom range (full-frame sensor) will handily address half the scenic challenges that confront the camera. The moderate focal length produces natural perspective, marrying the intrigue of close-quarter details with the drama of distant landforms.

ULTRA-WIDE-ANGLE LENS (ZOOM OR FIXED)

This specialty optic (20mm range or wider) impresses the viewer with vaulting skies, sweeping landforms and deep perspectives. It emphasizes the apparent distance between near and far elements of the scene while offering a grand field of view far exceeding normal vision. It's used to best advan-

tage in confined sites where the featured mountain, mesa or canyon looms close and large. You may want to carry this lens in the popular zoom format (usually around 18–35mm).

TELEPHOTO ZOOM LENS

I save this bruiser for situations when a close approach to the target is restricted by impassable terrain or obviated by design priorities based on the need to eliminate unwanted picture elements with tight cropping. Its magnifying power is useful in isolating the heart of a scene or generating an abstracted, tunnel-view impression. At moderate focal distances it works well in compressing perspective to create arresting juxtapositions of important pictorial elements, such as a twisted

Correcting Lens Distortion
Pincushion and barrel distortion are common with ultra-wide-angle lenses. You can correct this easily in Photoshop CS (Filter > Distort > Lens correction). The greater the distortion, the greater the peripheral area that must be cropped for complete correction. For this image I prefer the distorted view.

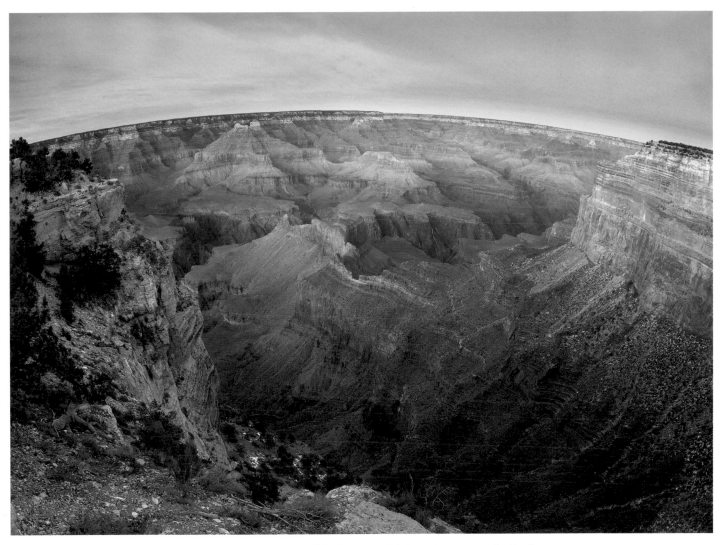

pine and its mountain setting. Insist on an internal focusing model.

TILT/SHIFT LENS

Sharpness freaks will fall in love with this specialty lens type. It brings view-camera depth of field to SLR devotees. With these lenses you can tilt the focus plane to match the landscape plane, thereby achieving more effective use of depth of field and a subsequent gain in overall detail at

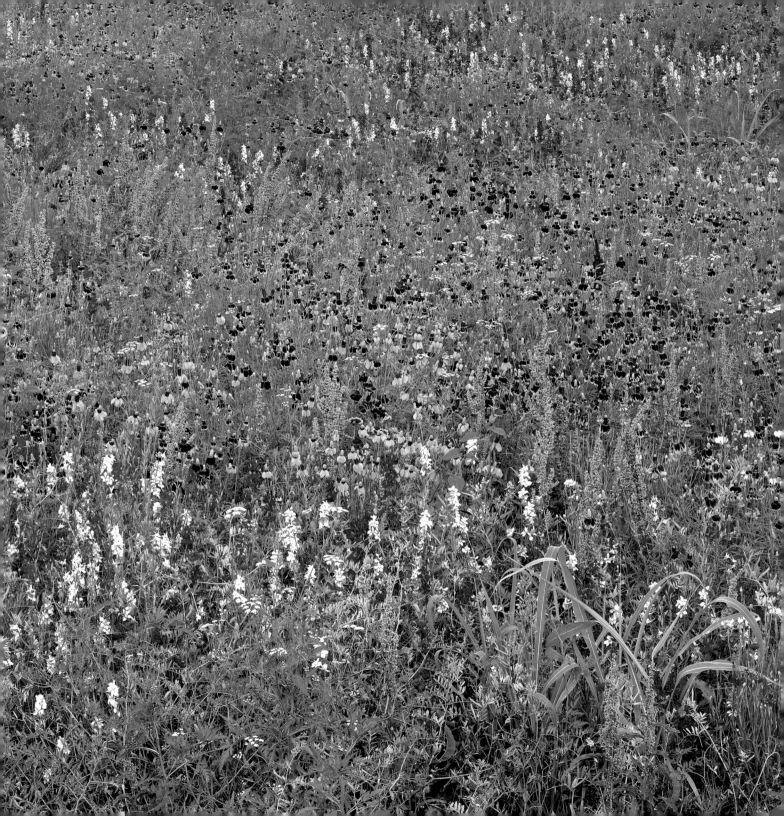

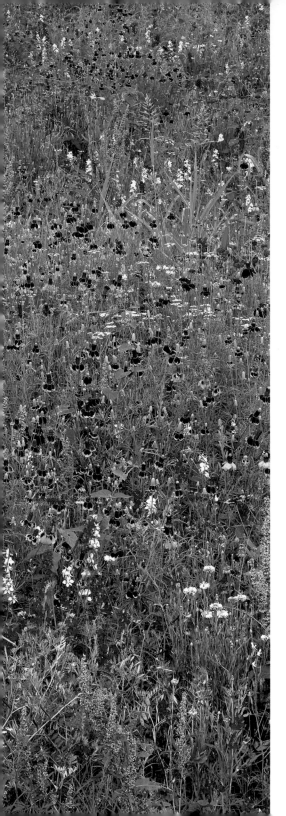

Tilt applied to Canon 90mm tilt/shift lens (on 2x teleconverter)

Focusing Tilt/Shift Lenses
Here are the iterative (trial-and-error) procedures I use for placing depth of field.
a) Scene contains prominent vertical foreground elements (e.g., trees). *Tilting the lens plane will not improve depth of field. Make no adjustments.*
b) Scene consists of a relatively flat plane (e.g., fields, ponds). *Follow these steps: 1) Focus on the foreground element. 2) Tilt the lens forward until the horizon appears sharp and then tilt back about half way. Now both the foreground and horizon are blurred. 3) Focus again on the foreground feature (further into the image field), which will bring near and far features into better focus. 4) Repeat steps 2 and 3 until overall sharpness is maximized.*
c) Scene consists of a relatively flat plane with numerous elevated features (trees, rock pinnacles, etc.). *Position the focal plane as in b) keying on two features—the most important foreground feature and one other high priority feature. Shoot at small aperture for more depth of field to sharpen the off-axis picture elements.*
Adjusting swing. *Adjusted similarly to tilt but is used for picture elements at right angles to the lens/subject axis. Use swing for fitting depth of field to vertical near/far features (trees).*
Adjusting shift. *Sliding the lens sideways off the optical center is called "shift." It is most useful for removing your shadow from compositions when the sun is low in the sky.*
Adjusting rise/fall. *Sliding the lens up and down off the optical center is called "rise/fall." It is most useful to re-establish framing of the original composition once you have adjusted tilt. If your lens does not have a rise/fall adjustment, you must reframe by adjusting the ball head.*

Shift applied to 45mm Hartblei lens

larger apertures. Canon, Rollei, Nikon and Hasselblad offer proprietary T/S lenses or systems while Horseman, Novoflex and Hartblei produce generic outfits for popular 35mm and medium format systems. These lenses excel when shooting flat terrain, beaches, lakes and ponds. Tilt and focus settings work in concert and must be set carefully to maximize the lens's potential (see box above).

Spring meadow, Jacksonport State Park, Arkansas. *Applying tilt and swing movements helped align the sensor plane with the meadow while a telephoto lens compressed the blossoms for a lush impression. Mamiya 645 AFD with Phase One P 25 digital back, Horseman View Camera Converter with 150mm f/5.6 Apo Rodagon lens, ISO 100, f/16 for 1/30 second.*

Logistics in the Field

Transporting, accessing and protecting equipment in the field

Joy Fitzharris

The East and West Temples, Zion National Park, Utah (below). Getting to this vantage point required a tricky scramble over steep slickrock and quick shooting to capture the brief display of dawn color.

Managing your equipment efficiently in the field makes photography more enjoyable, productive and creative. You should be able to find and put to use any piece of equipment almost instantly. Your fragile cameras and lenses must be protected from shocks, bumps, dirt and moisture. This will be made easier by keeping things simple and traveling lightly. Remove all unnecessary items from your field kit, including "just-in-case" lenses and accessories. They add weight and make finding useful equipment more difficult. The second essential is good organization. There are a lot of items in a landscape photographer's kit, and you can quickly lose track of them unless each is awarded a permanent, dedicated space that can be accessed instantly.

A backpack with padded compartments is what most photographers use to keep their equipment organized. Though popular, this approach is far from ideal. You must remove, safely situate and open the pack to access a camera, lens or accessory. The process is time-consuming and discourages spontaneity. Should a change in tripod position be necessary, you have to carry the open pack about like a tray

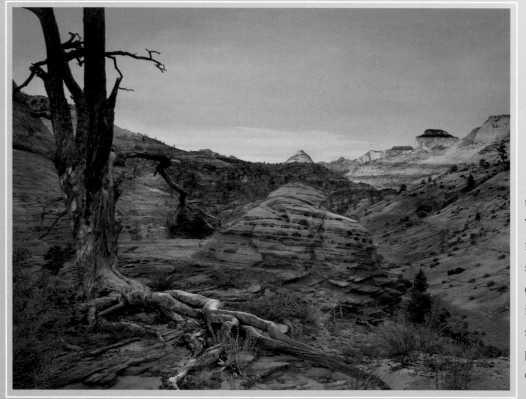

of hors d'oeuvres or tediously repack and unpack the contents. For serious photographers bent on making world-class images on a routine basis, there is a better way.

PHOTO VEST

A photo vest is the next best thing to working with an assistant. The Street and Field Vest Harness by Lowepro (www.lowepro.com) is my favorite. Much sturdier and more versatile than cloth vests, this system features a variety of interchangeable, easy-access, padded, all-weather pouches and cases attached solidly to a military-grade vest/harness and a spine-saving hip belt. Pouches and cases are specially designed for carrying lenses, filters, memory cards, batteries and a lot of other accessories. Kinesis (www.Kgear.com) and Tamrac (www.tamrac.com) make similar modular belt and shoulder harness systems but do not offer an actual vest.

With these systems you can quickly attach and arrange a variety of pouches, compartments and lens cases to suit the shooting situation. The system keeps everything in the right place and close at hand. It allows you to move about freely yet access equipment immediately on any terrain including marshes and swamps. If you are photographing in sand dunes, it keeps your lenses away from blowing particles that would otherwise jam lens and camera mechanisms. Most important, you can carry most of the weight on your hips, saving your back from strain and even injury.

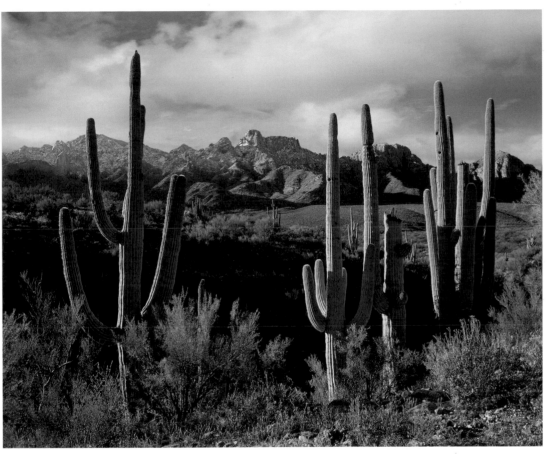

Santa Catalina Mountains, Catalina State Park, Arizona (above).
A photo vest keeps key accessories and lenses organized and ready for immediate use. This is important for capturing dramatic scenes in the rapidly changing light of a partially overcast day. Pentax 645NII, Pentax 45–85mm f/4.5 lens, polarizing filter, digital scan from Fujichrome Velvia, ISO 50, f/22 for 1/15 second.

When you get back to your vehicle, there's no need to repack equipment as would normally be necessary with a cloth vest. Simply lay the entire contraption in the trunk or on the seat (everything is in padded compartments) as you would a photo backpack. If flying, you can stuff your loaded vest into a carry-on bag or pack it in a suitcase to be checked.

FULL MEMORY CARDS

Lowepro offers a terrific pouch (called the Film Drop AW) originally intended for storing exposed film but now works just as well for stow-ing memory cards and extra batteries. It has a secure one-way slot at the top through which you can quickly push full cards. Unfortunately, this pouch also has a side zipper that you are supposed to use to extract the contents. It's only a matter of time until you forget to re-zip, resulting in memory cards dropping in your wake as they go in one end of the pouch and out the other. Fortunately, the zipper can be easily sewn or glued shut, leaving you to pull memory cards and fresh batteries back out through the top. Luckily, it's no more difficult than fooling with the zipper and your hard-earned shots and precious batteries stay secure.

Cascading Open-Top Filter Pouch

Although I don't carry as many filters as I did when I was shooting film, it is still important to have ready access to these accessories. This module, made from duct tape and single cut-down Singh-Ray filter pouches, stays in my vest and allows quick, one-handed access to any filter.

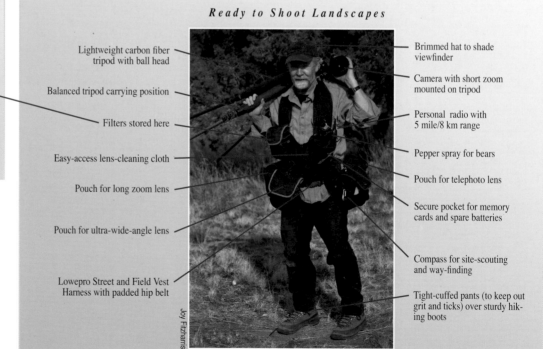

Ready to Shoot Landscapes

Lightweight carbon fiber tripod with ball head

Balanced tripod carrying position

Filters stored here

Easy-access lens-cleaning cloth

Pouch for long zoom lens

Pouch for ultra-wide-angle lens

Lowepro Street and Field Vest Harness with padded hip belt

Brimmed hat to shade viewfinder

Camera with short zoom mounted on tripod

Personal radio with 5 mile/8 km range

Pepper spray for bears

Pouch for telephoto lens

Secure pocket for memory cards and spare batteries

Compass for site-scouting and way-finding

Tight-cuffed pants (to keep out grit and ticks) over sturdy hiking boots

Joy Fitzharris

STAYING IN TOUCH

If you shoot alone it's a wise precaution to have a cell phone with you in case you get into trouble. If you work with a partner, personal radios (walkie-talkies) generally help to coordinate activities or keep you in touch should you choose to split up to cover more territory.

TRIPOD TREKKING

Like most photographers, I carry tripod and camera over my shoulder so that I'm ready to shoot in a few seconds. Unfortunately, on a hike longer than a mile or so, the off-center weight creates a strain on spine and hips even if you shift the burden from shoulder to shoulder. For long hikes you need to use the tripod trekking position as follows. With either the tripod head or the camera's lens in one hand and a leg of the tripod in the other, position the assembly over the shoulders behind your neck (see photo, left). This centers the weight on your spine (reducing strain) and also gives your arms a rest. It even works for heavy telephotos.

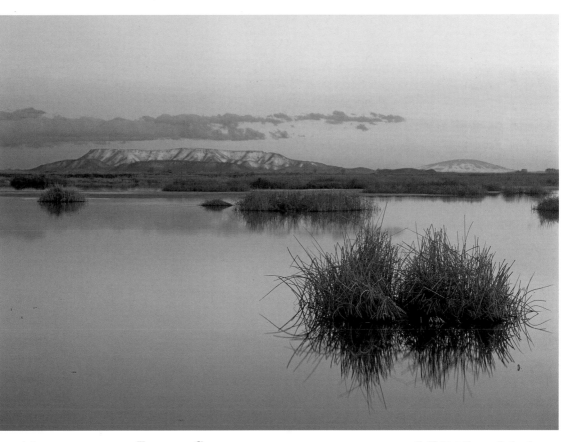

ESSENTIAL GIZMOS

• **Brimmed hat.** In addition to the usual protection from the elements, a hat shades the viewfinder from stray light and can even be removed for shielding the lens from flare in backlit shooting situations.

• **Pepper spray.** Landscape photographers routinely shoot alone during twilight, making themselves especially vulnerable to bear attacks. When working anywhere in bear country, it's wise to carry a professional repellent. Counter Assault makes one

Twilight at Alamosa National Wildlife Refuge, Colorado (above). Carrying your equipment in a vest is especially valuable when shooting in shallow pools. No need to head back to shore to extract a lens from your backpack (and disturb a perfect reflection in the process); just pull whatever you need from your vest without delay. Pentax 645NII, Pentax 45–85mm f/4.5 lens, one-stop split ND filter, digital scan from Fujichrome Velvia, ISO 50, f/22 for $^{1}/_{8}$ second.

Cascades Falls, Jefferson National Forest, Virginia (below). Icy mountain streams are beautiful subjects. Neoprene chest waders allow you to place the camera where it's needed while keeping you warm and dry. Mamiya 645 AFD with Phase One P 25 digital back, Mamiya-Sekor 105–210mm f/4.5 lens, polarizing filter, ISO 100, f/22 for 1 second.

of the best deterrents (www.counterassault.com).

• **Compass.** When evaluating a location prior to shooting, it's essential to know where the sun will rise and set. A compass helps with this in addition to providing basic way-finding en route.

• **Bic-type lighter.** Should you become lost, getting a fire started can save your life. It keeps you warm and attracts rescuers.

• **Tool knife.** Leatherman/Swiss Army-type tools are small and handy for numerous tasks, from repairing equipment to dealing with emergencies.

• **Chest waders.** Don't compromise on composi-tions. Take your camera into the stream or pool for precisely the angle you need. River sandals and quick-dry shorts are best for warm locations.

WHEN IT RAINS

Keeping your equipment dry in the rain is easy. Carry a small plastic bag permanently tucked away in your vest. Attach a mini bungee cord to a tripod leg for securing the bag over camera and ball head while hiking back to shelter or waiting out the storm (see sidebar, page 27).

BATTERY POWER FOR YOUR EQUIPMENT

Light meters, motor drives, electronic flashes, auto-focus and image-stabilized lenses, personal radios, digital cameras, digital backup storage and laptop com-puters require batteries to keep them operating. Managing your power sources is important for uninterrupted shooting. Here's an evaluation of battery features and suggestions for keeping them working at peak efficiency.

TOP BATTERY TYPES

• **NiMH (nickel metal hydride)** Configured in wide-application AA size. Good cold weather choice. Can be recharged up to 500 times at any stage of depletion without harm. Performance stays

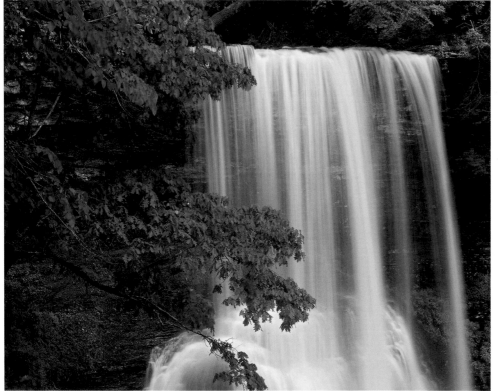

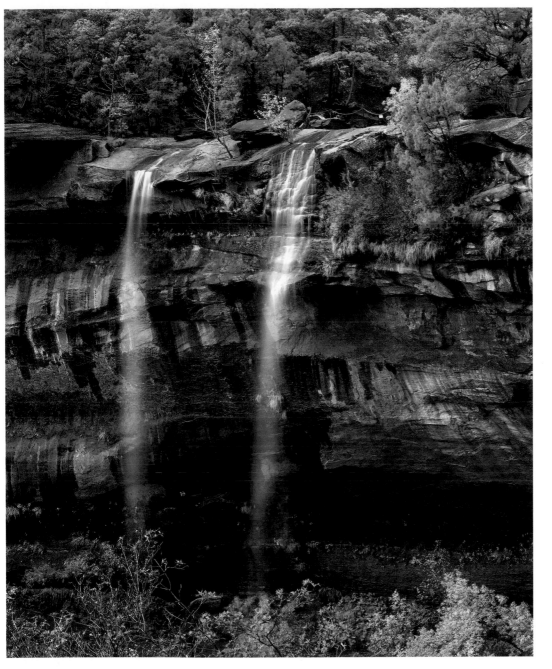

Cascades near Emerald Pools, Zion National Park, Utah (left). Soft light from an overcast sky, rosy tones reflected from sandstone ramparts and pastel tints of autumn's desert palette coalesce to create an idyllic wilderness scene. Getting the perfect camera angle in rough terrain is made easier by traveling light. If you are shooting along streams and rivers, you should also be prepared to get your feet (and more) wet. Mamiya 645 AFD with Phase One P 25 digital back, Mamiya-Sekor 105–210mm f/4.5 lens, polarizing filter, ISO 100, f/11 for ¹/₂ second.

Joy Fitzharris

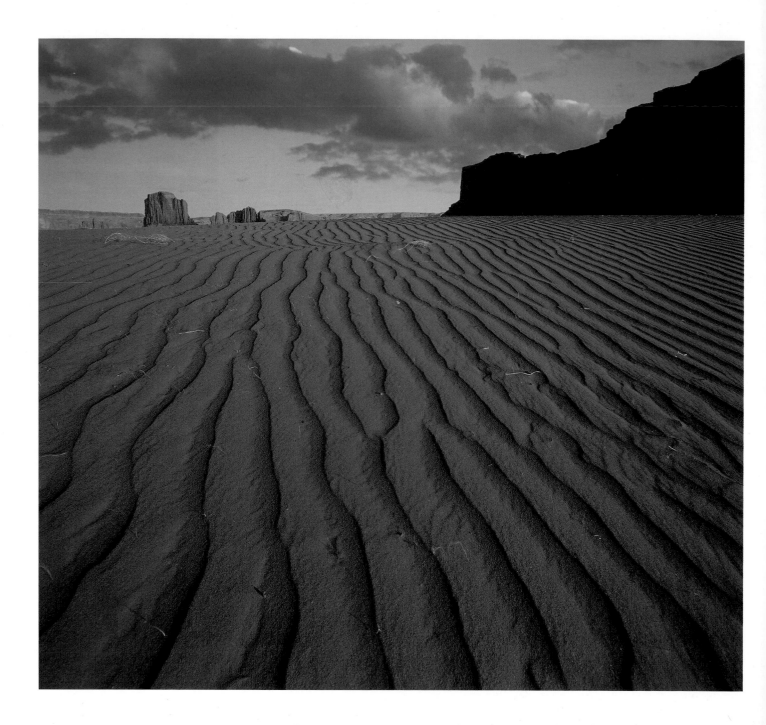

high throughout discharge cycle (unlike nickel cadmium). For top performance, batteries should have a minimum rating of 2,100 milli-amps per hour (mAh).

• Li-ion (lithium ion)

Configured in special dedicated sizes. Backups available from camera or after-market suppliers only. Small and light with large capacity and high performance throughout discharge cycle. Best cold weather choice. Can be recharged 1,000 times (with dedicated charger only).

• Disposable alkaline

Lower power and performance but inexpensive, widely available and configured in handy AA/AAA sizes. Fine for radios, light meters, GPS receivers.

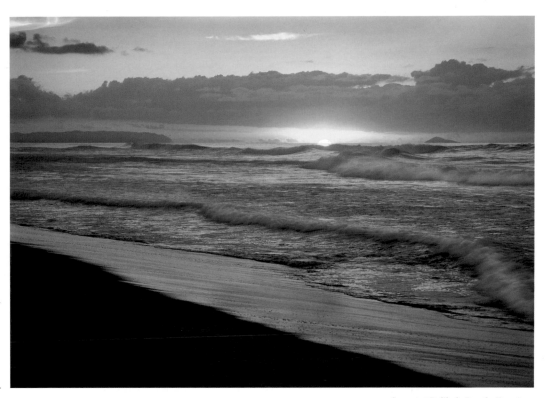

CHARGING AND MAINTENANCE

Recharge NiMh and Li-ion batteries before they are fully exhausted to maintain peak efficiency. Even when not in use, these batteries lose power slowly, so top them off once a month. As they deliver high performance until near full depletion, recharge or switch to a backup set as soon as your camera indicates low power.

Battery chargers come in numerous configurations and capacities, accepting multiple battery types and sizes simultaneously. To prevent battery damage by under- or over-charging, make sure the recharger has battery analyzing circuitry and discharge function. Quick-charge units (which restore power in 15 minutes) are convenient but reduce battery life and may not charge as fully as slow chargers (which take three to four hours).

SHOOTING IN WINTER

Winter calls for modifications in how you dress, how you handle your equipment and how you approach the picture-making process.

Sunset at Polihale Beach, Kauai, Hawaii (above). The sun takes but a few seconds to pass over the horizon. It's no time to run out of battery power. I make sure to switch to a fresh set well before the action starts. Pentax 645NII, Pentax 80–160mm f/4.5 lens, two-stop split ND filter, digital scan from Fujichrome Velvia, ISO 50, f/22 for 1/8 second.

Sand dune ripples at Monument Valley, Arizona (left). A grain of sand can quickly put a camera out of action. Keep your gear in a vest well above the danger zone.

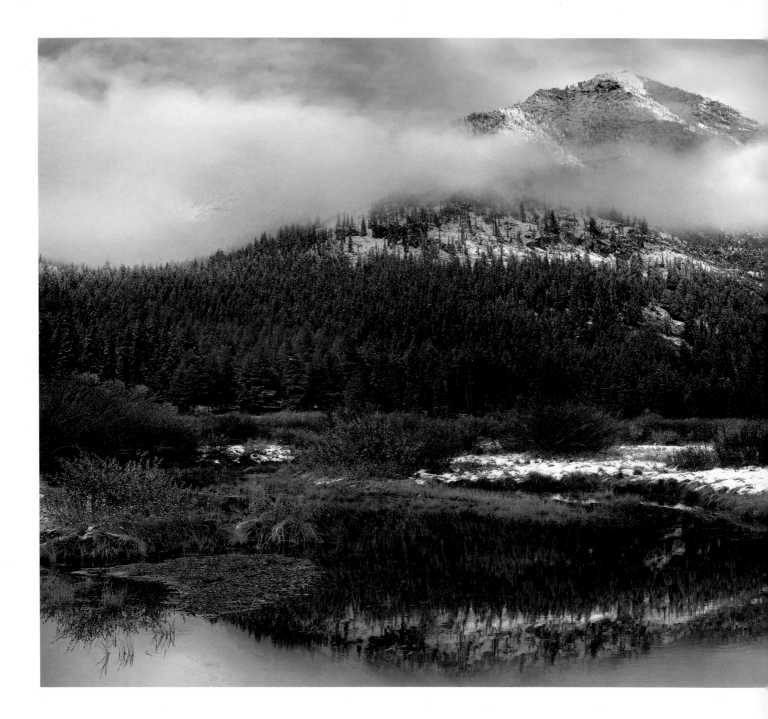

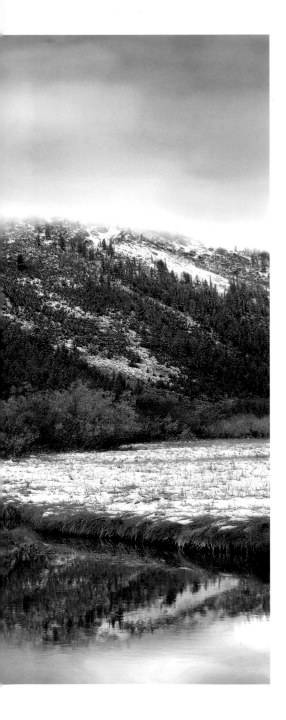

Staying comfortable during a subfreezing shooting session is as much a matter of remaining cool to avoid sweating as it is keeping warm. A photographer's activity level and in turn body temperature are seldom constant. One minute you may be hot and sweating, the next clammy and shivering. To remain comfortable, you need to both retain and shed body heat at will.

DRESS WITH ZIPPERS, NOT LAYERS

Photographers have plenty to keep their hands full without having to take layers of clothing on and off. Instead, wear clothes with plenty of long, strategically located zippers for easy venting. The basis of your cold weather outfit is a loose-fitting, non-insulated, water-shedding, breathable parka made of Gore-Tex or similar fabric. It should have an up/down front zipper and cover your buttocks. A hood with an elastic drawstring is essential.

KEEPING YOUR LEGS WARM

Some of your shooting will be done while

Snowy aspens and spruce trees Rocky Mountain National Park, Colorado (above). The soft light from overcast skies reduces subject contrast, allowing film and sensor to capture all the tones and color of the scene. Pentax 645NII, Pentax 300mm f/5.6 lens, digital scan from Fujichrome Velvia, ISO 50, f/8 for 1/30 second.

Phi Kappa Mountain and Summit Creek, Idaho (left). During winter the sun does not rise high in the sky, extending the time period for capturing a dramatically lit scene. Snow on the ground also reflects light into shadow areas to reduce contrast and reveal shadow detail. Mamiya 645 AFD with Phase One P 25 digital back, Hartblei Super-Rotator 45mm f/3.5 lens, one-stop split ND filter, ISO 100, f/22 for 1/2 second.

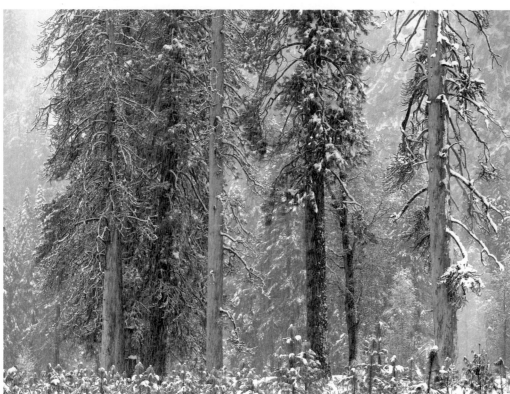

Winter in Yosemite Valley, Yosemite National Park, California (above). Snow accentuates color intensity, generating interest in otherwise mundane scenic features. Pentax 645NII, Pentax 80–160mm f/4.5 lens, digital scan from Fujichrome Velvia, ISO 50, f/16 for 1/2 second.

Elk Mountains, Colorado (far right). Simple arrangements of color make strong compositions. Pentax 645NII, Pentax 80–160mm f/4.5 lens, polarizing filter, digital scan from Fujichrome Velvia, ISO 50, f/11 for 1/15 second.

Velcro chin straps, insulated ear flaps (which can go up and down as needed), and a flexible bill (for shading the viewfinder). When it's extremely cold or windy I lower the flaps, raise my hood and zip up my inner turtleneck and outer parka to cover chin and mouth. This funnels warm, exhaled breath up and over my nose to prevent frostbite. If it's not too cold I wear a ball cap with a head-band that I let dangle about my neck or install over the cap and around my ears when more protection is needed.

KEEPING YOUR FEET WARM

If you keep your head warm, you won't have much of a problem with your feet. Ideal boots rise over the ankle and consist of breathable, waterproof, insulated Nubuck leather or similar material, waterproof Gore-Tex liners and Vibram soles. Usually one pair of heavy wool or moisture-wicking polypropylene fleece socks will supply ample insulation, provided your boots are not tight-fitting.

KEEPING YOUR HANDS WARM

The best way to keep your hands and fingers nimble, even in extreme conditions, is with a heavy pair of mittens or gloves (polar fleece-lined

kneeling on snow or ice. You need sturdy, water-shedding, lightly insulated pants with zippered bib, reinforced knees and elastic cuffs (snowboarding trousers are perfect). At a minimum there should be zippers along the legs reaching to above the knee to release excess heat when necessary.

REGULATING HEAD TEMPERATURE

As 70 percent of heat is lost through the head, this body part is the master valve for temperature control. I use a fleece-lined Gore-Tex hat with

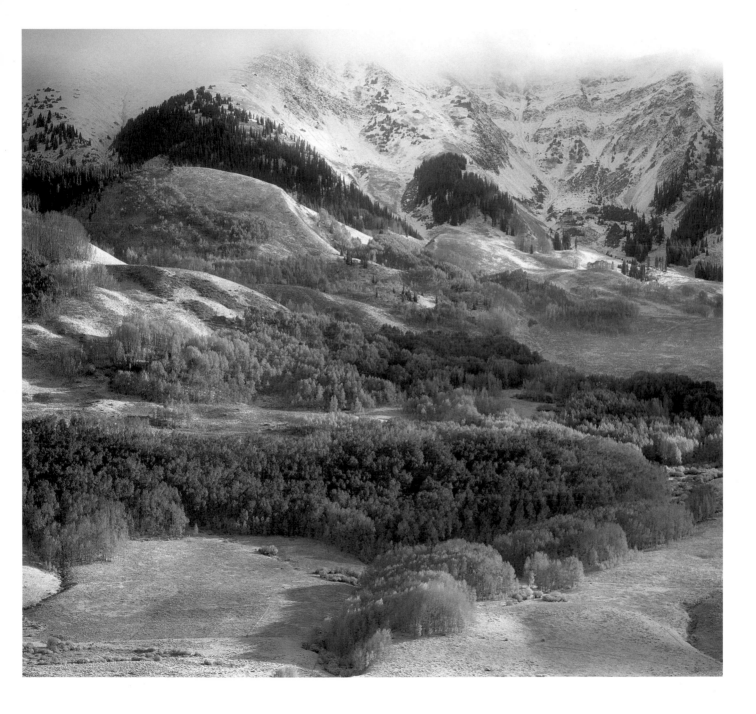

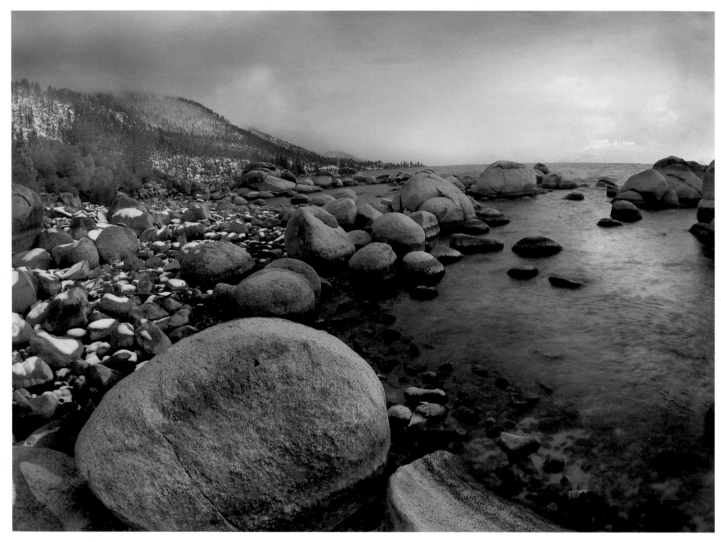

Hidden Beach, Lake Tahoe, Nevada (above). Ultra-wide-angle lens distortion (note curving horizon) was partially corrected in Photoshop. Mamiya 645 AFD with Phase One P 25 digital back, Arsat 30mm f/3.5 fisheye lens, one-stop split ND filter, ISO 100, f/22 for 1/15 second.

Gore-Tex with traction palms are my preference) attached to abbreviated idiot strings. Work the camera bare-handed, slipping your paws back into the gloves (which dangle conveniently at fingertip length from your wrists) whenever they become stiff and need a warm-up.

THE FULL MONTY

A full suit of moisture-wicking long underwear (Capilene or similar material) is necessary for warmth and to draw sweat away from your body. Over this I wear a wool or silk shirt, then a zippered polar fleece with a turtleneck collar; next

comes my snowboarding pants, then the outer parka shell.

There are a number of catalog websites where you can buy and find out more about outdoor expedition quality apparel. One of my favorites is www.rei.com.

THINK AHEAD TO STAY WARM

Operating this zippered, ready-vent garment system is simple. If you are working behind the camera with little physical exertion, keep your zippers and flaps closed. When you need to move from one shooting location to another, open zipper vents at the outset and make adjustments as you go along depending on internal heat buildup and weather conditions. There's usually no need to take anything off or on; just work your zippers to avoid both sweating and chilling.

CONDENSATION ON YOUR EQUIPMENT

When you re-enter a building from the cold, water vapor condenses on the exposed surfaces of your equipment, including interior mechanisms. This moisture can foul electronic components or initiate corrosion of other parts. You can avoid this by keeping a large trash bag in your vest or bag. Before going inside, put your entire vest, backpack or camera case inside the plastic bag and secure it with a twist tie. Once the contents warm up (it may take several hours), you can safely remove them.

COLD BATTERY FAILURE

Winter temperatures drain battery power quickly. To avoid this, keep your batteries (or battery cartridges) in an inner pocket close to your body until you are ready to shoot. Carry a spare set and switch around the power cells as needed. Lithium batteries provide the best performance in low temperatures.

Winter Light

Brightness. *When the scene is mostly taken up with snow, exposure readings require compensation to retain the high-key tones. Open up one or two stops from what the light meter indicates and keep a close eye on your histogram. In full sun, think about making a sequence of HDR exposures (see page 170).*

Contrast. *Snow and ice work as natural reflectors to throw light into shaded portions of a scene. This benefits picture quality and makes it unnecessary to use fill-flash or reflectors. Contrast between blue sky and snow, however, is great, and polarizing filters may add so much density that skies become nearly black.*

Quality. *In northern latitudes during winter the sun remains close to the horizon all day long, providing extended opportunities for low contrast, sidelit shooting. The dramatic rosy colors of sunrise and sunset similarly hang in the sky much longer, extending the attractive twilight shooting period.*

June Lake, Eastern Sierra Nevada Range, California. Snow-accented reflections are best pursued in early winter, when lakes are still open and snow is not deep enough to prevent safe and easy access. Mamiya 645 AFD with Phase One P 25 digital back, Mamiya-Sekor 55–110mm f/4.5 lens, one-stop split ND filter, ISO 100, f/22 for 1/4 second.

Part Two
Shooting Fundamentals

Exposure
Making reliable exposures in difficult situations

California poppies and desert bluebells near Lake Elsinore, California (below). An average scene like this has no significant amounts of very light or dark tones.

Professional landscape images start with accurate exposure. Fortunately, exposure is one of the easiest aspects of photography to master thanks to through-the-lens light meters, which measure the luminance of the scene as it will register on the sensor. These readings are coupled to shutter speed and aperture controls, making it easy to choose the correct settings, whether it be done manually or automatically.

Light Meters Can't Think

If you're photographing an average scene, light meters work without a hitch. Unfortunately, they operate as if every scene were average. They can't differentiate between snow, which is supposed to be very light, and a cold lava field, which is supposed to be very dark. Without some adjustment by the photographer, both are interpreted as average and rendered as neutral gray. Many scenes contain features both so light and so dark that when combined they exceed the recording range of the sensor. A light meter cannot decide which should receive priority. Only you can do this.

Metering Patterns

For most landscapes an evaluative or average

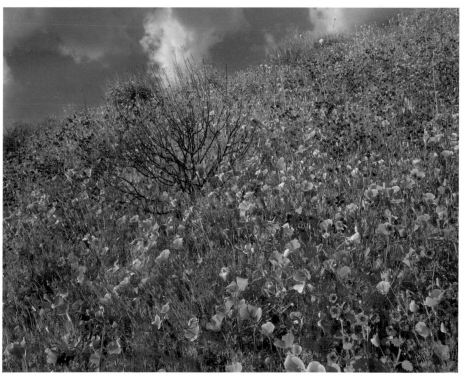

Reading Your Camera's Histogram

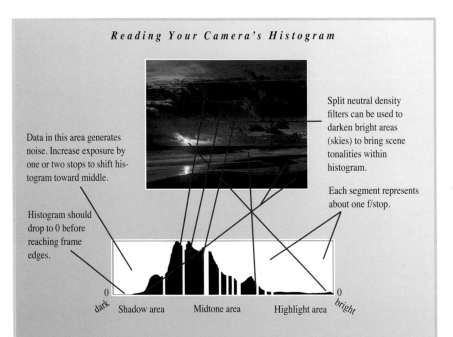

Data in this area generates noise. Increase exposure by one or two stops to shift histogram toward middle.

Split neutral density filters can be used to darken bright areas (skies) to bring scene tonalities within histogram.

Each segment represents about one f/stop.

Histogram should drop to 0 before reaching frame edges.

0
dark Shadow area Midtone area Highlight area 0 bright

To retain detail and color in highlight (bright) areas and shadow (dark) areas, the histogram should drop to zero before reaching the frame edge. For the best quality data keep the majority of histogram data center/right. If the histogram is humped to the left, you need to increase exposure; if it is humped to the right, you must decrease exposure. If the histogram extends beyond both ends of the frame, the brightness range (contrast) of the scene exceeds the sensitivity of the sensor. You can reduce scene contrast by using split and graduated neutral density filters or by waiting for softer light.

Expose to the right. *For the best quality shadows over-expose, but don't lose the highlights. The LCD image will appear washed out; don't worry, this is as it should be.*

a matter of checking the histogram on the LCD screen. The histogram graphs the luminance values in the frame and tells you instantly if all parts of the scene have been recorded on the sensor. Should this not be the case, you simply make appropriate adjustments to aperture and/or shutter speed until the readout indicates correct exposure.

EXPOSE TO THE RIGHT

When you are setting exposure, try to generate a curve that places the majority of data on the right side (bright region) of the histogram while making sure not to clip any of the highlights. The full screen view will appear over-exposed. This yields shadows areas that are less prone to noise and exhibit a more continuous, broader range tonality than those resulting from a balanced histogram where the data is centered.

DIFFICULT EXPOSURE SITUATIONS

For frontlit, sidelit and softly illuminated subjects of normal brightness, good exposures can be expected from an average or evaluative meter reading. It can be more difficult, however, when confronting scenes dominated by unusually light or dark subject matter or those composed of a mix of the two. It gets worse when there is limited time to reshoot or bracket due to changing conditions of sky or subject matter—sunset/sunrise, landscape features in the spotlight or scenes incorporating

metering pattern works fine. Only in situations where a small but critical feature is significantly lighter or darker do you need to switch to either spot or center-weighted mode to make an exclusive reading of this area.

HISTOGRAM CHECK WITH DIGITAL CAMERAS

For digital camera users, correct exposure is

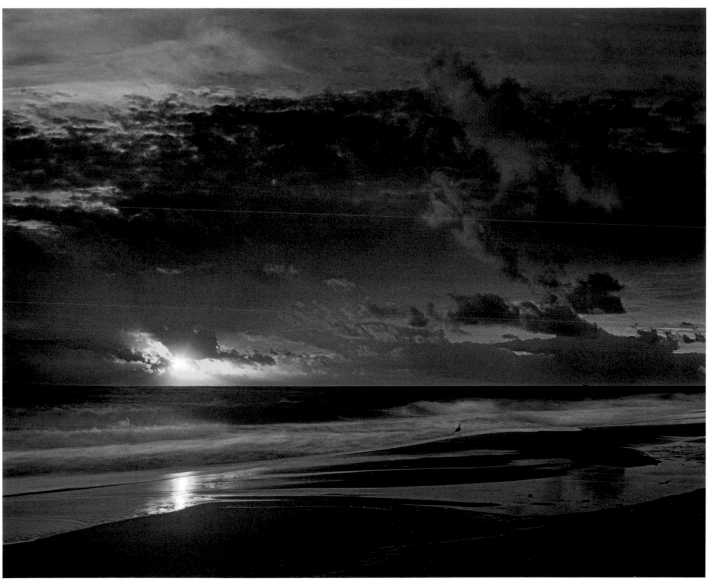

wildlife on the move. Following are descriptions of some of the difficult situations you will face and and how to deal with them.

BACKLIT SUBJECTS AND SCENES

Digital sensors sometimes cannot record both the highlights and shadows of scenes lit from behind.

Gull on beach, John D. MacArthur State Park, Florida. To fit this scene into the histogram required the use of a split neutral density filter.

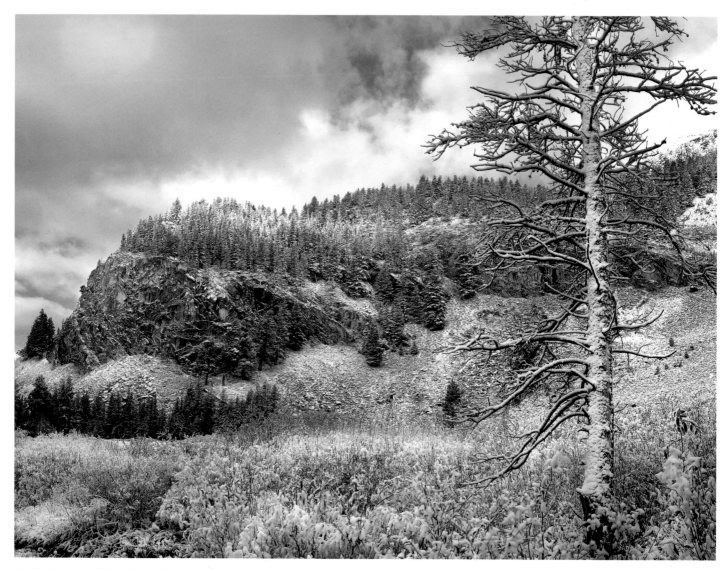

Boulder Mountains, Idaho (above and bottom right). To retain the brightness of this snowy scene, exposure was based on a center-weighted reading from an area of average density (see illustration opposite).

Decide which tonal area is key and then give it exposure priority. For shadows, I take a center-weighted reading on the center of interest and then decrease exposure by about one stop to maintain the backlit mood as well as to retain details in the glowing periphery. I then scrutinize the histogram to make sure I have captured the tones that are critical to the mood I am after.

WHITE AND LIGHT SCENES

Predominantly white scenes record as neutral gray if shot without exposure compensation. I increase exposure by one to two stops over the meter reading to maintain these light tones. If the main subject of the scene is white to very light colored and occupies less than 1/4 of the frame (e.g., bear grass blooms), I decrease exposure by a half stop to prevent overexposure of the subject.

BLACK AND DARK SCENES

Very dark scenes (coniferous forests in shadow) will record as neutral gray if exposure is made without compensation. To retain density, I decrease exposure by one stop. If the main subject of

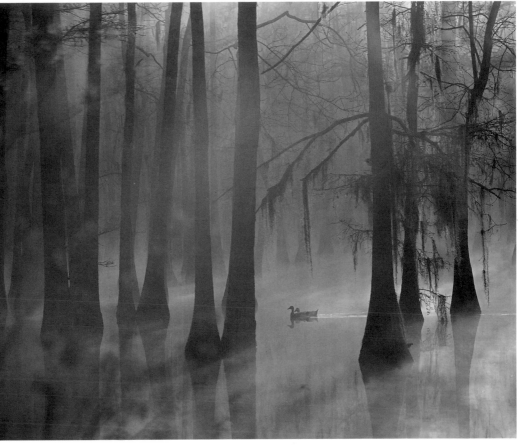

the scene occupies less that about 1/4 of the frame I increase exposure by a half stop of average and evaluative readings to open up detail in the subject. Then I check the histogram.

HIGH CONTRAST AT HIGH NOON

If shooting during the siesta period on a cloudless day, subject contrast is usually too great to be recorded fully. Favoring midtone and shadow detail

Mallards in baldcypress grove, Calcasieu River, Louisiana (above). Here backlight and lens flare created a tricky exposure situation. To ensure correct exposure, I bracketed the scene one stop over and under an average reading and picked the best images once the film was developed. Pentax 645NII, Pentax 80–160mm f/4.5 lens, digital scan from Fujichrome Velvia, ISO 50, f/11 for 1/30 second.

Exposure with Filters

Making an accurate exposure is tricky with scenes having a combination of very bright and dark areas. Split neutral density filters can be used to hold contrast within the exposure latitude of the digital sensor.

A one-stop ND filter was placed at an angle to match the slope of the terrain at Organ Pipe Cactus National Monument, Arizona.

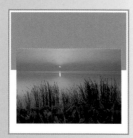

A two-stop ND filter was aligned with the horizon before the spot exposure reading was made for this view of the Indian River at Titusville, Florida.

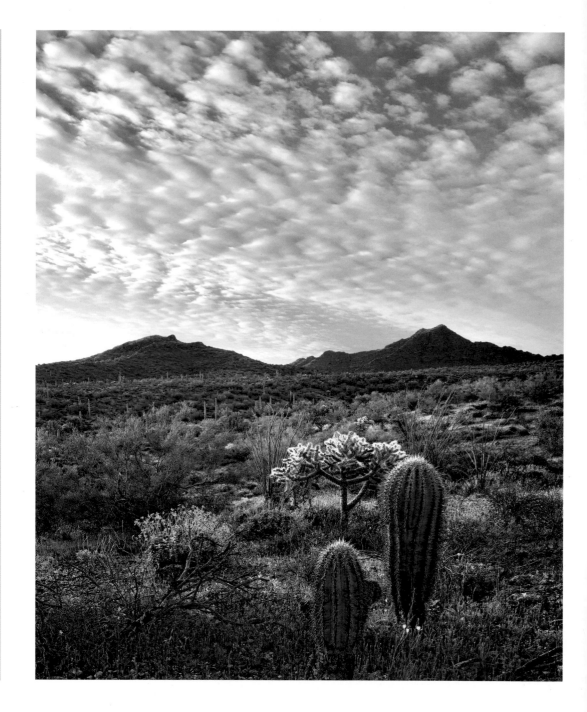

results in overexposure of highlights; if highlights receive priority, midtones and shadows are underexposed. This is why thoughtful nature photographers take naps after lunch. If you must shoot, expose to retain highlight detail (it's common for us to encounter tones so dark that detail is lost but not the other way around). Better still make a series of varied exposures spanning the brightness range and combine them in Photoshop (see page 170)

SUNRISE/SUNSET

Due to the brilliance of the sun, these dramatic tableaux generate wide-ranging exposure readings depending on how the scene is composed. For consistent results I make a spot-meter or center-weighted reading of an average-toned section of the sky that excludes the sun. Using these settings, I

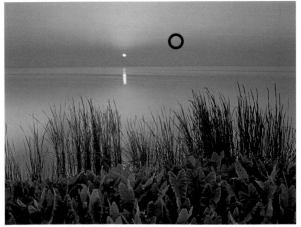

reframe the scene and take the picture. Then I check the histogram.

Exposure consistency in digital photography is the product of histogram checking. Exposure quality comes from selecting the best exposure for the subject; usually from bunching the data to the right side of the histogram (over-exposure) while being sure to retain the highlights. You'll have little trouble if you stick to this basic approach.

Lesser flamingos over Lake Magadi, Kenya (above). To maintain the dark tones of the lake, I manually reduced exposure by one stop from the average reading then overexposed during scanning. Canon EOS 3, Canon 100-300mm f/5.6L lens, digital scan from Fujichrome 100, f/8 for 1/500 second.

Sunset on the Indian River, Titusville, Florida (left). Exposure was based on a spot reading of an average sky area away from the sun.

Aperture and Shutter Speed

Controlling image detail with depth of field and exposure time

Saguaros and wildflowers, Organ Pipe Cactus National Monument, Arizona (below). *This scene was photographed at large aperture (f/4.5) for minimum depth of field.*

Depth of field is that part of the image that is rendered in sharp detail. One way to evaluate it is to use the camera's depth-of-field preview. This mechanism closes the aperture to the f/stop that you have set for actual exposure, allowing you to see what is sharp and what is not. Otherwise, the lens diaphragm stays open and the viewfinder remains bright in order to make focusing and composition easier.

A better way is to make a capture and then check the areas you wish to be rendered sharply (or softly) on the LCD monitor at maximum magnification. Make adjustments to aperture if needed then grab another capture and check the LCD again.

SETTING DEPTH OF FIELD

When shooting landscapes, setting depth of field generally guides other camera adjustments, like exposure and point of focus. Most landscape images are conceptual composites, that is, they are judged by how the various elements of the scene relate to

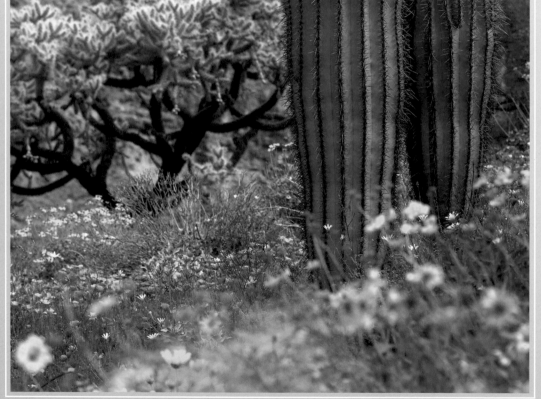

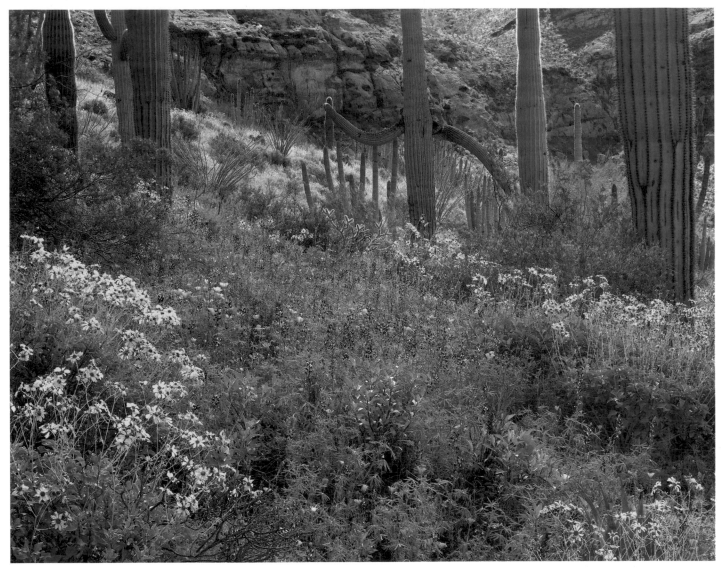

one another, particularly in terms of color, light and perspective. To reveal these relationships effectively, it is advantageous to record as much detail as possible throughout the scene from foreground to horizon. Attaining complete depth of field is usually the starting point for establishing composition, even insofar as what you chose to include or exclude from the frame.

Saguaros and wildflowers, Organ Pipe Cactus National Monument, Arizona (above). This scene was photographed at small aperture (f/22) for maximum depth of field.

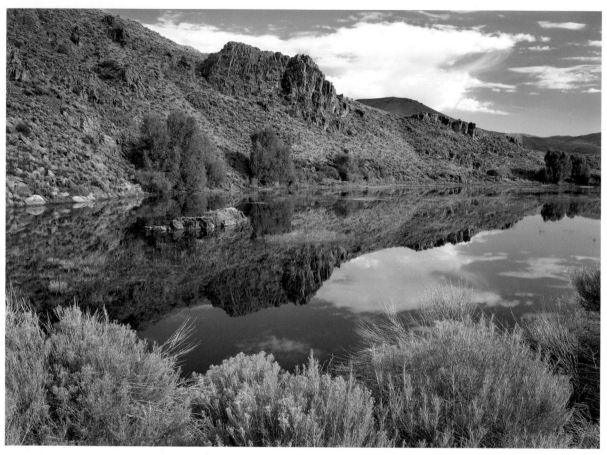

Red rock reflection, Curecanti National Recreation Area, Colorado (above). Maximum depth of field was achieved from the wide-angle lens' smallest aperture of f/16.

Teardrop Arch, Monument Valley, Arizona (far right). Maximum depth of field was achieved from the telephoto lens's smallest aperture of f/32.

How Much Depth of Field

Depth of field's extent is dependent on magnification of the subject and aperture size in this way: the greater the magnification (regardless of lens focal length), the less the depth of field; the smaller the aperture, the greater the depth of field. Magnification is dependent on lens focal length and distance from the subject. The longer the lens and the closer you are to the subject, the greater the magnification. Aperture size is normally given priority in landscape photography due to its effect on depth of field. Once aperture is set and depth of field established, shutter speed is adjusted to provide correct exposure.

Positioning Depth of Field

The lens is focused to position the depth-of-field zone to maximum advantage—so that the most important features of the scene are rendered sharply. About one-third of the in-focus field falls in front of the focus point with about two-thirds falling behind. Armed with these facts you can adjust the camera to attain total field sharpness at an appropriate shutter speed. (Brief exposures are normally desired to avoid the problem of subject movement due to wind.) Setting the lens' *hyperfocal distance* is the term photographers use for this procedure.

Hyperfocusing Made Easy

To capture detail from infinity to close-up, you need to set the lens at the hyperfocal distance. Use the depth-of-field preview lever to view the scene at shooting aperture. Make sure the viewfinder is well hooded, give your eyes a few moments to adjust to the dimness and examine the scene carefully. Start with focus at infinity and back off until the most distant features begin to lose sharpness. Reverse focus a smidge and then examine the foremost picture elements for adequate detail. If they are not sharp, adjust to a smaller aperture or move the tripod back from the foreground features and repeat the process.

For manual focus optics you can hyperfocus using the depth-of-field scale on the lens. Adjust focus so that the infinity mark is indexed to the lens aperture being used. Depth of field extends from infinity to the distance indexed to the working aperture at the opposite end of the scale.

Aperture at f/11 Focus set for f/11 at ∞

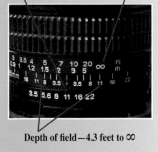

Depth of field—4.3 feet to ∞

Trading Resolution for Depth of Field

To attain the best combination of image resolution and depth of field, you need to determine the sharpest aperture for the lens (consult manufacturer's test reports or www.pop-photo.com). Use this setting whenever it provides adequate depth of field for your purposes. Sometimes a lens's highest resolving aperture is only marginally better (e.g., 55 lines per mm vs. 50 lines per mm) than an aperture two or three stops smaller. In such cases, opt for the lower resolution/greater depth-of-field aperture if it furthers your compositional goals. Here is a sample list of some of my lenses with their best resolving apertures and best compromise apertures for full depth of field with normal framing of a landscape scene. Some top performing apertures deliver lots of depth of field, others don't come close. You can make up a similar list for your own favorite optics to consult while shooting.

Lens	Best Aperture	Compromise Aperture
35mm f/3.5–22	f/5.6–74 lines/mm (Excellent)	f/16–60 lines/mm (Excellent)
55–110mm f/4.5–32	f/11–56 lines/mm (Excellent)	f/22–43 lines/mm (Very Good)
105–210mm f/4.5–32	f/8–62 lines/mm (Excellent)	f/22–40 lines/mm (Very Good)

Mule deer at Badlands National Park, South Dakota. By increasing ISO speed to 400, I was able to use a fast shutter speed (to freeze motion) and small aperture (to maximize depth of field) to capture this passing moment. Mamiya 645 AFD with Phase One P 25 digital back, Mamiya-Sekor 105–210mm f/4.5 lens, two-stop split ND filter, ISO 400, f/22 for 1/125 second.

SHUTTER SPEED AND CONTROL OF MOTION

Still photography's expression of motion is one of the medium's most distinctive features. The shutter's measure of time and light fortunately attends a range of creative choices for interpreting the hurly-burly of the wilderness world.

Shutter speed controls how long the digital sensor is exposed to light, a critical compositional issue if the subject, camera or both are moving during the shot. Fast (brief) shutter speeds freeze action, while slow (long) speeds cause action to be blurred. As neither impression is accessible to human vision, a fascinating novelty is afforded motion images. To manage this effect, you need to have direct control of shutter speed selection.

AUTO-EXPOSURE WITH SHUTTER PRIORITY

Auto-exposure (AE) with shutter priority (Tv) allows you to choose the shutter speed while the

camera sets the aperture for correct exposure. This method proves its mettle when shooting subjects under rapidly changing angles and intensities of light, allowing you to concentrate on the artistic challenges of framing and firing while the camera takes care of exposure.

SAFETY SHIFTING IN TV MODE

Many DSLR cameras offer a "safety shift" feature (sometimes accessed as a custom function). Turn it on and the camera will momentarily modify the chosen shutter speed (or ISO speed) if it is too fast or too slow for lighting conditions (e.g., your choice of two seconds may cause overexposure even at the lens's smallest aperture).

FREEZING/PEAKING

For freezing motion, you needn't squander precious light by mindlessly twirling in the fastest setting on the dial. Seldom is more than $1/125$ second needed in landscape photography. The light saved will allow a smaller aperture with more depth of field. Following are stop-action considerations for scenes that include wildlife:

• Small animals have relatively quicker movements than larger ones.

• The longer the lens and closer the subject, the faster the movement across the sensor.

• Synchronizing shutter release with a stall in the action (the peak of a deer's leap) enhances the stop-action effect.

Sugar maple and blue beech trees along Mad River, Vermont (right). *This scene was photographed with two different shutter speeds, one to freeze all motion and one at a slower speed to show the movement of the foliage in the wind. To attain the slower speed, a two-stop neutral density filter was used to reduce scene brightness. Canon EOS 2, Canon 70–200mm f/2/8L lens, digital scan from Fujichrome Velvia, ISO 50, f/22 for 2 seconds (blurred image) and f/8 for $1/15$ second (frozen motion image).*

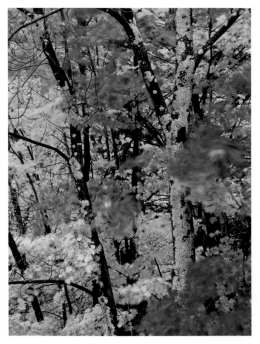

• Higher ISO speeds extend the range of action-stopping exposure times.

BLURRING/PAINTING

On the flip side of the motion coin are images that use intentional blur as an abstract expression of speed and time. This approach can be applied creatively to many subjects—falling snow, swaying leaves and branches, nodding wildflowers, passing wildlife and even stars in the night sky. Except for moving water (which is usually appealing no matter how long the exposure time) the starting point for featuring blur effects is a shutter speed about two stops slower than the exposure necessary to freeze action. Overextending exposure times, especially with wildlife, blurs the subject excessively so that its identity and purpose in the composition is lost. Blurred features are usually more compelling when contrasted with nearby sharply rendered elements.

When working on a blur motif, the camera is normally stabilized on a tripod while the moving subject paints its course over the film or sensor.

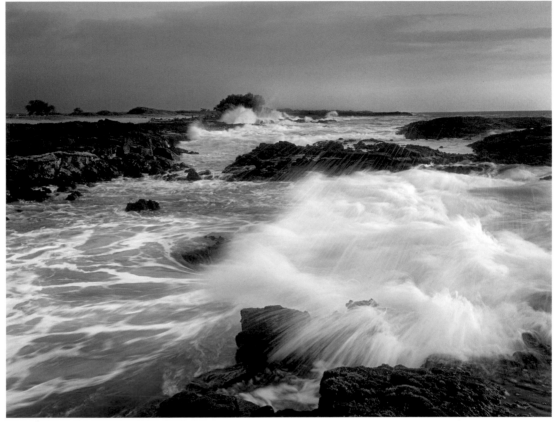

Try to visualize how image elements moving at different speeds and directions will register in the application of the motion vector, exposure duration and moment of shutter release. Although unpredictable, blurred motion shots with their broad strokes of whizzing color are always intriguing and easy as pie to make. Check your LCD for instant playback and, if necessary, make new exposures with the needed modifications.

Wawaloli Beach, Big Island, Hawaii (above). Digital shooters *can immediately check the camera's LCD screen for the effect of blur-producing shutter speeds, reshooting, if necessary, until the desired effect is achieved.*

Part Three

Creating an Image

Illuminating the Scene
Proactive lighting techniques

Recognizing light in its numerous variations and understanding how it is reflected or absorbed by the subject is key to making exceptional landscape photographs. Light should be considered and applied in terms of its quality (soft or hard), its color and the angle at which it strikes the subject.

TIMING AND CAMERA POSITION

Getting the best light on the subject is accomplished by choosing the right time to shoot and the best position for the camera. Some landscapes should be photographed under diffuse light (to project rich color), some under hard light (to accentuate texture or shape). Some scenes look most dramatic when the light comes from the side (sand dunes), others when it comes from behind (autumn aspens).

AVOID CLEAR MIDDAY SKIES

When skies are clear at midday, the sun casts dense shadows and generates brilliant highlights, a garish effect ill-suited to capturing the subtle color and texture of the landscape. Clouds improve conditions, scattering light and deflect-

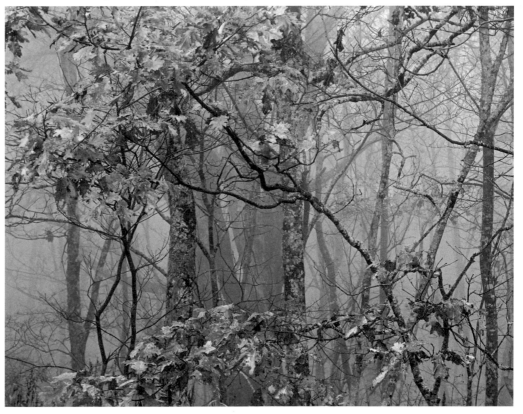

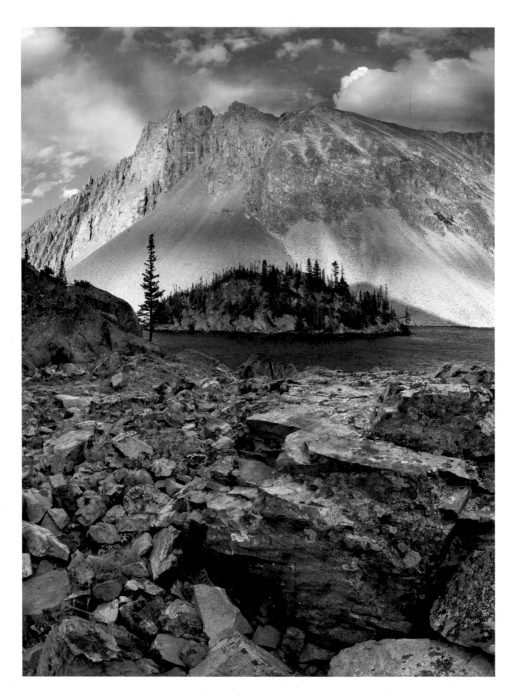

ing it into shadow areas to lower contrast and improve color saturation. In general, the visual appeal of natural light improves the closer the sun is to the horizon and when the sky is broken by clouds. These are periods when your shooting will be most productive.

OVERCAST LIGHT

Overcast skies produce soft light, which illuminates the subject evenly without noticeable shadows. Soft light allows digital sensors to record a complete range of tones for most scenes, serving up saturated color and fine detail in the brightest and darkest parts of the scene. Exposure is easy to determine and changes little regardless of where you aim provided the sky is excluded from the frame.

FRONTLIGHT

Shoot with the sun behind you and you are using frontlight. Due to its direct and even illumination, frontlighting is recommended when you wish to portray saturated color, contrast between different colors and fine detail in all parts of the scene. The lower the sun, the flatter the scene appears.

SIDELIGHT

When the sun illuminates the scene from

the side it reveals form and texture. Sidelight produces long, deep shadows that reveal the dimples, ridges and other details of terrain in greatest relief. Because sidelit subjects are a mixture of highlight and shadow, exposure should be based on a midtone and carefully checked against the histogram readout. If clouds are present they will deflect and reflect light into shadow areas, reducing contrast.

BACKLIGHT

Backlighting is the most abstract and dramatic type of illumination. Its effect is most distinctive on scenes with translucent features (poppy petals, aspen leaves) or elements with shaggy or fuzzy peripheries (cacti, lichens). It generates high subject contrast, recording subjects as if they glow from within.

If features projecting above the horizon are photographed against a bright background (e.g., sunset sky) that receives exposure priority, they will be underexposed and appear as silhouettes. If the landscape features are softly edged, they will be

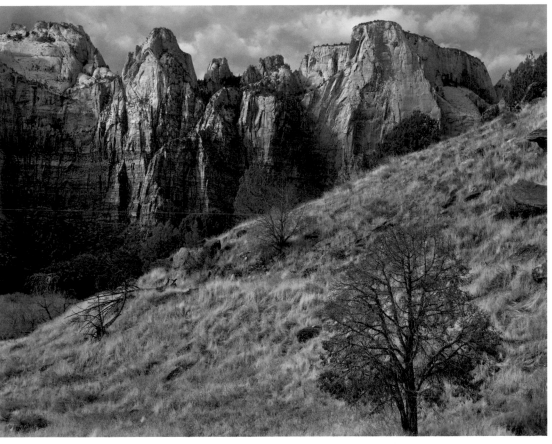

outlined by a halo of golden light. In backlit situations, it's advisable to bracket and choose the frame you like best once you can view the image at high resolution on a computer screen.

TWILIGHT

When the sun is just below the horizon, light from the glowing sky overhead illuminates the scene. If clouds are present they will reflect

Towers of the Virgin, Zion National Park, Utah (above). As seen here, both form and texture are revealed by sidelight.

Nohku Crags, Colorado (far left). This scene is illuminated by frontlight from a partly overcast sky, resulting in good shadow detail and saturated color throughout the image field.

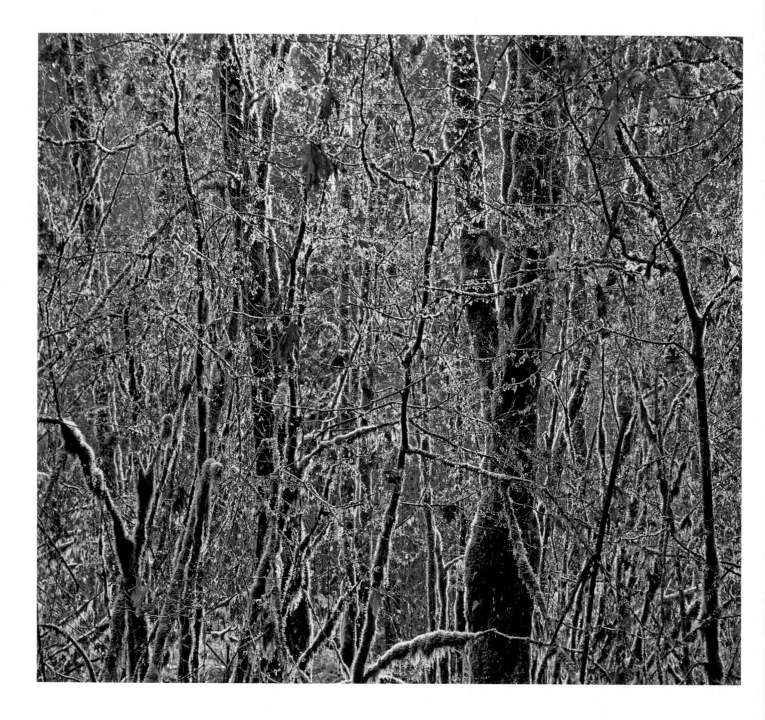

additional
warmer, direc-
tional light
into the scene
that will more
clearly define
terrain con-
tours. Although
twilight calls
for long expo-
sures (several
seconds to a
minute depend-
ing on the ISO
selected), this is
one of the pre-
mier times for
landscape shooting (see page 140).

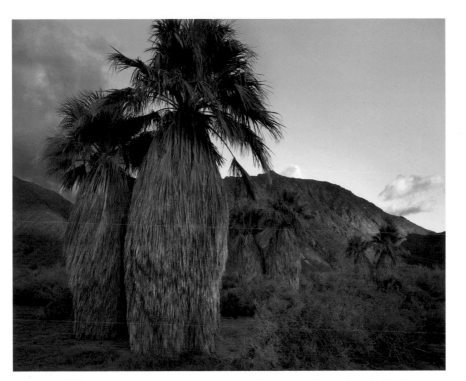

FILTERING THE LIGHT

In landscape photography, filters are used
primarily to reduce subject contrast and enhance
color. The filters described here are all you need to
cover the full range of landscape opportunities in a
professional manner.

STANDARDIZE FILTER SIZE

It's best if all filters are of a size to fit your
largest diameter lens. Lenses taking smaller filters
can be equipped with step-up rings that will allow
mounting of the larger filters, thus eliminating the
need for carrying more than one size.

THE INDISPENSABLE POLARIZING FILTER

The polarizing filter is the most useful for
landscape subjects. It screws onto the front of the
lens and adjusts (by twisting a ring) to modify
the amount of polarized light reflecting from the
subject. It's like sunglasses for your camera. Here's
what it does:

• **Increases color saturation.** A polarizer intensi-
fies the color of almost any subject that is wet or
shiny (metallic surfaces excepted). Leaves, rocks,

***California fan palm, Anza-Borrego
Desert State Park, California (left).***
*Both polarizing and split neutral
density filters were used to reduce
contrast in this scene. Mamiya 645
AFD with Phase One P 25 digital
back, Mamiya-Sekor 35mm f/3.5
lens, ISO 100, f/16 for 1 second.*

***Big-leaf maples in autumn, Cas-
cade Mountain foothills, Washing-
ton (far left).*** *Backlight dramatically
illuminates the dangling, translucent
leaves and shaggy moss of this
tightly cropped forest scene. Canon
EOS 2, Canon 70–200mm f/2.8L
lens, digital scan from Fujichrome
Velvia, ISO 50, f/16 for 1/30 second.*

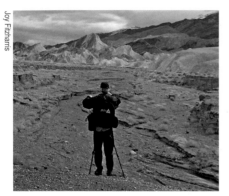

Joy Fitzharris

Minerva terrace at dawn, Yellowstone National Park, Wyoming.
Even when shooting in twilight with the sun below the horizon, a polarizing filter will add welcome density to skies. Maximum effects are attained when you shoot at right angles to the sun. Mamiya 645 AFD with Phase One P 25 digital back, Mamiya-Sekor 55–110mm f/4.5 lens, polarizing filter + one-stop split ND filter, ISO 100, f/22 for 2 seconds.

smooth bark, grasses and flower petals all show improved color saturation. Judge the effect through the viewfinder.

• **Boosts blue skies.** A polarizer deepens the color of blue skies. The maximum effect is achieved when shooting at right angles to the sun. If you want to find a camera angle that shows the sky at its polarized best, point your index finger at the sun, extend your thumb and it will point to the zone of maximum polarization. Rotate apparatus freely; it even works when standing on your head.

• **Heightens cloud contrast.** Skies a little featureless? Clouds not popping out of the composition? Attach a polarizer and give it a twist. You'll be surprised at the additional contrast and color that lurks in a bank of cirrus or stratus.

• **Modifies reflections.** You can adjust the polarizer to control reflections from ponds, lakes, rivers and oceans. It can be set to reveal interesting subsurface features, capture the mirrored image of looming landforms, or change the reflection patterns of ocean waves or stream ripples.

• **Adds neutral density.** You'd like to make a blurred, impressionistic rendering of a waterfall but there's too much light for the slow shutter speed needed. A polarizing filter reduces light transmission by one to two stops, allowing you to extend exposure times by the same amount.

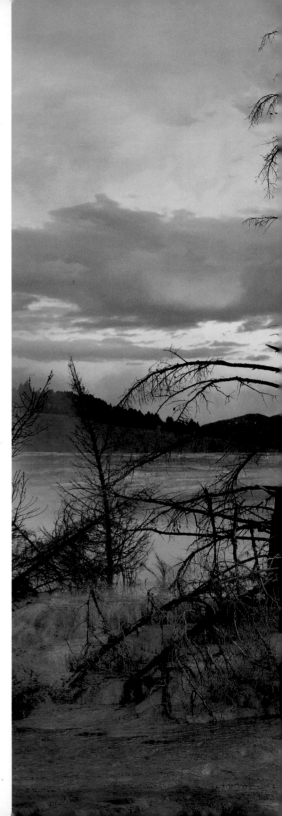

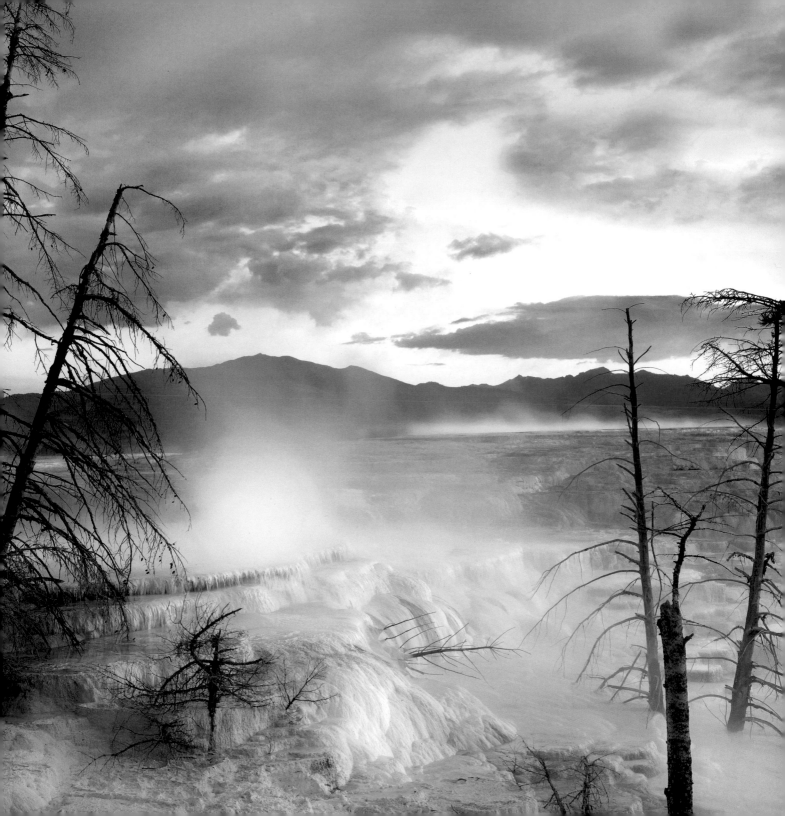

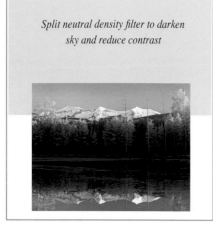

Split neutral density filter to darken sky and reduce contrast

Moonrise, East Beckwith Mountain, Colorado (right). *Even when shooting with digital cameras, which have more exposure latitude (greater dynamic range) than transparency film, split neutral density filters improve image quality by reducing scene contrast. Here the filter was positioned to reduce the brightness of the sky. Mamiya 645 AFD with Phase One P 25 digital back, Mamiya-Sekor 105–210mm f/4.5 lens, Singh-Ray polarizing filter + one-stop split ND filter, ISO 100, f/16 for 1/8 second.*

Moss-covered oak trees, Eagle Creek, Columbia River Gorge, Oregon (far right). *Here a polarizing filter reduced glare from waxy leaf surfaces to yield greater color saturation. Pentax 645NII, Pentax 45–85mm f/4.5 lens, Singh-Ray polarizing filter, digital scan from Fujichrome Velvia, ISO 50, f/16 for 1/4 second.*

SPLIT NEUTRAL DENSITY FILTERS

The neutral density (ND) type of filter is one of the most important accessories for controlling light contrast. Half of this rectangular filter is clear and the other half is neutral density (gray), which darkens the part of the scene over which it is placed. These plastic resin filters are used mostly in high contrast landscape situations when the sky is brighter than the terrain. The filter is mounted in a special holder so that it can be moved up and down and/or tilted to fit the design of the scene. Cokin holders are the standard used for many brands. Filters and holders are offered in two sizes—a small amateur size (A) and a larger professional size (P). The P series accommodates both small and large diameter lenses. I don't use filter holders. Instead, I attach the filters directly to the lens using duct or gaffer tape. This allows greater versatility when using two or more filters at a time (see illustration on page 117).

The dark part of the filter is positioned over the bright part of the scene (usually the sky) by examining the effect in the viewfinder. Study the view at stopped-down aperture to be sure of plac-

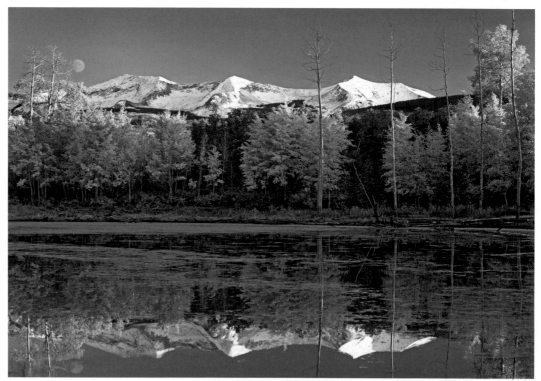

ing the filter precisely. Avoid
overlapping the gray area onto
the land (snow-capped peaks
excepted) as this will darken
the edge of the terrain unnatu-
rally. Leaving too much space
generates a bright margin along
the horizon. Meter the scene in
the normal way with the filters
in place. One- and two-stop
filters are suitable for most
landscape work. Hard-edge
filters (those with a more abrupt
border between clear and dark
halves) are useful when shooting
seascapes or other views with
straight, featureless horizons.

PORTABLE REFLECTOR

I usually carry a portable reflector in a pouch
attached to the back of my vest (see page 78).
This reflector is a large (40 inches/100 cm diam-
eter), circular, fold-up model made by Photoflex.
It is double-sided with a soft white surface and
a reflective silver surface. I use it to throw light
onto foreground elements that are shaded. When
working in this way, I release the shutter with the
camera's self-timer to keep two hands free for pre-
cise angling of the floppy reflector. The silver side
can project fill light up to 10 yards (9 m).

BEST ISO FOR LANDSCAPES

The lowest range ISO speeds usu-
allly render the best quality image file.
However, if you are shooting subjects
that are moved by the wind (wildflowers,
grasses) and you wish to render them
sharply, select the highest low/no-noise
ISO possible (consult ISO test reports
for your camera). This will give access
to a shutter speed that will be able to
freeze the moving elements.

Digital Contrast Control
*Split ND filters are not just for transparency film
shooters. For digital capture, you use them in
much the same way to restrain contrast in
extreme situations. However, you needn't strive
for a perfect balance of tones as you would with
film. As long as the histogram is centered well
within the curve space, you can make precise
localized adjustments to contrast without generat-
ing noise or reducing color quality when working
in Photoshop.*

Composition Basics
Fundamental principles of picture design

Joy Fitzharris

Nokhu Crags, Colorado (below).
*This composition is organized
around the most visually attractive
feature in the scene—the spotlit
mountain side.*

Composition is the way you arrange the components of the picture. This is most easily done if you ignore the identity of the scene's features (flower, mesa, stream) and think in terms of formal components (color, line, shape and texture). By basing your organization on basic elements you communicate in a universal language that reveals your message to anyone who can see.

DOMINANCE

Image design is based on the premise that some elements are more visually dominant than others. The use of this principle will help you organize the graphic features of a landscape view.

Most compositions are organized around a single striking terrain feature (a visual center of interest). Sometimes they are based on a number of elements working together to create a theme or visual impression. Often compositions are a combination of both.

Establishing visual priorities for picture elements is based on an intuitive sense that renders such conclusions as:
• Red is more attractive than yellow.
• Large draws more attention than small.

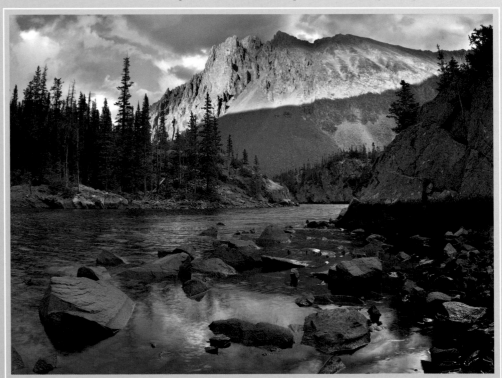

• Difference is more eye-catching than conformity.

• Diagonal is more dynamic than horizontal.

• Sharpness is more attractive than blur.

• Light is more attractive than dark.

A view that confronts you at the edge of a lake or the base of a waterfall serves up a host of such comparisons. In practice, however, they are not so simple, nor are the conclusions so obvious. You may need to compare the appeal of a vertical red line with one that is diagonal and yellow, or a large, gray, rough texture with one that is small, chartreuse and smooth. Fortunately, our eyes can easily make such assessments if we do not allow the identity of the subject to influence our judgments.

COLOR

Color evokes the greatest emotional reaction of any graphic element. Its presence significantly influences every design. More often than not, it is this aspect of a scene that induces a landscape photographer to stop and set up the camera. Color not only projects a visual force all its own but it is also an integral part of other picture elements—shapes, lines, textures—that we find in a photograph. Our reaction to color is spontaneous and instinctive. Color control in landscape photography is achieved primarily through a process of subject selection, framing, timing and camera angle, particularly as it is applied to the relationship of differing hues.

WARM AND COOL HUES

Each portion of the color spectrum evokes a

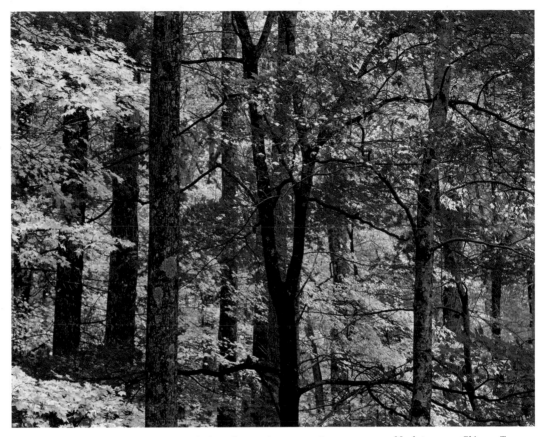

Maple trees near Chimney Tops, Great Smoky Mountains National Park, Tennessee (above). Red is the most attractive color to humans and almost always the dominant element of any composition in which it appears. Its presence must normally be inherent to, or used in support of, the center of interest. Pentax 645NII, Pentax 45–85mm f/4.5 lens, polarizing filter, digital scan from Fujichrome Velvia, ISO 50, f/22 for 1 second.

distinct emotional response. The most attractive color is red—a hue that signals life's crucial elements, blood and fire, and their connection to food and warmth, danger and death. It is difficult to use red effectively in a photograph unless it represents or supports the center of interest.

Red, yellow and orange, the warm colors, have more visual power than cool colors—the blues and greens. The appeal of a particular hue is specific to each viewer depending on his or her experience, current state of mind and personal tendencies. As photographers we can use color subjectively in our designs so long as we base its application on the universally accepted qualities of warm and cool hues.

Color Purity

In assessing the relative strength of a color you also need to consider its purity. A color is most powerful when it has not been diluted by white or black. Color purity is inherent in the subject matter, but it can also be affected by the intensity and angle of illumination. Colors in shadow areas have more black and are less brilliant; in highlight areas colors become washed out. Neutral density and polarizing filtration can be used in selected parts of the scene to control color saturation and contrast. Computer adjustment of digital images offers much greater control.

Color Is Relative

The power of a color is greatly determined by its relationship to other

Marcellina Mountain, Colorado (below). Complementary colors (here red and blue) gain apparent intensity when captured in the same scene, generating a more dynamic composition. Pentax 645NII, Pentax 45–85mm f/4.5 lens, polarizing filter, digital scan from Fujichrome Velvia, ISO 50, f/16 for 1/30 second.

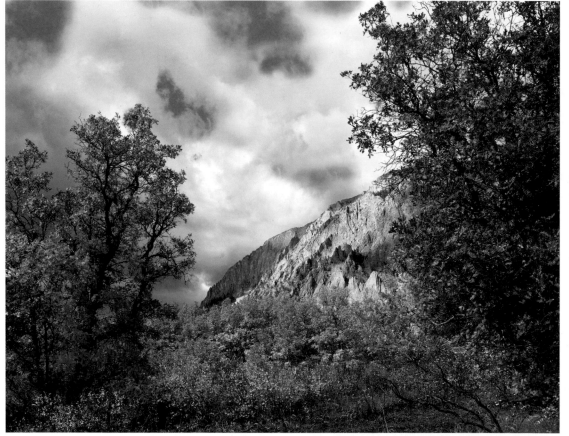

colors in the picture. Color gains apparent strength when juxtaposed with complementary hues, or those opposite on the color wheel (green with magenta, red with cyan, yellow with purple). Fiery autumn foliage appears more intense if set against a blue sky or when mixed with the green of conifers.

Intense, vibrant colors are more attractive than muted ones, but they are not necessarily more desirable. The color scheme of a photograph should support the main theme. A design that incorporates intense, contrasting colors is visually exciting, causing the eye to bounce back and forth between competing hues. A contrasting color scheme suits dynamic picture themes that express action, conflict, joy, anger or celebration; it is not usually suitable for portraying passive, introspective concepts.

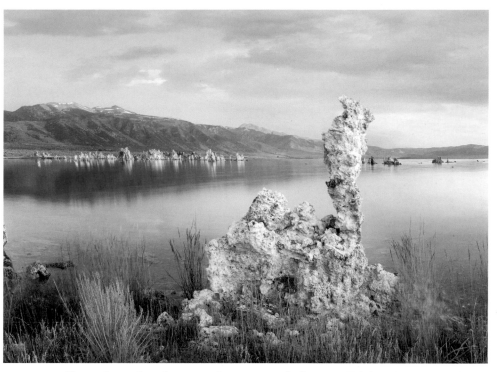

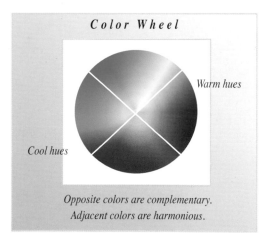

Color Wheel

Warm hues

Cool hues

Opposite colors are complementary.
Adjacent colors are harmonious.

Harmonious color schemes are those composed of one or two similar hues, such as blue and turquoise or brown and maroon. They may be made up of contrasting colors like red and blue if an intermediate hue (purple) is included to create a smooth transition. A picture structured on color harmony produces a coherent visual effect. Color harmony suits images with peaceful themes incorporating horizontal lines and smooth shapes.

The effect of color on the image is pervasive. It helps to distinguish and identify the subject of a composition, it communicates mood and emotion, and in many pictures its sensory appeal is strong

Tufa formations at Mono Lake,
Eastern Sierra, California (above).
Twilight is a great time to create images with harmonious color schemes. The soft, cool light reduces color intensity and contrast. Mamiya 645 AFD with Phase One P 25 digital back, Mamiya-Sekor 55–110mm f/4.5 lens, Singh-Ray two-stop split ND filter, ISO 100, f/16 for 4 seconds.

enough to act as the central theme. Color is an integral part of our perceptive process, our dreams, our memories and our personalities. You will normally deal with color effectively if you trust your instincts, approach it intuitively and use it in a way that feels right to you.

THE CENTER OF INTEREST

Most landscape photographs have a visual center of interest—one element that dominates the composition. In its most simple application, it is a picture of something—a crashing wave, grove of saguaros or sand dune. The center of interest orchestrates the design, determining the nature and arrangement of the other picture elements.

PLACEMENT

Where to locate the center of interest within the frame can only be determined in the context of other design factors. The prime real estate of any picture is the center. This is where the eye is most likely to begin its exploration of the image. If you place the center of interest in this position it creates a static design —an effect that is rarely desirable. The eye settles on the center of interest, scrutinizes it periodically and then scans the remainder of the frame for anything else of interest. As it has already found the most compelling element, it soon returns to the center of the frame for another, usually final, look.

But suppose you leave the most valuable area of the frame empty and place the center of interest elsewhere. The eye enters in the middle, finds nothing of interest and begins to scan the frame. Sooner or later it finds the center of interest but on the way it has come across other attractive elements. When all is seen, the eye gravitates back to the center of the frame, but again it finds nothing and begins the search anew, likely taking a different path to the main subject. The dynamism of this process excites our visual sense and sustains viewer interest.

The visual power of the main subject determines how far from the center it can be placed. If there are other equally dynamic visual elements, then it can become dominant only by occupying the central area of the frame. A main subject with distinctive visual properties can be placed almost anywhere and it will be discovered by the eye. If it is placed too remotely and the remainder of the composition is of little interest, the image's visual boundaries re-center to the exclusion of a portion of the frame, causing picture imbalance.

Sand bank and gull tracks, Lake Superior, Michigan (below). A strong composition is generated by locating key picture elements according to the rule of thirds. Here the horizon is positioned $^1/_3$ from the top; the sand bank curve begins and ends near $^1/_3$ intersection points. Pentax 645NII, Pentax 45–85mm f/4.5 lens, polarizing filter, digital scan from Fujichrome Velvia, ISO 50, f/16 for $^1/_{30}$ second.

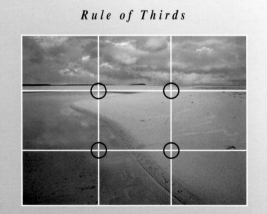

Rule of Thirds

Locate center of interest and important supporting features at points of intersection. Place horizon at top or bottom one-third positions. Bring diagonals out of the frame at one-third intersections.

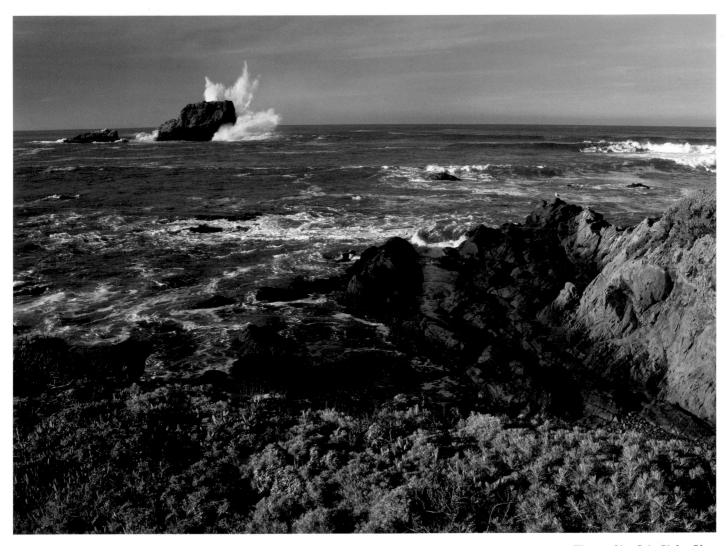

RULE OF THIRDS

You can be pretty sure of a strong but conventional composition if you follow the well-known rule of thirds. This principle calls for the most compelling visual feature to be placed roughly one-third of the way from the top or bottom of the frame and one-third of the way from either side. It is a reliable way to construct a dynamic, balanced composition.

Wave crashing, Point Piedras Blancas, Big Sur, California (above).
Here the center of interest is placed according the rule of thirds (top/left) to create a dynamic composition. Rock formations and horizon lead the eye toward the exploding wave.

Design Templates

Window Frame
Terrain targeted by peripheral elements.

Texture Squash
Telephoto compression of patterns.

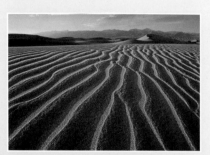

Railroad Track
Leading line(s) to featured landform.

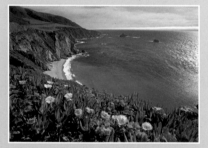

Foreground Feature
Based on appealing close-up elements.

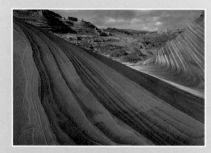

Intersecting Layers
Overlapping of diagonal planes.

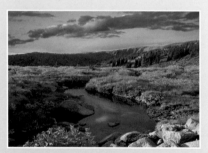

S Curve
Distinct shape winding through frame.

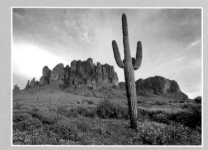

Juxtaposition
Marriage of two near/far features.

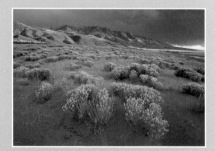

Deep Space
Similar elements arranged in receding size.

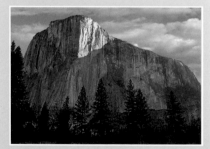

Snapshot
Straight ahead, frame-filling take.

THEMES

The organization of many landscape images is based on theme rather than a single dominant feature. Such pictures project an idea, relationship or concept through the collective impression of diverse picture elements. A theme such as "twilight peace" might be expressed by flowing shapes, pastel colors, horizontal lines, fair skies and soft clouds. Some themes are purely visual, finding full expression as provocative patterns, expressive colors, stimulating textures or abstractions of line and form. Some images incorporate a visual center of interest as a component in a thematically organized design. This twofold approach can be especially compelling.

CONTROLLING THE DESIGN

There are many ways of controlling, modifying, emphasizing and locating the features of a scene in the development of a composition:
• Select a subject that expresses your intent.
• Choose the appropriate season, time of day and moment of exposure.
• Take a revealing angle on the subject.
• Use filters and reflectors to modify lighting.
• Adjust lens focal length and camera position to control magnification and perspective.
• Set shutter speed to control motion and blur.
• Set depth of field by adjusting the aperture.

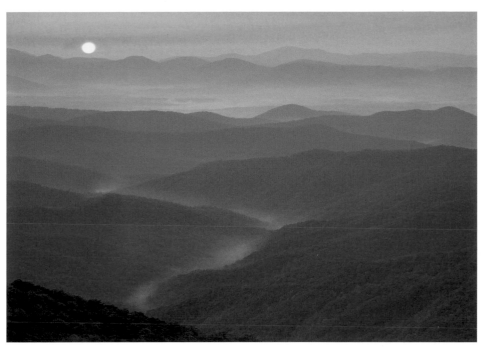

• Use the LCD monitor set to full screen view to analyse the capture. This gives the best approximation of the picture's ultimate effect on the viewer.

DESIGN TEMPLATES

I've included some design templates to get you started on composing landscape images. Look for these motifs when you are analyzing a location. All of them spring from the composition principles discussed here. Mix and match; take as little or as much as you need from each. They will get you thinking as a picture designer, help you make the most of early photo opportunities and allow you to more clearly express your feelings about nature.

Shining Rock Wilderness, North Carolina (above). This image is an example of composition based on a marriage of visual theme (harmonious colors and soft light) and center of interest (rising sun) supported by the leading line of a fog-shrouded valley. Mamiya 645 AFD with Phase One P 25 digital back, Mamiya-Sekor 105–210mm f/4.5 lens, Singh-Ray one-stop split ND filter, ISO 100, f/11 for 1/8 second.

Art of the Possible

Adapt your shooting schedule to natural conditions

Aspens at Independence Pass, Colorado (below). Soft light from a partially overcast sky and an absence of wind sped me toward this aspen grove draped with tinted foliage hanging motionless in the still atmosphere. I had spotted the trees the previous day when conditions were ill-suited to capture their beauty. Mamiya 645 AFD with Phase One P 25 digital back, Mamiya-Sekor 55–110mm f/4.5 lens, ISO 100, f/16 for 1 second.

Whether out for a day or on a week-long tour, photographers hope to maximize production of top-caliber images. To this end you need to adapt your shooting agenda to nature's changing program.

Some scenes are most appealing when skies are overcast, others look best at sunset or on foggy mornings. Matching subjects to complementary light and weather is how to make every exposure count. Following are guidelines for organizing a day shooting nature subjects with a focus on landscape.

AT SUNRISE, SHOOT THE LANDSCAPE

Sunrise is the best time for many subjects. On still, partly cloudy mornings set your sights on landscape motifs that feature plants—wildflowers, lush foliage, tawny grasses—that etch themselves onto the sensor in exquisite detail due to soft light and still atmosphere. Coupled with a colorful sky, this is a can't-miss opportunity. If there are no clouds, wildlife is the best alternative. Most active

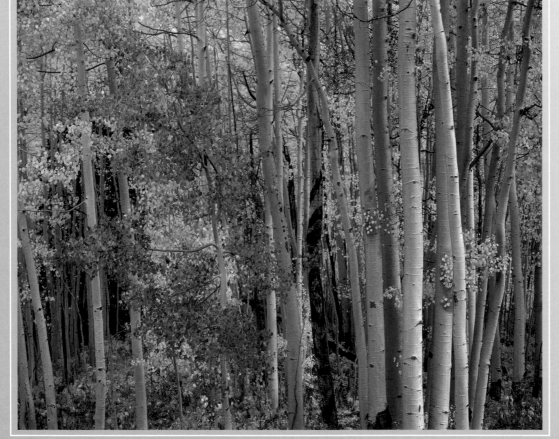

at dawn, animals generate strong motifs regardless of sky conditions. Due to weak illumination, you should focus on three approaches—intentionally blurred shots of animals on the move, silhouettes and static, atmospheric portraits. If overcast conditions prevail, this is your time for taking a coffee break.

EARLY MORNING IS FOR WILDLIFE

Once the sun has cleared the horizon, illumination levels rise quickly, expanding shutter speed range. This is prime time for wildlife—recorded as razor-sharp portraits, in stop-action studies or as features of broad terrain. Although landscapes no longer glow under the theatrical lighting of sunrise, they remain high priority if the sky is dappled with clouds and the scene distinguished by appealing color—turquoise tarns or fiery autumn forests, subjects that deliver their strongest hues under bright, soft light. By late morning, light grows too contrasty for either wildlife or standard scenic approaches, but other opportunities develop. Rising temperatures coax wildflowers to spread their petals in photogenic distinction, making them magnets for other subjects—bees, butterflies, spiders and hummingbirds. Although light is harsh, shallow depth of field due to high magnification helps soften shadows and highlights. Handheld reflectors make it easy to reduce contrast and improve color saturation on diminutive subjects.

If the sky is overcast, it's best to target floral still-life themes, either close-up or as wide-field

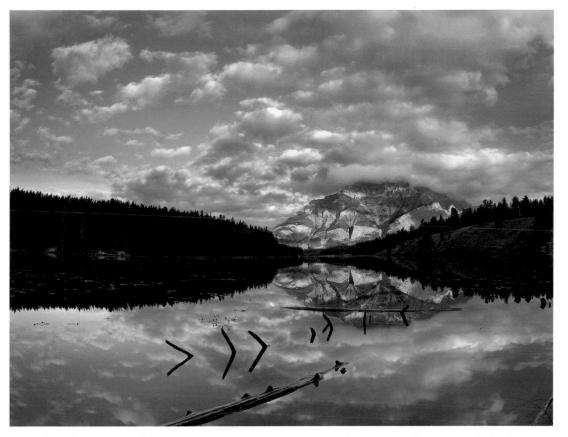

Cascade Mountain, Banff National Park, Alberta. Partially cloudy skies produce ideal conditions for photographing dramatic landforms. Clouds create opportunities for capturing key terrain features in a natural spotlight. Mamiya 645 AFD with Phase One P 25 digital back, Mamiya-Sekor 55–110mm f/4.5 lens, Singh-Ray polarizing filter, ISO 100, f/16 for 1/8 second.

Pick Your Season

Not only is it important to pick your subjects relative to sky conditions and time of day, but season is also an important factor in planning a shoot. Every patch of terrain has a special time for wildflowers (Arizona desert in February, Colorado alpine in July), fall color or snowy accents. Species behavior also is seasonally dependent—horseshoe crabs gather onshore in May whereas polar bears do it in November. Birds don their most beautiful plumage in spring but present themselves in sky-filling flocks in autumn. Nature photographers will find the World Wide Web to be the most up-to-date and reliable source for this information, much of it coming from people closely observing their local region.

Cathedral Rock from Red Rock Crossing, Arizona (right). *These towering buttes present their best faces and most revealing profiles to the setting sun. During summer monsoon rains, Red Rock Creek fills to offer pools that mirror the rock formations. Pentax 645NII, Pentax 45–85mm f/4.5 lens, polarizing filter, digital scan from Fujichrome Velvia, ISO 50, f/16 for ¹/4 second.*

views, before the wind picks up. Autumn forests and blooming meadows are great choices.

MIDDAY IS FOR RECHARGING

With the sun overhead, subject contrast may exceed the range of the sensor. Harsh light also robs the scene of the romantic atmospheric effects of early morning. This is your opportunity to rest up for the great light to come at the end of the day. Or if you're full of energy, scout new locations, although you may have difficulty judging how they will appear in the more appealing illumination of sunset or sunrise. Should skies be overcast, conditions are ideal for capturing meadows or forests in motion, either stop-action or blurred.

LATE AFTERNOON IS SCOUTING TIME

Late afternoon offers much the same conditions (and therefore similar subject choice) as mid-morning. Wind, however, is more likely, making it a productive time to work on blurred motion imagery of colorfully vegetated terrain. It's also the best time to scout new landscape locations for the late day shooting period as landforms and cloud cover now give strong indications of their photogenic potential come sundown.

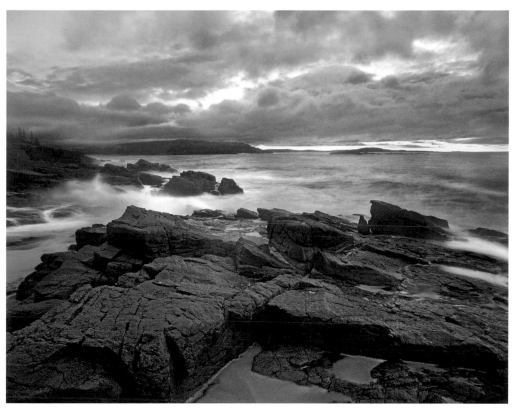

AT SUNSET, DO LANDSCAPE'S OTHER SIDE

With conditions not much different from sunrise, this period gives opportunity to shoot scenes illuminated from the opposite direction—crucial for alpine and ocean settings, which often have a "good side." It's wise to plan your day based on natural conditions, but keep in mind that your schedule needs to be as flexible as the weather is changeable. Good luck!

Old Soaker, Acadia National Park, Maine. Windy conditions should propel you to the shoreline, where incoming waves create opportunities for blurred motion imagery. Pentax 645NII, Pentax 35mm f/3.5 lens, Singh-Ray two-stop ND filter, digital scan from Fujichrome Velvia, ISO 50, f/22 for 2 seconds.

Expressing Perspective
Techniques for recording the third dimension

Pine trees and pond near Loxa-hatchee River, Florida (below). Uniform size cues, like these tree trunks, are excellent tools for ex-pressing depth in a photograph.

The portrayal of depth is often the primary attraction of a landscape photograph. To express the third dimension convincingly, you need to capture and arrange the features of a scene in a way that best projects their spatial qualities, keeping in mind that we see the world differently than does a camera. Not only do our two eyes work in stereoscopic view, but we move about, crane our necks and reappraise the scene from different angles to gain a better appreciation of depth and scale. By contrast, the still camera is afforded but a single, static view. To bridge this optical gap, we need to emphasize the cues in the landscape that express depth.

Size Cues

The relative size of landscape features is one of the most obvious cues in conveying the depth of a scene. Objects that are close appear larger than those that are far. Utilizing this cue is first a matter of incorporating familiar features in

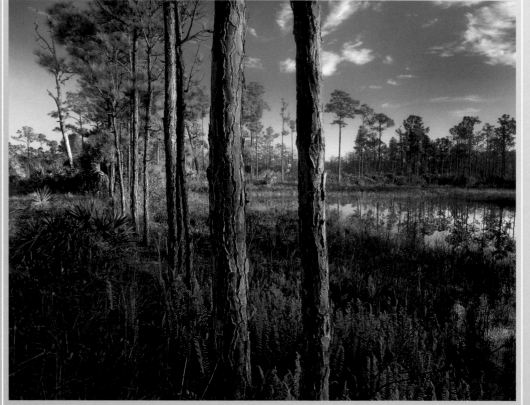

your composition that are similar in size, or at least are perceived to be so by the viewer, and then positioning the camera so that they are presented on film in differing proportions. Such components include trees, shrubs, wildflowers and animals of the same species. The ideal placement of the camera shows such size cues arranged at intervals on a diagonal plane or some variation of it (e.g., an S curve).

There are other less common but equally powerful size cues to which you should be sensitive. When cumulus clouds dapple the sky, they become smaller as they near the horizon. Sand ripples, caked mud flats and ocean waves can all be used to present a uniform pattern of decreasing size cues. From an appropriate camera angle, rivers, streams, sand dune ripples and fallen logs all exhibit the "railroad track" phenomenon—the convergence of parallel lines toward a vanishing point (a variation on the size cue perspective effect).

ANGLES OF VIEW

Lens focal length generates a powerful perspective effect (see sidebar, page 99). By emphasizing the differences in size cues, wide-angle lenses increase the perceived distance between elements in the composition and promote a feeling of deep space. Telephoto lenses achieve the opposite effect by compressing the distance between elements in the scene. To accentuate these extreme effects you should position the camera as close as possible to the nearest size cue in the composition. You normally will need to shoot at f/16, or smaller, to achieve satisfactory depth of field. Much of the time, you will be working in concert with other design prerogatives at some compromise distance.

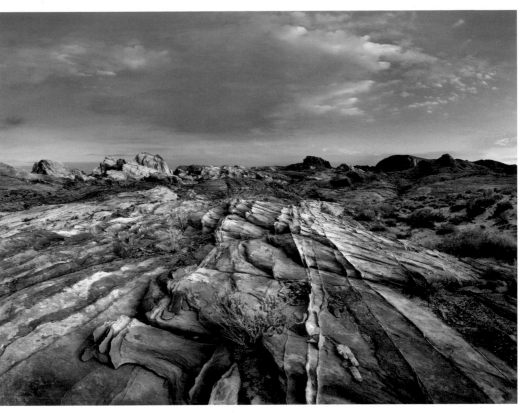

Rainbow Vista, Valley of Fire State Park, Nevada (above). The ripples in this sandstone are an example of "railroad track" portrayal of perspective. They carry the eye deep into the picture space toward the primary landscape features. Mamiya 645 AFD with Phase One P 25 digital back, Mamiya-Sekor 35mm f/3.5 lens, Singh-Ray polarizing filter, ISO 100, f/16 for 1/2 second.

ANGLING FOR DEPTH

Because the eyes of a standing human are some 5 or 6 feet (2 m) above the ground, landscape features that are close to us are positioned lower in our field of view than those more distant (clouds excepted). For a maximum three-dimensional effect, you should set up at about a 45 degree angle (above the horizontal) on the first size cue in the composition. Use a focal length wide enough to include at least the horizon and a bit of sky. If you place the camera too low, you will lose visual exposure of the spaces between size cues; if you set up too high you will lose the horizon and the familiar eye-level configuration of the size cue. Either

position results in a flattening of the scene.

You also need to position the camera horizontally so that the number of size cues portrayed is maximized and cues are kept separated and distinct. This step may require you to move the camera forward or backward as well as sideways. In most situations you should set depth of field to include both the closest size cue and features on the horizon (usually infinity). Setting camera position is normally a trial-and-error procedure exercised until the most effective design is achieved based on interrelated factors of color, light and subject matter as well as the desired perspective effect.

CONTROLLING OVERLAP

Another useful perspective tool that needs skillful handling is overlapping. Precise lateral and vertical placement of the camera is usually needed for this strategy to work effectively, especially when utilized with smaller landscape features such as trees or rocks. Such elements are often so similar that they blend together in a muddle not readily distinguished by the viewer. To avoid confusion, try to overlap only simple areas of contrasting color, line direction, brightness or shape (horizontal limbs crossing vertical trunks, for example). The most effective use of overlapping can be done with intersecting landscape planes. Such situations are

Kaiparowits Plateau, Utah (below). Here the camera was carefully positioned to portray maximum depth. Horizontal placement was made to keep the fence posts well separated to clearly show their diminishing size. Vertical placement is about 45 degrees above horizontal on the foot of the closest post—high enough to reveal space between ground features but low enough to avoid the flattening effect of an aerial view. Mamiya 645 AFD with Phase One P 25 digital back, Mamiya-Sekor 55–110mm f/4.5 lens, Singh-Ray polarizing filter, ISO 100, f/22 for 1/8 second.

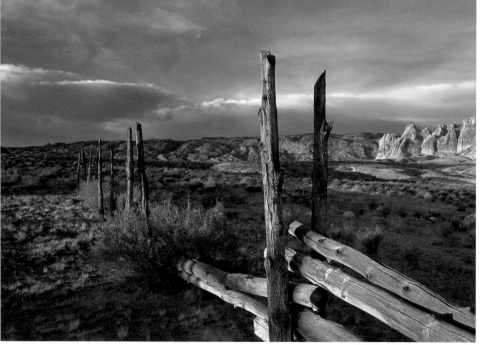

Framing Deep Perspective

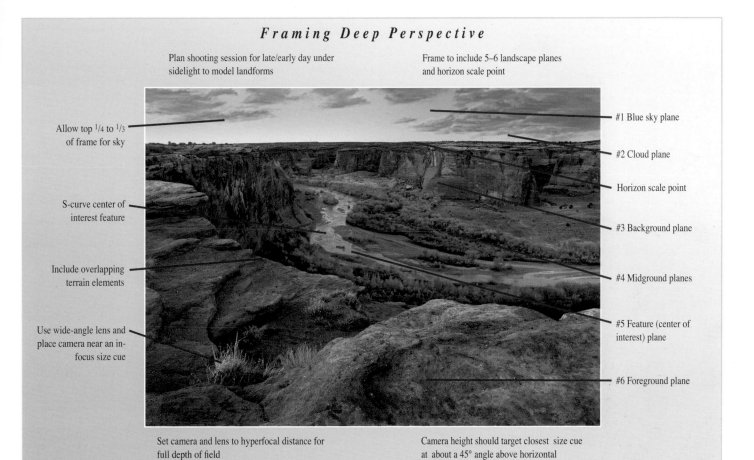

Plan shooting session for late/early day under sidelight to model landforms

Frame to include 5–6 landscape planes and horizon scale point

Allow top ¹/4 to ¹/3 of frame for sky

#1 Blue sky plane

#2 Cloud plane

Horizon scale point

S-curve center of interest feature

#3 Background plane

Include overlapping terrain elements

#4 Midground planes

Use wide-angle lens and place camera near an in-focus size cue

#5 Feature (center of interest) plane

#6 Foreground plane

Set camera and lens to hyperfocal distance for full depth of field

Camera height should target closest size cue at about a 45° angle above horizontal

Junction Overlook, Canyon de Chelly National Monument, Arizona

encountered in hilly or mountainous terrain. Try to frame areas where there is a confluence of interesting contour outlines running in opposing diagonal directions. Topographies lit from the side or back, or photographed in early morning, when mist hangs in low-lying areas, will show the most definition between planes and the most overlapping.

SIDELIGHT FOR VOLUME

Landscapes illuminated from the side exhibit shapes whose surfaces and contours are well distinguished by areas of highlight and shadow. This makes it easy for the viewer to compare and identify important size cues and other spatial relationships within the scene. The overlapping of

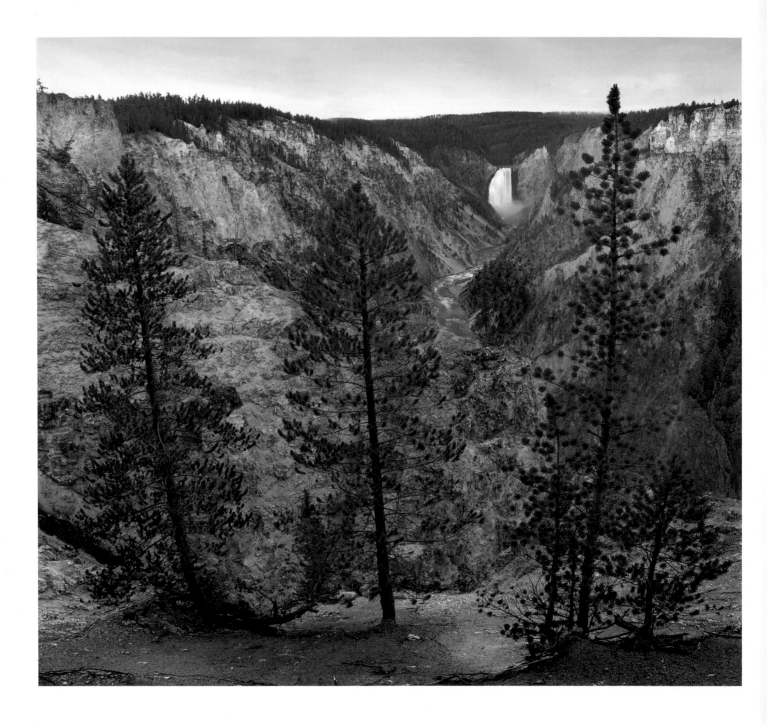

objects or planes is emphasized and clarified because the shadow portion of one is set against the highlight portion of another. The earlier in the day you shoot, the greater the effect. To flatten perspective and achieve an impression that

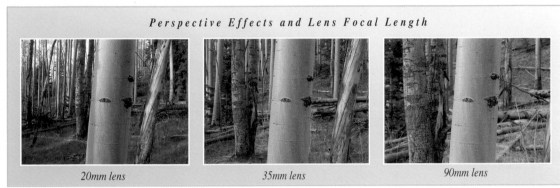

Perspective Effects and Lens Focal Length

20mm lens *35mm lens* *90mm lens*

is somewhat surreal, shoot early or late in the day with the sun directly behind you for full frontal illumination.

Hazy Days (Atmospherics)

Due to particles suspended in the atmosphere, close objects appear more detailed than those further away. Aerial perspective is commonly encountered as fog, mist, snow, dust and haze. When shooting in these moody conditions, you will encounter varied opportunities on the periphery of the atmospheric phenomenon (edge of storms, cloud banks) where you can modulate the effect by changing position or waiting for a change or movement of the weather pattern.

Dimensional Ironies

An interesting ways of dealing with perspective is to combine contradictory spatial cues for ironic effect. You can interpret an assembly of haze-rimmed, overlapping foothills by shooting with a space-compressing telephoto or, conversely, use a wide-angle lens to record a featureless stretch of still water punctuated by a single island.

Six Planes

When scouting for deep-perspective scenes, I look for landforms exhibiting five distinct planes. Ordered from near to far, they are as follows. The foreground plane features interesting landscape details that set the scale for the composition; the mid-plane contains well-defined size cues that lead the eye into the picture; the feature plane shows the center of interest—usually a dramatic landform; the cloud plane is ideally a puffy collection of cumulus or nimbus, and the sky plane comprises the final backdrop in pure shades of blue, rose, peach or amber, depending on the time of day. Sometimes a sixth plane (the horizon plane) spreads itself behind the feature plane. I try to record each plane as clearly and forcefully as possible (see illustration, page 97).

Grand Canyon of the Yellowstone, Yellowstone National Park, Wyoming (far left). Ironic spatial effects are generated in this view of the Yellowstone River Canyon. A moderate telephoto lens compresses space while camera angle and framing incorporate numerous perspective cues that expand it. Mamiya 645 AFD with Phase One P 25 digital back, Mamiya-Sekor 105–210mm f/4.5 lens, Singh-Ray two-stop split ND filter, ISO 100, f/22 for 2 seconds.

Photogenic Opportunities

Recognizing the potential of a landscape setting

Yellowhead Mountain, Mount Robson Provincial Park, British Columbia (below). A still atmosphere and soft, early morning light were strong indicators that this mountain scene, reflected in the still waters of a lake, would surrender a compelling image.

What are the signs that indicate opportunities for great landscape images? You will rarely encounter all of them in one setting, but the more, the better. Here's what you should look for.

COLOR

The presence of strong color is perhaps the best indicator of the landscape's potential for surrendering a terrific photograph. The most attractive color to humans is red. Find this hue, even in small batches, and chances are you've found a good place to set up your tripod. Wildflowers, lichens, leaves, rocks, even flamingos in rosy hues can be incorporated into the wider scene. Give these color nuggets a lot of attention by placing them prominently in sharp detail in the foreground region of the composition.

CLOUDS

Clouds of any kind, anywhere in the sky, portend exciting imagery. Most preferred are formations that are

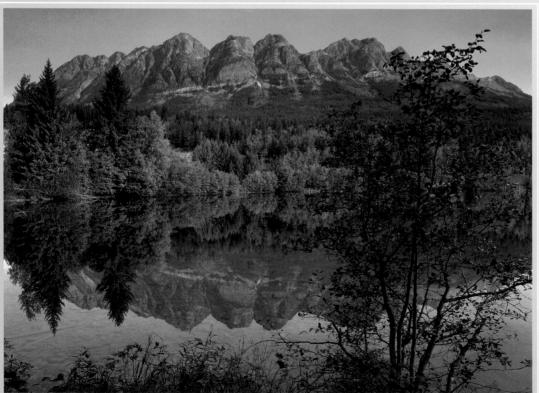

near the horizon and above the target area. At sundown or sunrise, these clouds can turn shades of rose, mauve, scarlet and yellow. Even when shooting during midday, clouds are beneficial. Their interesting formations can be used to relieve the starkness of a clear blue sky. When passing through clouds, sunlight is diffused and refracted into shadow areas, illuminating detail and color and bringing more of the scene within the exposure latitude of the film.

CALM WEATHER

The absence of wind means you can shoot at extended exposure times (especially valuable during twilight periods) and still attain sharpness in vegetation and other fragile elements of the scene. Longer shutter speeds allow the use of smaller apertures, which means greater depth of field and more extensive detail capture. When shooting at sunset or sunrise with a low ISO setting, polarizing filter and small aperture, exposures of several seconds are common. Your best chance for calm occurs about 30 minutes before and after sunrise. Be patient and shoot between breezes.

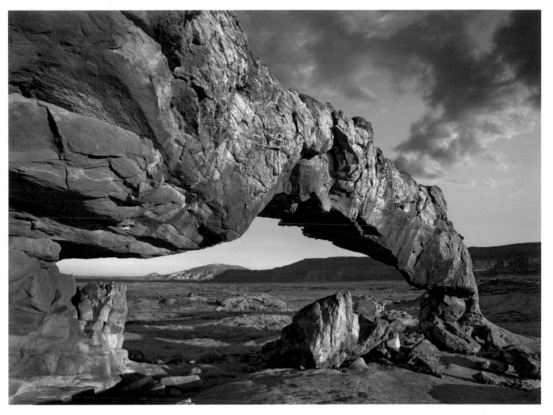

STRATEGIC SHOOTING ANGLES

Search for a camera position that is north or south of the target landscape. This angle records terrain at sunset or sunrise when it is illuminated by sidelight. Why should you want sidelighting? It allows the most effective use of polarizing filters, giving extra density to sky regions and improving overall color saturation. It also models landscape features, showing contours, shapes and textures distinctly. In Europe and North America, a camera view from the south is often best, opening the

Sunset Arch, Grand Staircase-Escalante National Monument, Utah. Cumulus clouds scattered in a blue sky and richly colored rock formations were obvious signs that this location would offer exciting photo opportunities approaching sundown. Mamiya 645 AFD with Phase One P 25 digital back, Mamiya-Sekor 35mm f/3.5 lens, Singh-Ray polarizing filter, ISO 50, f/16 for 1/8 second.

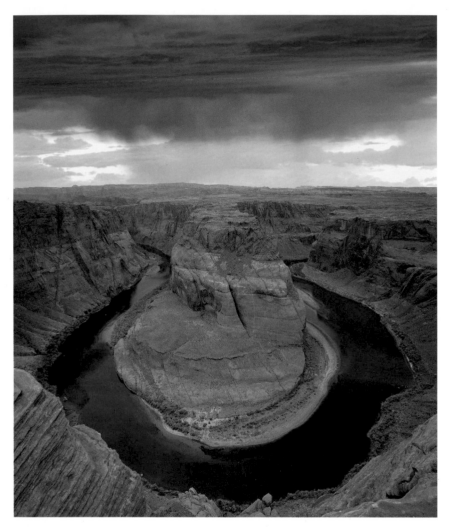

*Horseshoe Bend near Page,
Arizona. A clear western horizon
and moving cloud formations
signaled a great sunset opportunity
at this jaw-dropping location. I
included foreground elements on the
canyon edge to establish a sense of
scale and emphasize perspective.*

energy. Such meteorological events add novel distinction to scenic photographs. Staying abreast of weather forecasts will help you be on site when atmospheric effects are working their magic.

FOREGROUND FEATURES

The best landscape photographs are made in locales with interesting foreground details—saguaro cacti in the Arizona deserts, bear grass and blueberries in the Yukon, jumbles of boulders and ancient pines in the Eastern Sierra, rhododendrons in the Great Smoky Mountains. These micro features establish the scale of a scene, acting as perspective cues to generate a convincing impression of three dimensions. Foreground features also aid strong composition. You can use trees and rocks to frame and focus viewer attention on a waterfall, sandstone arch or snow-capped pinnacle.

OPEN HORIZONS

When you find an appealing landscape, check to see if the east and west horizons are clear of light-blocking landforms—an important consideration no matter what shooting angle you chose. If the targeted terrain lies close to adjacent mountains, it may be shrouded in deep shade when light and sky are most photogenic. The scene will be murky with a blue cast and bereft of form and texture. One of the horizons must be open. If it's to the east, plan your shooting session for dawn; if the west is clear,

landscape to strong sidelight and weak frontlight over the course of the day for most of the year.

MOODY WEATHER

Fog, mist, haze, falling snow and flashing lightning infuse ordinary landscapes with moody

be there for late afternoon and sunset. This scheduling offers the best chance of combining rich colors, dramatic skies and well-modelled landforms.

REFLECTING WATER

Beaver ponds, vernal pools, lagoons, river backwaters and tide pools are indicators of great scenic shooting. With appropriate camera positioning and lighting, bodies of water can be used to throw mirror-like reflections of the landscape, redoubling its beauty and presenting a repeated harmony of picture elements. These reflections become most striking in calm weather during periods of sunrise and sunset when the oblique angle of illumination leaves the pool's substrate in shadow, producing mirror-like reflections.

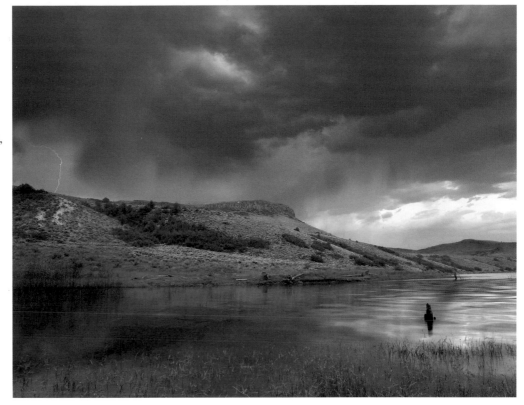

Surefire Lightning

Digital shooters can easily capture lightning to accent landscape images. Make sure you have plenty of battery power. Set up the camera for a long exposure time by adding a polarizing or neutral density filter (or both) and adjusting ISO to lowest setting and lens to a small aperture. When the lightning starts, begin taking pictures non-stop, one after another. With a 10 second exposure, the shutter will be open for approximately 10 of every 15 seconds (depending on battery condition and image processing time) and you should soon record a few bolts, perhaps even several during one exposure. During a lighting storm, displays usually repeat about every minute, allowing you to time exposures with more accuracy. Once your compact flash card is full, you can erase the failed takes and start again.

PRISTINE ENVIRONMENTS

Your shooting will be peaceful and more productive if you concentrate on areas where nature is protected and human artifacts are largely absent— national parks and forests and designated wilderness areas.

These are the clues of beautiful landscape opportunities. Search them out and you're sure to make some great images.

Twilight thunderstorm, Curecanti National Recreation Area, Colorado. Thunderstorms, especially late in the day, provide great opportunities for dramatic weather photographs. When using a digital camera, it's easy to capture lightning flashes (see sidebar). Mamiya 645 AFD with Phase One P 25 digital back, Mamiya-Sekor 35mm f/3.5 lens, Singh-Ray polarizing filter + one-stop split ND filter, ISO 50, f/16 for 6 seconds.

Part Four

Spectacular Settings

Bonfires of Autumn
Capturing the rich color of the woodland palette

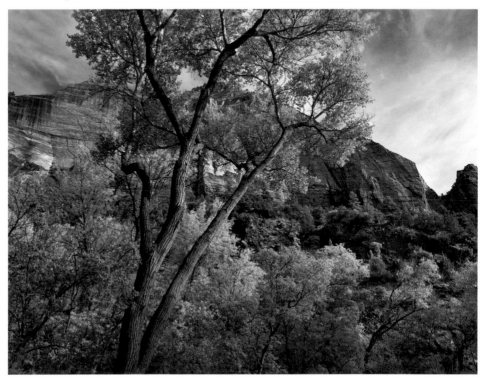

North America's deciduous forests present the planet's most spectacular show of seasonal color. Some of the best picture sources are found along the margins of lakes, pools and streams, where moving water, reflections, ice and frost add special accents to the autumn mix.

TIPS FOR TOP COLOR

Here are some guidelines for capturing the heart of this motif—clean, saturated color with zippy contrast and revealing detail in highlights and shadows.

• If your camera allows selection of a color profile (special picture style) select "landscape" or "scenic" which usually introduces a slightly warm, saturated color bias.

• Use a polarizing filter to eliminate reflections from wet or waxy surfaces of leaves. These shiny highlights mask the pigmentation of the vegetation and reduce color saturation.

 • Cloudy mid-mornings present the best combination of minimal wind and ample light, both of which you need for recording sharp detail in leaves and trunks from foreground through to the background (or see page 176) .

• Exclude overcast skies from the compositions.

• Shoot when the vegetation is wet. In combination with a polarizing filter, the "soaked look" yields the highest color saturation.

Joy Fitzharris

Cottonwoods, Zion Canyon, Zion National Park, Utah (below). *Color contrast and saturation were increased by use of a polarizing filter. Mamiya 645 AFD with Phase One P 25 digital back, Mamiya-Sekor 35mm f/3.5 lens, Singh-Ray polarizing filter, ISO 100, f/16 for $1/30$ second.*

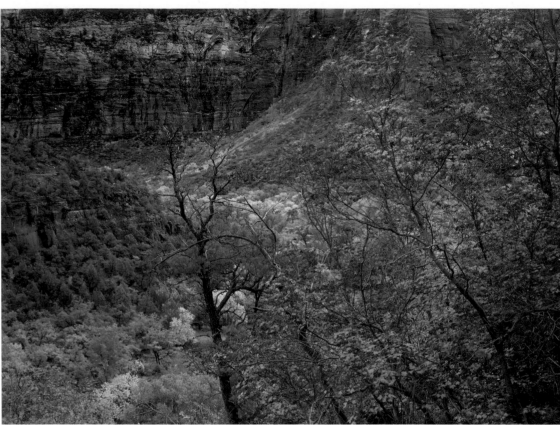

Autumn maples above Zion Canyon, Zion National Park, Utah (above). Taking a camera angle that placed the red of maples next to the green of piñon pine and cottonwood accentuated the color of each tree species. Mamiya 645 AFD with Phase One P 25 digital back, Mamiya-Sekor 55–110 f/4.5 lens, Singh-Ray polarizing filter, ISO 100, f/16 for 1/8 second.

• Photograph when fall color is at its peak. The Internet provides "peak leaf" reports for many areas.

• Look for compositions that team autumn's warm hues with their complementary colors (red with green, yellow with blue).

ARTISTIC APPROACHES

Once you've found a photogenic forest, you need to come up with an artistic approach that organizes the abundance of color into an expressive theme.

Here are a few suggestions.

• **Foliage in motion.** Combine solid trunks with leaves swishing in the breeze. Dial in a shutter speed in the one-second range and time your exposure to catch some gentle puffs blurring the foliage to create a dreamy impression.

• **Frame a scene through colorful foliage.** Good timing is needed to capture this classic calendar motif. To render all elements sharply, the framing branch or branches need to be motionless to allow long exposures at small apertures.

• **Still leaves/rushing water.** Capture a still-life duality that sets colorful fallen leaves against the milky flow of a stream blurred by setting a slow shutter speed. Use a polarizer and, if possible, channel the bubbling liquid through the frame on the diagonal. A tripod, of course, is mandatory.

•**Wide views overhead.** Grab your widest optic and stretch out on the forest floor to throw the colorful underbelly of the canopy against the blue

sky. It's best to assume the prone position at mid-morning on a still, sunny day, when a polarizing filter can add saturation and density to the heavens overhead (see page 37).

• **Target a patch of patterned color**. Establish a commanding position atop a hill. Mount a tele-photo zoom on a sturdy tripod and take aim at a swath of intense autumn tint. The intersection of diagonal edges is the bull's eye for strong compositions.

•**Weave a fabric of trunks and leaves.** A telephoto lens (200–400mm) to compress perspective and a small aperture (f/22–45) to push sharpness into the near and far reaches of the scene will recast a thick stand of autumn trees into a weaving of rough bark, intertwined branches and lacy foliage. Avoid fram-ing a center of interest in order to emphasize pure, uniform texture.

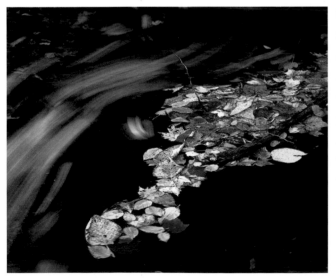

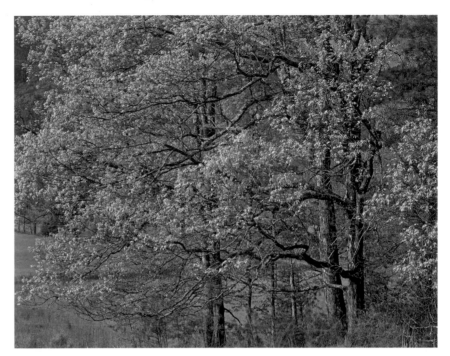

• **Record the magic of a snowfall.**
You'll need to monitor nightly weather forecasts to catch the autumn forest under a dust-ing of snow. The magic doesn't last long once warmed by the sun and people and animals start tracking up the pristine set-ting. So be on scene at first light. Look for subjects with plenty of saturated chroma and blue sky leaking into the background—the white accents will boost intensity even more.

Cades Cove, Great Smoky Mountains National Park, Tennessee, (above). Soft, hazy light and still at-mosphere made for ideal conditions in this take of spring foliage showing the golden tints of autumn. Pentax 645NII, Pentax 45–85mm f/4.5 lens, polarizing filter, digital scan from Fujichrome Velvia, ISO 50, f/11 for ¹/₁₅ second.

Stream, Great Smoky Mountains National Park (left). A slow shutter speed captured a blurred impression of leaves swirling in a stream. Pen-tax 645NII, Pentax 80–160mm f/4.5 lens, polarizing filter, digital scan from Fujichrome Velvia, ISO 50, f/32 for 4 seconds.

Cascades and Waterfalls

Interpreting the beauty of flowing water

Latourell Falls, Columbia River Gorge, Oregon (below). The most important factor when shooting waterfalls and cascades is to shoot during overcast or twilight conditions, preferably with the sun at your back. Pentax 645NII, Pentax 80–160mm f/4.5 lens, polarizing filter, digital scan from Fujichrome Velvia, ISO 50, f/16 for 1 second.

Waterfalls, streams and cascades—flowing water is nature's most common and dynamic element, providing photographers nearly everywhere with a ready motif both expressive and challenging. These suggestions will launch your exploration of this propelling subject.

• **Insist on soft light.** Rushing water's froth, bubbles and foam highlight its appeal, defining the shape and extent of the streaming energy. Unfortunately, these bright accents create excessive subject contrast. To capture maximum detail and color you must shoot with soft light—under overcast skies (ideal), in shade (add a warming filter) or during twilight (beware of color cast).

• **Give priority to shutter speed.** Shutter speed determines how the flowing elements appear on film or sensor. A long exposure produces impressionistic imagery—soft, dreamlike blurs of the water's movement. A brief exposure produces stop-action results, usually a less pleasing effect. (For approximate shutter speed settings,

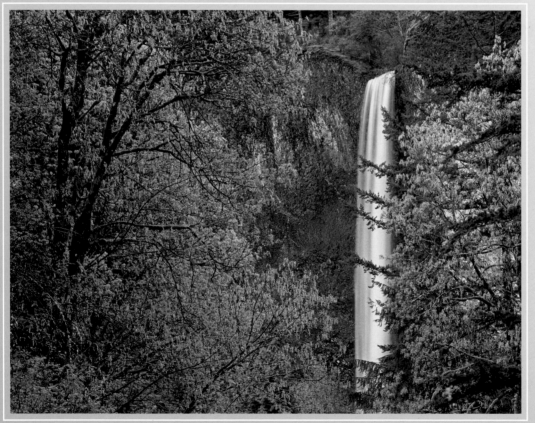

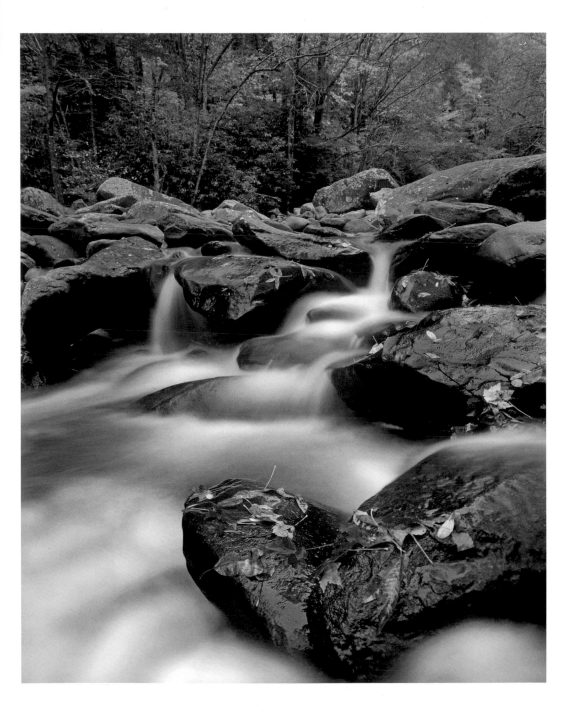

Cascades, Little Pigeon River, Great Smoky Mountains National Park, Tennessee (left). *Look for compositional arrangements that capture the stream moving through the frame diagonally. Try to frame the blurred cascade with colorful, sharply rendered features. Use rocks or other solid picture elements to block the exit of the stream from the frame in order not to carry viewer interest out of the picture. Pentax 645NII, Pentax 45–85mm f/4.5 lens, polarizing filter, digital scan from Fujichrome Velvia, ISO 50, f/22 for 2 seconds.*

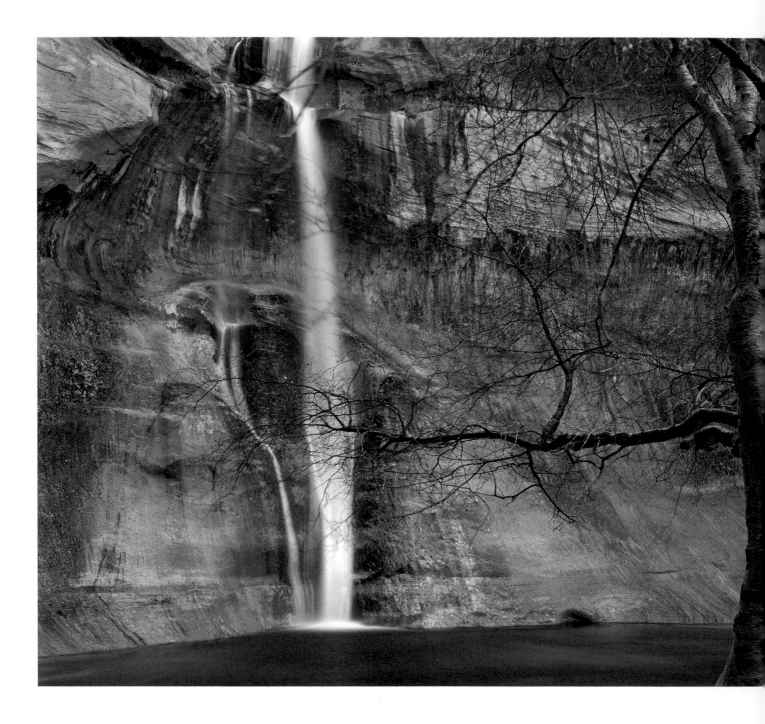

see sidebar below.) Of course, you can refer to the LCD to tune in the precise effect. If there's too much light to access the shutter speed you want, even at the lens's smallest f/stop, add a polarizing or neutral density filter to reduce brightness or change to a lower ISO setting.

• Isolate the foam. With blur-producing exposure times, foam and bubbles translate into silky shapes and streaming patterns that normally constitute the most attractive part of the scene. Isolate these attention-grabbers with tight framing (facilitated by using a zoom lens) and use them as the basis for your composition.

• Add punch with a polarizing filter. A polarizing filter eliminates reflections from wet terrain features, increasing color saturation. Just as important, it removes glare from water surfaces, which emphasizes by contrast the lighter tones of frothy areas.

• Incorporate rocks and foliage. Including rocks, pebbles, trees, shrubs, fallen logs, leaves and wildflowers sets the scale of the scene and emphasizes its three-dimensional qualities.

• Cue on diagonals. Compose the scene so that frothy stretches move diagonally

Calf Creek Falls, Escalante-Grand Staircase National Monument, Utah (left). Silky blurred effects are accentuated if you can find a camera angle that places still vegetation (the branches in this image) across the rush of water. Here the branches also unify the two polarized halves of the composition. Mamiya 645 AFD with Phase One P 25 digital back, Mamiya-Sekor 105–210mm f/4.5 lens, Singh-Ray polarizing filter, ISO 100, f/22 for 1 second.

Shutter Speed Rough Guide

CASCADES AND WATERFALLS

Shutter Speed	Close-up View	Full Framing	Distant Framing
1/4 second	velvety effect	velvety effect	as viewed
1/30 second	velvety effect	as viewed	frozen action
1/125 second	as viewed	frozen action	frozen action

STREAMS AND RIVERS

Shutter Speed	Close-up View	Full Framing	Distant Framing
1/2 second	silky effect	silky effect	as viewed
1/15 second	silky effect	as viewed	frozen action
1/60 second	as viewed	frozen action	frozen action

WAVES AND SURF

Shutter Speed	Close-up View	Full Framing	Distant Framing
1 second	gauzy effect	gauzy effect	as viewed

Havasu Falls, Grand Canyon, Arizona (below). To get this intimate view I had to set up my tripod in the stream itself. When photographing waterfalls and cascades you should be prepared to get wet in order to get the best camera angle. Pentax 645NII, Pentax 45–85mm f/4.5 lens, polarizing filter, digital scan from Fujichrome Velvia, ISO 50, f/22 for 1 second.

through the frame. Do not allow a narrow stream of foam to flow into the corner of the viewfinder as this bisects the picture space and escorts attention out of the composition.

• **Simplify the design.** For scenic vistas, try to limit design elements to simple expanses of three subject categories (e.g., cascade/trees/rocks or wave/sand/sky).

• **Look for the S curve.** Water flowing in an S curve or series of S curves seldom fails to produce an attractive image, especially when recorded with a blur-producing exposure time (see chart, page 111) and animated with bubbles and foam.

• **Attend to the sky.** On overcast days, frame out any portion of the white sky as it will drain attention from your main subject. During twilight, when colors are warm and rich, including the sky and horizon provides scale and depth. Use a split neutral density filter to restrain contrast.

• **Go below the flow.** Take a tripod position that allows you to shoot upstream (from the base of a cascade or waterfall). From this angle water courses are revealingly tilted toward the camera, making more effective use of depth of field and increasing the graphic appeal of terrain features. Blur-producing exposure times are a function of the speed of the flow coupled with the degree of subject magnification (more magnification = more blur). Try a variety of shutter

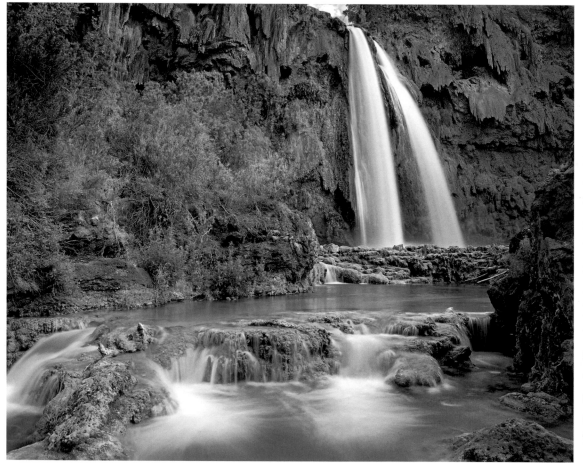

speeds to be sure of getting the effect you want.

• Get in the flow.

Enter the stream or pool to get the precise magnification and camera angle needed for your composition.

PRECAUTIONS

When shooting waterfalls, camera-soaking spray may prevent a close approach, so be prepared to shoot at a distance with longer lenses, especially on windy days. When sprinkles are unavoidable, keep the camera covered with a plastic bag until you are ready to shoot. Check the front of the lens frequently for droplets and dry them completely before shooting. If it's not too wet or windy, I drape a hand towel over the camera. This keeps everything fairly dry and allows easy access to viewfinder, camera controls and lens barrel and makes for a quick mop-up of filters and lens elements when needed.

Whenever shooting scenes featuring water, it's a good idea to be prepared to get your feet (or more) wet. Chest waders for cold weather and quick-dry shorts and river sandals for balmy conditions will

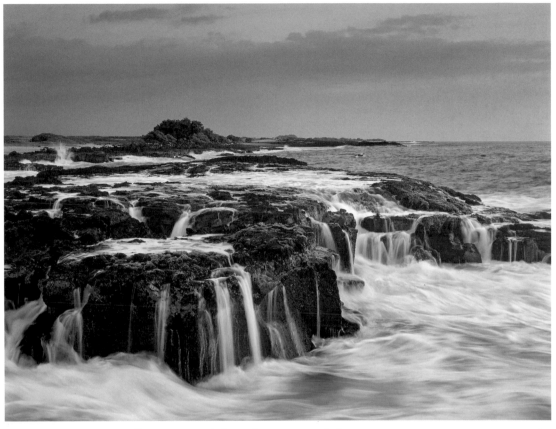

allow you to reach the perfect camera angle in comfort. A padded photo vest will keep your equipment dry and close at hand. Assume all rocks and logs are slippery and all bottoms are soft and deep until tested. Use your folded tripod to probe deep spots and steady yourself when crossing strong currents. Insure your equipment against all perils.

Enjoy the rush!

Wawalowi Beach, The Big Island, Hawaii (above). Twilight is an excellent time to photograph moving water. Soft light brings the tones of terrain and water within the range of the sensor, but you must reduce the brightness of the sky with a split neutral density filter. Pentax 645NII, Pentax 35mm f/3.5 lens, two-stop split ND filter, digital scan from Fujichrome Velvia, ISO 50, f/22 for 2 seconds.

Radiant Reflections

Recording mirror-like reflections in lakes and ponds

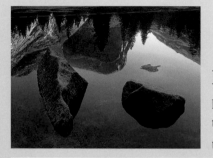

Reflections of the landscape are one of the photographer's favorite subjects. The attraction springs from the repetition of color, texture and shape formally stamped into an organic matrix, a pattern which projects an ironic union of hard ground and liquid illusion. Below are the techniques I have found most useful in capturing these magic scenes.

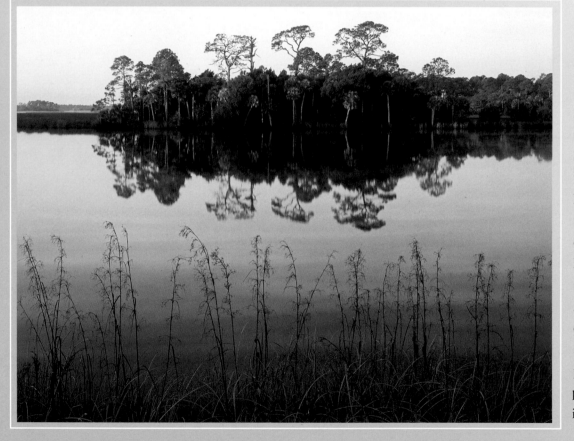

NECESSARY EQUIPMENT

To attain ideal camera angle, you often will need to enter the pool or hunker in the shallows. Your tripod should be fitted with clip-lock legs to avoid jamming with water, sand and mud. Neoprene chest waders will keep you warm and dry during colder seasons. In summer, shorts and sneakers usually suffice. All equipment should be carried on your person in a quick-access vest or hip pouch. Zoom lenses allow precise framing when access is limited by water depth,

ooze, cattails or slippery rocks. Lens coverage of 20 to 100 mm (35mm format) is normally ample. Your tripod with camera mounted doubles as walking stick and depth-finder en route to the shooting position, should it be through water.

RECONNAISSANCE

Look first for a fetching landscape that will be under front- or sidelight at sunrise or sunset (the best time for calm water and attractive light). Then look for a pool that will catch the featured terrain in reflection. Ponds, lakes, marshes and even wet sand offer potential for great reflections. Shelter-

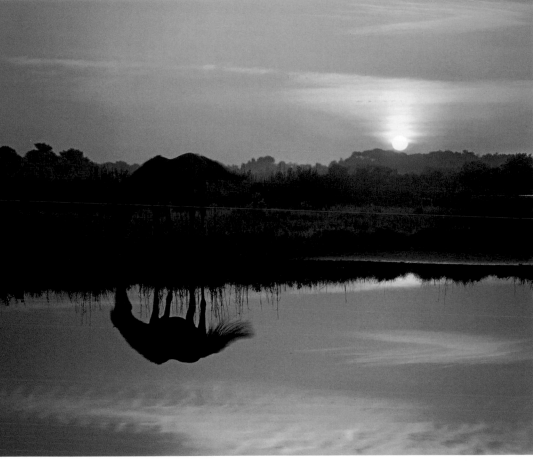

ing trees or elevated terrain, provided they do not block the view, will guard the pool from wind. A few foreground elements—logs, rocks or aquatic vegetation—stabilize the water, generating greater reflection clarity. These buffers can be incorporated as design elements in the composition. As foreground features, they set the scale of the scene, create an impression of three dimensions

and, where they interrupt the mirrored landforms, reaffirm the ironic interplay of solid matter and its fragile rebound.

CRYSTAL VISIONS

A perfect reflection comes from water that is untouched by the wind. For the best opportunities, arrive well before sunrise. Be patient. Brief periods

Fakahatchee State Preserve, Florida (far left). Reflections usually are most clear and detailed at dawn or shortly after. A blue/gold polarizer created the moody color.

Wild pony, Assateague Island National Seashore, Maryland. A zoom lens and fast footwork captured this wild horse and rising sun, a scenario that lasted but a few seconds.

Polarizing filter

One-stop ND filter

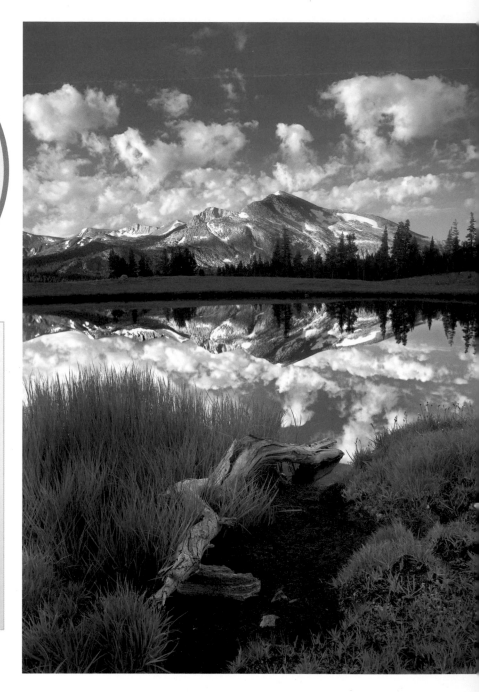

Combining Filters for Maximum Impact

When photographing reflections in the ideal early morning period, you often will find that the featured terrain is dramatically illuminated but the foreground is still in deep shade (see illustration above). To bring up the color and detail of the foreground, apply a one- or two-stop split ND filter over both landscape and its reflection. If the scene is sidelit, you can also use a polarizing filter to add contrast and color to the sky.

To capture the beautiful color of sunrise/sunset skies when scenes are frontlit and unaffected by polarizing filtration, use two split ND filters to "squeeze" the color from shaded terrain (see illustration opposite page). Place the two-stop filter over the sky and the one-stop filter over its reflection to increase the relative brightness of the shaded terrain. It's especially important to keep filters clean and fog-free when working with stacked arrangements.

of calm frequently arrive a few minutes after the sun appears.

For brilliant reflections in shallow pools, keep the camera position low (shoot while kneeling in the water) to prevent the image of the pool's substrate (especially if it is light sand or gravel) from bleeding into the surface reflection.

FILTERS FOR NATURAL RESULTS

The eye cannot look at a landscape and its reflection simultaneously. As it shifts back and forth, the pupil adjusts for the differences in brightness, with the result that the visual impression of the reflection is brighter (and more exciting) than what film or sensor records. This usually can be redressed with split ND filters by giving the reflection (usually a bit darker) about one stop more exposure than the actual landform.

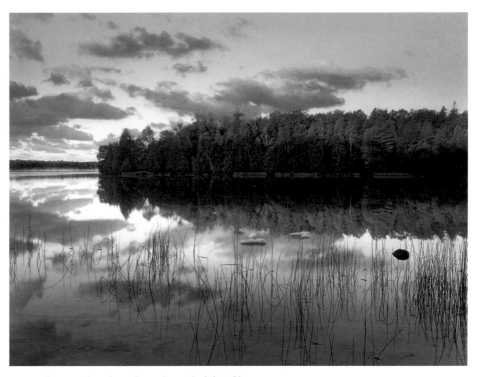

Filter Squeeze (see sidebar opposite)

Two-stop ND filter

One-stop ND filter

In most situations, I attach a polarizing filter to darken the sky and strengthen color and contrast. With the polarizer adjusted in this way the reflection is not affected, the result being a relative brightening of the reflection and overall reduction in scene contrast. Sometimes a polarizer is all you need to maximize the intensity of a reflection, especially if the water is clear and still and the scene is sidelit for maximum polarized effect on the sky. With soft, hazy or full sidelight, the polarizer must be carefully adjusted to avoid weakening the reflection. The brilliance of the reflections should approach but not exceed that of the real thing.

Cypress Lake, Bruce Peninsula National Park, Ontario (above). Including reeds or rocks to break up the reflection emphasizes by juxtaposition the ironic interplay between firm terrain and fragile reflection. Here tonal values were balanced by split ND filtration and subsequently refined in Photoshop.

Mammoth Peak, Yosemite National Park, California (far left). For this brilliant reflection, I lowered the camera to about knee height. Mamiya 645 AFD with Phase One P 25 digital back, Mamiya-Sekor 35mm f/3.5 lens, Singh-Ray polarizing filter, ISO 100, f/22 for 1/4 second.

Dramatic Dunes
Procedures for great sand dune photographs

Sand dunes seem especially created for the enjoyment of creative photographers. These simple three-dimensional formations respond dramatically to changes in lighting angle and camera position.

Their elemental simplicity and uniformity force the photographer to concentrate on composition rather than content.

SHOOTING PREPARATIONS

Shooting sites free of footprints are essential. To reach them may require hiking beyond the normal tramp of sightseers. Sports sandals with socks or hiking boots will get you there on cool feet free of blisters (resist the urge to shoot barefoot). To avoid equipment failure, keep camera and lenses away from the sand in a photo vest or belt pouch. A single piece of grit can abruptly end your shooting session. Sunglasses and sunscreen are mandatory due to brilliant reflections radiating from the sand. In the dry environments typical of dune areas, staying hydrated is important. Be sure to take plenty of water on long distance excursions. For brief morning or evening forays, drink 2 cups (500 ml) of liquid just before heading out.

EQUIPMENT

Your main concern is to pack lightly—walking in sand takes double the effort of normal terrain. Good use will be made of zoom lenses from ultra-wide to moderate telephoto length (200–300mm) plus close-up accessories. Filter needs are minimal due to the brightness and reflective properties of the terrain. Normally, a polarizing filter and hard-edge one-stop split neutral density filter are the only tools needed to moderate contrast and add density to skies. Alternatively, you can control contrast by using HDR and compositing techniques (see page 170).

TIMING IS EVERYTHING

To express the distinctive forms and textures of sand dunes, you must shoot when the sun is low in the sky. The best photography occurs in the 15 minutes before sunset or after sunrise. With such a small window of opportunity, give yourself plenty of time to get into position, keeping in mind that travel through sand is slower than normal and you may encounter photo opportunities en route.

GEMS IN THE SAND

On the way to your shooting site, be alert for wildflowers, animal tracks and other natural artifacts. The uniform texture of sand provides a simple setting for shooting these macro-subjects, and the sand's brightness works as a built-in reflector to improve contrast. But don't linger too long

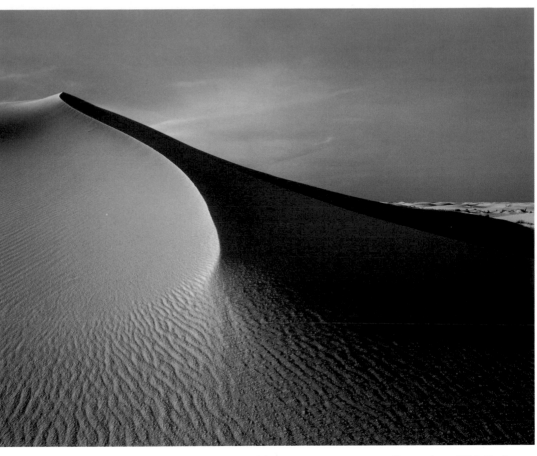

Gypsum dune at White Sands National Monument, New Mexico (above). Sidelighting with the sun 15 or 20 degrees above the horizon is often the best illumination to show the form and texture of sand dunes.

Great Sand Dunes National Park, Colorado (far left). Foreground vegetation provides scale and depth to dune imagery.

Kelso Dunes, Mohave National Preserve, California (far right). A hike to a dramatic tripod site, free of footprints, may sometimes exceed a mile and requires at least double the energy for a similar trek over hard terrain. Take only the equipment you anticipate using and leave well ahead of the sunset/sunrise period. Mamiya 645 AFD with Phase One P 25 digital back, Mamiya-Sekor 55–110mm f/4.5 lens, Singh-Ray polarizing filter, ISO 100, f/16 for 1/2 second.

Sand verbena at Imperial Sand Dunes Recreation Area, California (right). The best time for capturing pristine dunes, free of tracks, is first thing in the morning after a windy night. Mamiya 645 AFD with Phase One P 25 digital back, Mamiya-Sekor 55–110mm f/4.5 lens, Singh-Ray polarizing filter, ISO 100, f/16 for 1/8 second.

Hot Dunes

Indiana Dunes National Lakeshore, Indiana
Steep, fine-grained, ivory-colored dunes with ghost trees, broken woodlands and Lake Michigan in the distance. Crop out the neighborhood's nuclear reactor.

Great Sand Dunes National Park, Colorado
Tawny, towering (750 feet) ridges sandwiched into the ice-capped Sangre de Cristo Mountains with ghost trees, colorful desert shrubs, mule deer and disappearing creeks.

Mesquite Flat Sand Dunes, Death Valley, California
The big daddy of photo dunes nestled in the scorching heat of Death Valley. Approach from the south opposite the Devil's Cornfield for track-free vistas.

White Sands National Monument, New Mexico
Snow-white gypsum dunes with peachy skies and purple mountain backdrops. Scattered yuccas make interesting foregrounds. Call the park service for a private pre-dawn entry (gate is locked).

Coral Pink Sand Dunes State Park, Utah
Large rust-tinted dunes flanked by mountains and freckled with wildflowers in May and June. Call ahead for flower reports. Avoid the ATV trails.

Bruneau Dunes State Park, Idaho
Monster dunes backing a quiet lake and marsh for great reflections that double the drama. Desert/prairie/marsh environment.

Oregon Dunes National Recreation Area, Oregon
Extensive dune fields along the Oregon coast with streams, quiet estuaries and ghost trees. Flanked by coniferous forests and the blue Pacific. Bring a sweater and windbreaker.

over these gems—you need to be on center stage at least 20 minutes before showtime.

PHOTOGENIC DUNES

The ideal dune photo is free of footprints

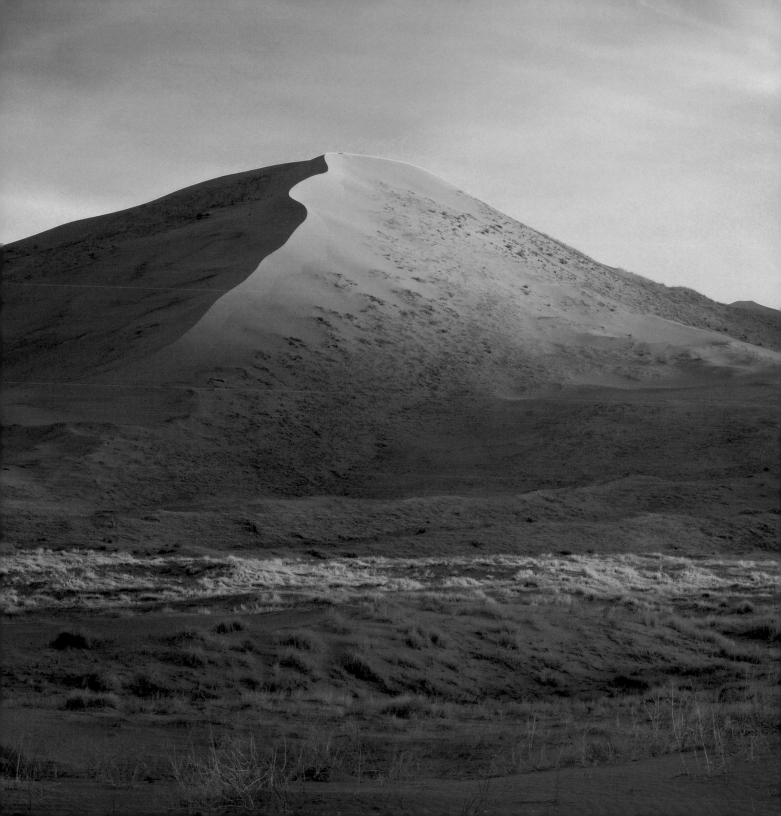

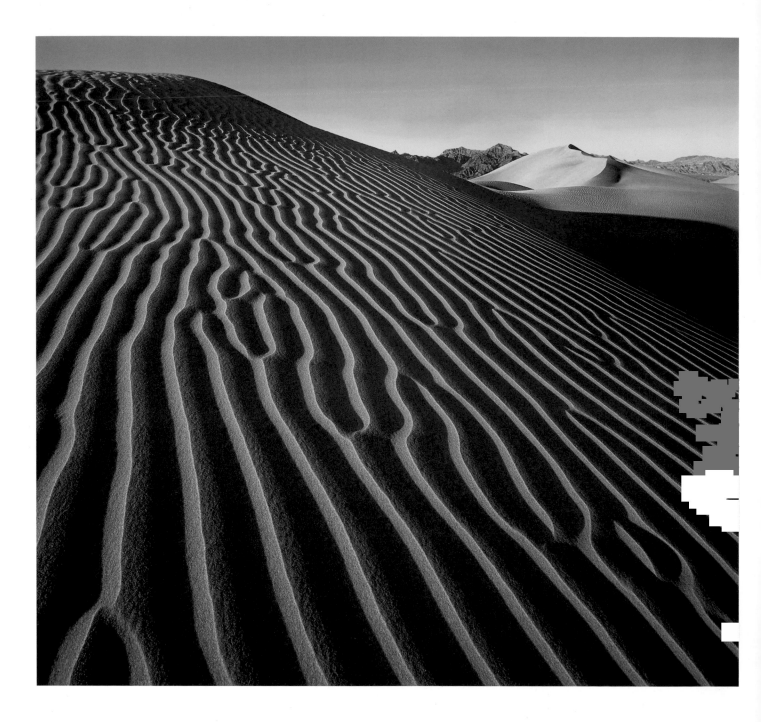

Record Ripples in Relief

• *Look for long, deep, parallel ripples in low cross-light on a level or rising plane.*

• *Set up the camera on a tripod at the base of the pattern within knee height of the ground.*

• *Use an ultra-wide-angle lens (20mm or less) set for minimum aperture and hyperfocal distance.*

• *Angle the camera to show the micro-ridges running diagonally through the frame or moving into the distance as symmetrical converging parallels.*

• *Include the horizon with clouds or terrain features occupying 10 – 15 percent of the upper picture space to show scale and dramatize perspective.*

• *Attach polarizing or ND filters to moderate contrast and darken skies as necessary.*

• *Be sure the foreground sand is not blowing about, and trip the shutter with an electro-magnetic release or self-timer. Use matrix metering and bracket exposures up and down by a full stop. Check your histogram. It's gotta be a winner!*

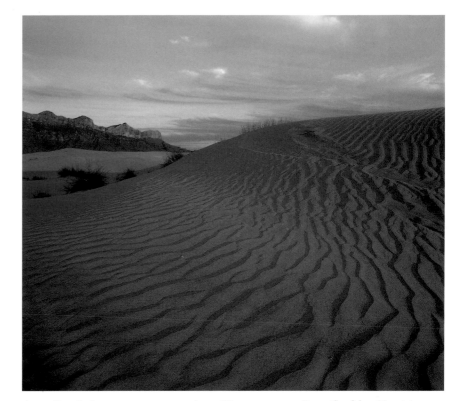

(including your own). But most dunes are hot spots for tourists and local recreation seekers and you'll need to do some trudging to find an untrammeled area, especially for afternoon shoots. Pristine, smoothly swept sites can be found just about anywhere at sunrise following a windy night. To avoid tracking up your own compositions, you have to plan ahead. First identify a group of dunes or a dune/landscape combination that you suspect will be especially photogenic. Large dunes with curving crests running at a right angle to the sun are always a good bet. Then approach the target along the line of your preferred shooting angle, photographing the undisturbed scene as you move along. The most dramatic tripod position is usually on top of the dune, where you can frame the crest's graceful curve angling through the scene toward a distinctive feature into the distance.

Photographing dunes is like a day at the beach—lots of sun and sand, though normally not quite as much water, and plenty of challenging photo opportunities.

Dunes, Guadalupe Mountains National Park, Texas (above). Dune ripples can be used to guide viewer attention toward featured landscape elements (see sidebar, this page).

Mesquite Flat Sand Dunes, Death Valley National Park, California, (far left). A low camera position and sidelight are key to showing the form and texture of dunes.

Sunrise and Sunset

Seizing opportunities at the magic hour

Joy Fitzharris

Sunset and sunrise generate the most dramatic photos in nature's image bank. Ready access to these visual treasures requires an instinctive command of a handful of pertinent compositional models. Five of these can't-miss motifs are described here.

TERRAIN IN THE SPOTLIGHT

Look for a distinctive landform lying below a cloud-patched, wind-buffeted sky with the sun casting sidelight or front-sidelight onto the center of interest. The cloud-choked horizon should offer an open, snooted (telescoping) window to pass a direct beam onto the subject, however briefly.

This motif requires fast action, patience and luck. Keep your ideal composition prepped for the curtain call. If and when the light strikes, shoot quickly, mind your histogram and recompose until you're sure the ephemeral drama has been satisfactorily recorded.

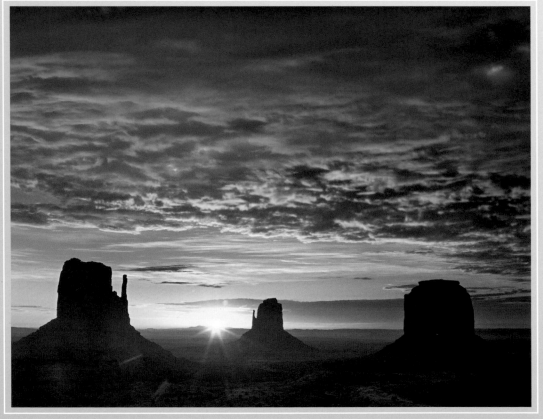

BIG COLORFUL SKY

This model calls for a sky over the target landform nearly replete with coarsely textured cloud formations together with a clear horizon in the area where the sun will rise or set. Choose a focal length that will fill the frame with the most colorful and shapely parts of the cloud show (terrain features are billed as secondary design elements). The heavens reach their peak of color when the sun is below or crossing the horizon. Use a split neutral density filter to curb scene contrast.

SUNBEAMS AND HALOS

To generate theatrical backlit effects, look for translucent shapes (foliage, light clouds, fog, birds, hairy creatures) arrayed before a dark backdrop (dense cloud banks, shaded hillsides, mountains, ridges) illuminated by full sun low on the horizon.

Set tight framing with a zoom lens to emphasize the glowing peripheries of the main features. When the sun is included in the scene, flare (starbursts of light) produces highly theatrical effects. To avoid flare but capture sunbeams tracing through patches of mist or fog, exclude the naked sun from the frame and shield the front lens elements from direct sunlight with your hand or a compositional element (tree trunk, pinnacle, etc.). Bracket exposures by a stop over and under an evaluative reading and use these takes if need be to add more detail to highlights and shadows in Photoshop (see page 170).

SUCCINCT SILHOUETTES

The silhouetted features should be distinctive, well defined and (ideally) related shapes projecting

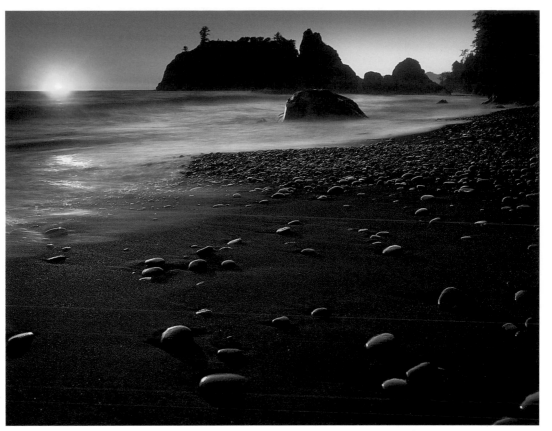

The Mittens at Mounument Valley, Utah (far left). For sunset or sunrise silhouette motifs, make sure the landscape features project well above the horizon and are separated from one another.

Ruby Beach, Olympic National Park, Washington (above).
As the sun moves across the horizon at sunset or sunrise, light contrast is reduced, making it possible to record more detail in highlight and shadow areas of the scene.

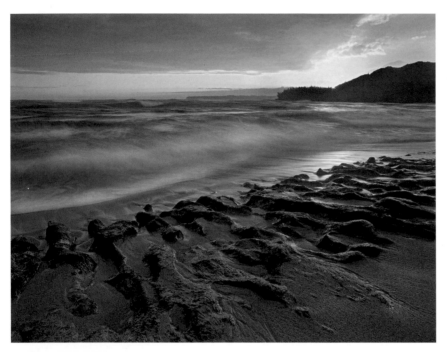

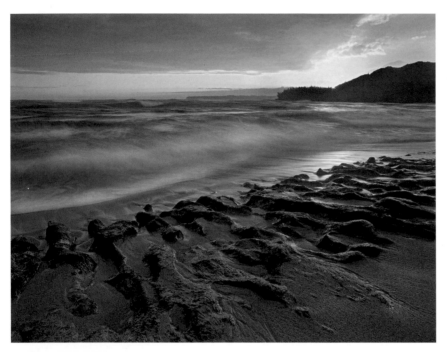

Bottom

Top

One-stop split ND filters

*Top filter darkens sky and water.
Bottom filter darkens sky only.*

into the sky (trees, sea stacks, rock pinnacles, looming mountains, natural arches, cacti, birds, mammals). The sun should be either in front or to one side of the camera.

Place the camera low enough to throw the silhouettes against the sky's most eye-catching expanse of sky. Adjust camera angle and position so that featured components do not overlap, in order to reveal their characteristic profiles. Manually set exposure from a close-up reading of the key sky region and check the histogram.

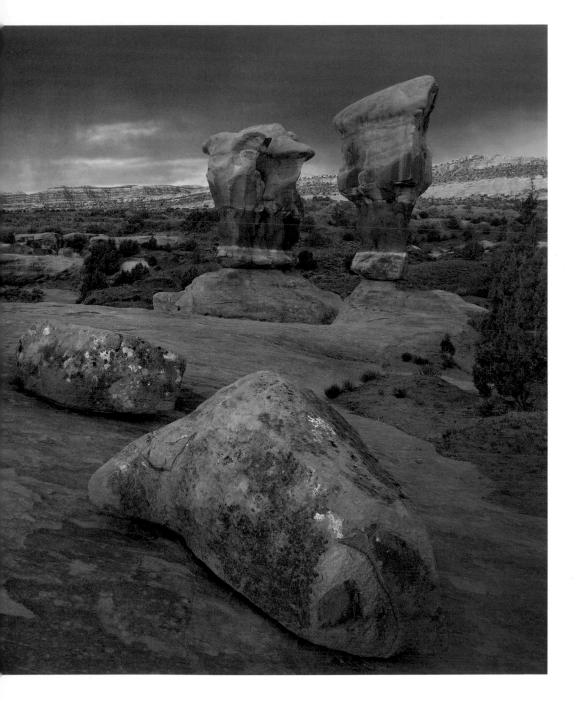

Waioli Beach, Hanlei Bay, Kauai, Hawaii (far left). *You can use natural features, such as the trees in this image, to shield the lens from the direct rays of the sun to limit both contrast and flare. Pentax 645NII, Pentax 45–85mm f/4.5 lens, Singh-Ray split ND filters (see illustration), digital scan from Fujichrome Velvia, ISO 50, f/16 for 1/2 second.*

Devil's Garden, Escalante-Grand Staircase National Monument, Utah (left). *Alpenglow, as seen illuminating the mesas in this image, lasts but a few seconds and is often the dramatic highlight of the sunset. Make sure all camera preparations are completed before the sun reaches the horizon. Mamiya 645 AFD with Phase One P 25 digital back, Mamiya-Sekor 55–110mm f/4.5 lens, Singh-Ray one-stop split ND filter, ISO 100, f/22 for 2 seconds.*

Flare Fighters

The sun's near camera-level position at sunrise and sunset often causes unwanted image flare (distracting streaks and patches of light) resulting when rays strike the front lens elements. Here's a lineup of top flare fighters.

• A lens hood specifically designed for the lens in use. Works fine except that it makes attaching and adjusting polarizing and split neutral density filters difficult or impossible

• Your hand. Always accessible and does not interfere with filters. Steadiness required during long exposures.

• Your hat. A stiff-brimmed cap provides broader coverage than a hand but is less convenient.

• The commercial Flare Buster (www. flarebuster.com). A square shade (mounted on a hot-shoe-anchored arm) that works just like your hand but is steadier and a lot less convenient.

• A tree. Block the sun's direct rays by carefully positioning the camera in a spot of shade cast by natural elements, trees being the most cooperative.

• Table-turning. Embrace flare—incorporate it in your composition. Effect must be judged at shooting aperture.

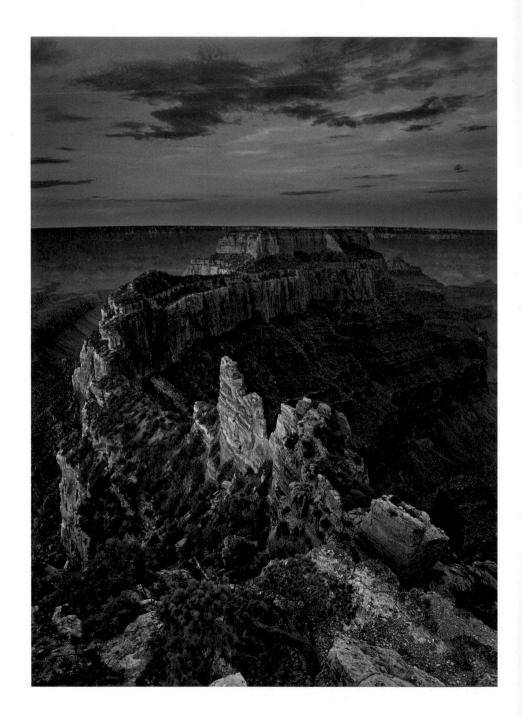

Wotan's Throne, Cape Royal, Grand Canyon National Park, Arizona (right). *Scout your position and test camera angles in advance to be sure of capturing the best moments of the sunrise.*

GOLDEN ALPENGLOW

Opportunities for this mountain motif materialize when the sun rises or sets through a cloudless or slightly hazy horizon backing your camera position at an elevation lower than the starring landform feature.

Alpenglow, the rosy supernatural radiance on mountainous forms, lasts but seconds as the sun passes over the horizon. Set up your composition in advance and be ready to shoot and bracket quickly. A split neutral density filter usually is needed to restrain scene contrast.

PREPARING FOR A PRIZEWINNER

The striking effects of sunrise and sunset pass all too quickly. Be prepared and you'll make the most of these unique photo opportunities. Here's my routine (in order) for getting ready.
• Scout the routes to the shooting location.
• At the site, thoroughly rehearse camera angles,

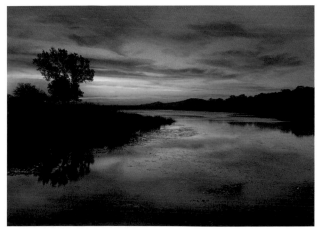

positions and lenses.
• Check sunset/sunrise times to finalize schedule.
• Review weather forecast to anticipate composition models.

• Make a quick inspection and test of equipment (including tripod leg movement).
• Clean lens elements and filters.
• Load ample battery power to shoot through the entire session.
• Be ready to capture the first series 30 minutes before the sun meets the horizon

With practice you'll soon be working these formal models into unique and intuitive creations.

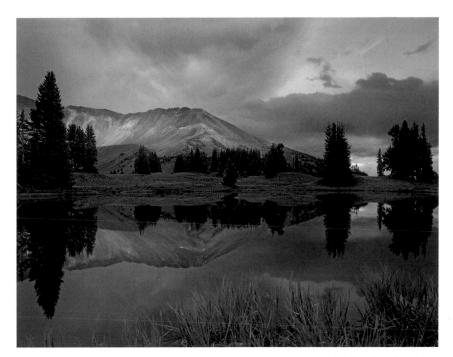

Mount Baldy from Paradise Divide, Colorado (above). *A polarizing filter was adjusted to darken the sky while not diminishing the reflection. Pentax 645NII, Pentax 45–85mm f/4.5 lens, Singh-Ray polarizing filter, digital scan from Fujichrome Velvia, ISO 50, f/16 for 1 second.*

Sunrise, Elmer Thomas Lake, Wichita Mountains National Wildlife Refuge, Oklahoma (left). *For silhouettes, position the camera to cast the main features against the most colorful part of the sky.*

Oceans of Light
Recording the changing moods of the shoreline

***Big Sur Coast from Garrapata
State Park, California (below).*** *This
composition was devised to frame
the breaking surf with the sweep of
coastline. Pentax 645NII, Pentax
45–85mm f/4.5 lens, polarizing filter,
digital scan from Fujichrome Velvia,
ISO 50, f/22 for 1 second.*

Few of nature photography's attractions match the thrill of shooting at the ocean's edge. Photo sites are serenaded by the hiss of waves and the thunder of surf, perfumed with seaweed and salt spray and hung with ever-changing tableaux of open ocean and soaring sky. Shooting techniques can be routinely simple and seldom fail to generate satisfying imagery.

READY FOR THE BEACH

The first consideration is to equip yourself for amphibious work. You'll be shooting close to incoming waves and their magnitude is unpredictable. I carry my equipment in a vest and, depending on temperature, wear chest waders or shorts and river sandals with socks. This permits me to move around tide pools, scramble over rocks and shoot even when waves are swirling around the tripod. I carry the usual assortment of scenic

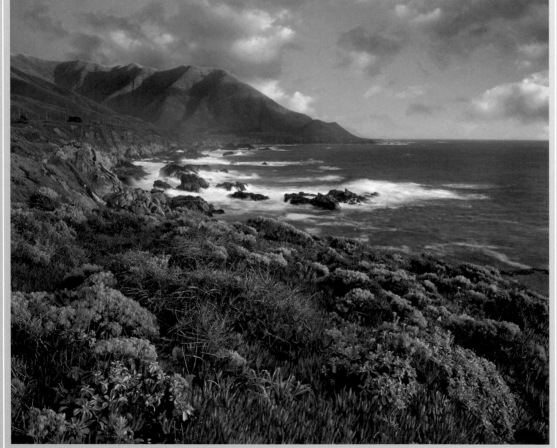

tools—a couple of zoom lenses covering ultra-wide to moderate telephoto focal lengths, a cable release and polarizing and graduated neutral density filters.

Tripod Positions

The best camera positions (especially when there is surf) are often right where waves break onto the beach. Unfortunately, this territory is also the most hazardous for equipment. I keep a soft cotton cloth in my vest to wipe ocean spray from camera and lenses. Another precaution is to keep an eye on your tripod when it is set up in sand that may be flooded by incoming waves. A single wave can quickly undermine the tripod and topple the camera into salt water. Should this calamity occur, it's usually best to keep the doused equipment in a bucket of fresh water until you can get it in for repairs. Mechanical lenses and cameras are usually salvageable whereas electronic equipment is likely a write-off.

Timing and the Tides

Early morning is the preferred shooting time. Footprints in the sand from the day before have been erased by nighttime wind and waves, and the atmosphere is calm enough to record well-defined reflections in tidal pools. This schedule is ideal for the Atlantic coast, which lies open to the rising sun. On the Pacific edge, coastal mountain ranges and seaside cliffs leave many beaches in shadow during the best light of early morning. Here, you should look for shorelines with low elevation backdrops or those on the south-facing beaches of projecting headlands. Another favorite time, dependent not on the sun but the moon, is during low tide. Sea stars, mussels, kelp and other sea life are exposed to provide added decoration to compositions. Receding seas also reveal expanses of sand, rocks and reefs —novel landscapes dotted with reflecting pools

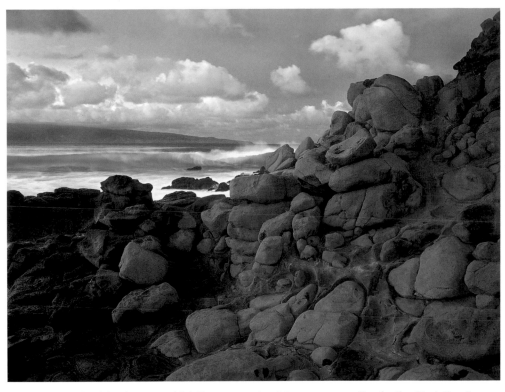

Honolua Bay, Maui, Hawaii (above). When shooting beach scenes, polarizing filters are essential for controlling reflections on wet vegetation, rocks and the water itself. Pentax 645NII, Pentax 45–85mm f/4.5 lens, Singh-Ray polarizing filter + one-stop split ND filter, digital scan from Fujichrome Velvia, ISO 50, f/16 for 1/8 second.

and often bisected by bubbling freshwater streams, ideal elements to control and direct visual interest. To find out tide conditions, consult this Internet site—http://www.tidesonline.nos.noaa.gov.

CAPTURING THE ACTION

For most of my beach photos, I look for a combination of strong foreground elements and interesting wave action. Once the camera and tri-pod are set up and the scene is carefully framed, I attach a cable release and observe incoming waves, taking a shot each time a dramatic splash or sinuous stream of moving water is anticipated. Make numerous recordings as catching peak action is difficult to time correctly. Also try a range of shutter speeds for varied blurring effects. You can seldom be certain of precise exposure due to the unpredictable movement of breaking waves (keep a close eye on the histogram). Review the composition results periodically and make necessary adjustments. On days when big scene-stealing waves arrive only irregularly, it takes some time and effort to get enough images to feel confident of success.

On sandy beaches, receding waves leave behind momentary patterns of wet, glistening sand, rivulets and pools that reflect the color of the sky if you posi-tion the camera appropriately. Organize the composition around these colorful elements. Their intensity fades quickly as water drains off the beach, so fast shooting is required. Fortu-nately the patterns are more or less repeated with each wave, so

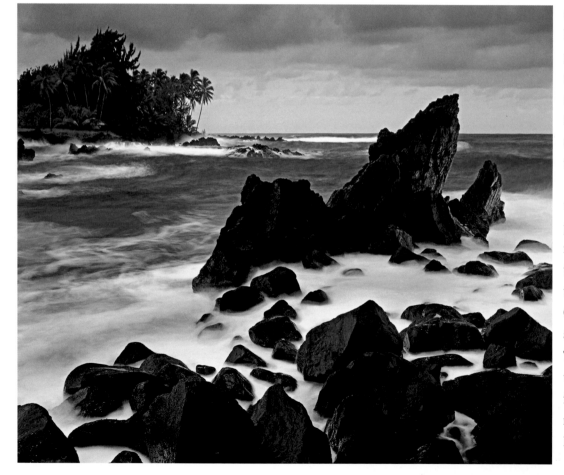

Honomanu Bay, Maui, Hawaii (below). Often the best place to set up your tripod is right at the edge of the surf. Look for a composition that allows you to angle the shoreline di-agonally through the frame. Pentax 645NII, Pentax 45–85mm f/4.5 lens, digital scan from Fujichrome Velvia, ISO 50, f/16 for ¹/4 second.

if you are patient, the desired effect is eventually forthcoming.

TAMING SCENE CONTRAST

It's difficult to underestimate the importance of using split neutral density filters. Without them the sky would be overexposed, devoid of strong color and detail. Hard-edge split ND filters are ideal for shoreline shooting as compositions frequently involve a clean, uninterrupted union of sky and sea. To judge the effect, make a test capture and analyze the results on the LCD.

LIVING ACCENTS

Beach scenes gain identity and perspective when living elements such as gulls, herons, kelp or sea stars are part

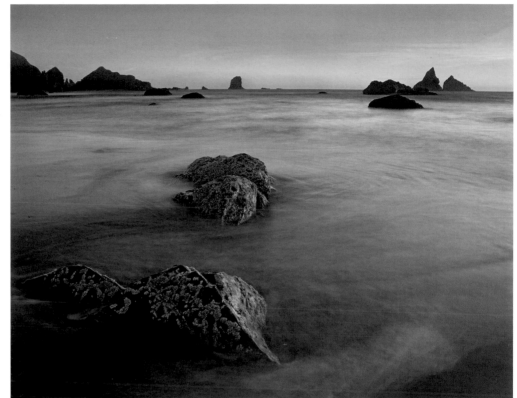

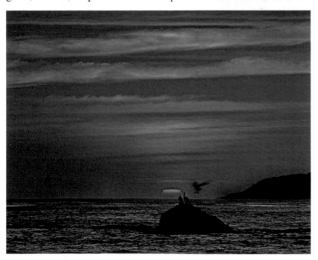

of the composition. Try to portray these subjects prominently by moving in with a wide-angle lens set for the hyperfocal distance or, using a longer focal length, place them against a clear stretch of sky or sand— any simple area where they will stand out.

These suggestions should help you bring back some artful souvenirs of your day at the beach.

Twilight at Lone Ranch Beach, Oregon (above). A two-stop split neutral density filter reduced the brightness of the sky, producing rich color and balanced tone throughout the image.

Pelicans coming to roost, Big Sur Coast, California (left). Careful camera placement and advance preparation caught these pelicans against the setting sun.

Floral Wilderness

Capturing the beauty of meadows in bloom

Joy Fitzharris

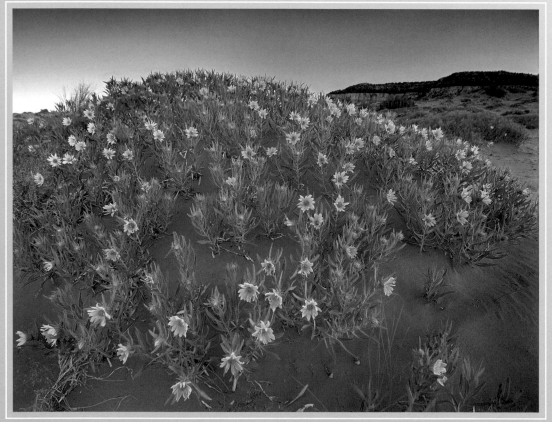

Wildflowers decorating the broad landscape set the landscape photographer's pulse racing. One of the most appealing of subjects, it is also one of the most frustrating to capture in any measure close to its actual beauty. Here are guidelines that will help you realize these dreamy scenarios on film.

THE BLOOMING SEASON

You can find meadows awash in color somewhere in North America from February to September. The first region to load its spring palette is southern California, followed by the desert regions of Texas, Arizona and Nevada. By early May the display has spread continent-wide. It continues throughout the summer in sub-alpine meadows, fields, and desert regions under monsoon rains. (See sidebar, page 139.)

MATCHLESS MEADOWS

The properties you should look for in an ideal wildflower meadow site are as follows.

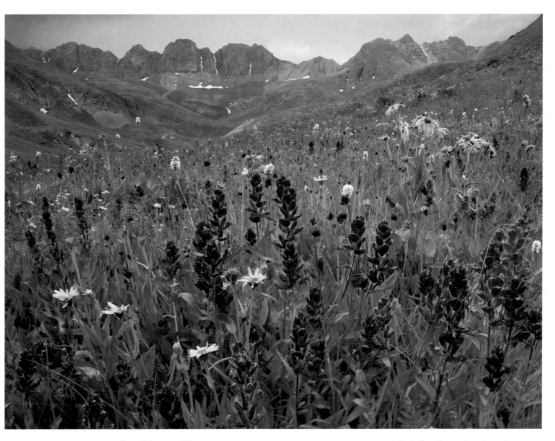

• The flowers should be at, or just reaching, their blooming peak. Fields on the decline, even if colorful, weaken the freshness and vigor of the spring motif.

• The display of blossoms should be dominated by a mix of three hues, one of which should be white to serve as a color reference (e.g., blue/yellow/white).

• The land should be tilted toward the intended tripod location to make it easier to record the image in total sharpness.

• The meadow should offer its best compositions under early morning frontlight. This illumination generates the most color saturation and holds contrast within the range of transparency film or sensor. Morning is usually the calmest period of the day and so affords the opportunity to capture blossoms in a motionless, detail-revealing state.

• The background to the meadow (often the horizon) should exhibit distinctive features (trees, landforms, interesting clouds). These elements will pull the eye through the scene, creating both unity of composition and visual tension.

SET UP FOR FRONTLIGHT

The best conditions for meadow photography take place very early or late in the day (including twilight), when the atmosphere is calm and light is diffuse and casts a barely discernible shadow. In spite of the softness of the illumination, it is important to keep the sun behind you to wring the most pure and brilliant color from the scene. Even if it is out of sight below the horizon, its directional bias is still sensed by the camera.

Paintbrush meadow, American Basin, Colorado (above). Scout your wildflower territory for compositions that provide front- or sidelight in the early morning, when the atmosphere is likely to be calm.

Arrowleaf balsamroot sunflowers, Coral Pink Sand Dunes State Park, Utah (far left). This patch of flowers, growing on the side of a dune, was tilted toward the camera, making it easier to capture the full array within the depth-of-field zone.

Go with the Blow

When the light is too weak to use an action-stopping shutter speed, you can avoid frustration by using the wind for creative effects by incorporating blurred elements in your composition. You'll want enough blur to make the effect seem intended rather than negligent. To strengthen blur, increase exposure time or place the camera closer to the moving elements.

ALL IN FOCUS

The image will usually be most arresting if it displays sharply from front to back. This can be accomplished by shooting at the lens's smallest aperture to maximize depth of field and by focusing about one-third of the way into the picture space to center the in-focus zone over the framed area. Use your camera's depth-of-field preview feature to check results in the viewfinder.

LOW-ANGLE PERSPECTIVE

Here the intent is to take the viewer into the flower patch for an intimate impression. By placing the camera directly on the ground, the blooms are set up against one of nature's most inviting hues—the blue ceiling of a sunny day. An ultra-wide-angle lens in the 20mm range

(35mm format) provides a strong impression of three dimensions. An extension tube of 12–15 mm fixed between camera and lens will provide eye-popping magnification of the closest flowers. At appropriate angles, a polarizing filter will provide more color density in the sky, should this prove beneficial. Position your camera so that leaves and petals brush against the front of the lens. Take some time to arrange the overload

Poppy blooms at Temescal Canyon, California (far left). To catch wild-flowers at the peak of bloom, you need to consult the World Wide Web (see sidebar, page 139). Mamiya 645 AFD with Phase One P 25 digital back, Mamiya-Sekor 55–110mm f/4.5 lens, Singh-Ray polarizing filter, ISO 100, f/16 for 1/4 second.

Sunflowers, desert primrose and sand verbena, Anza Borrego Desert State Park, California (below). Alpenglow on distant peaks pulls the eye from the colorful blooms through the frame, generating a dynamic composition.

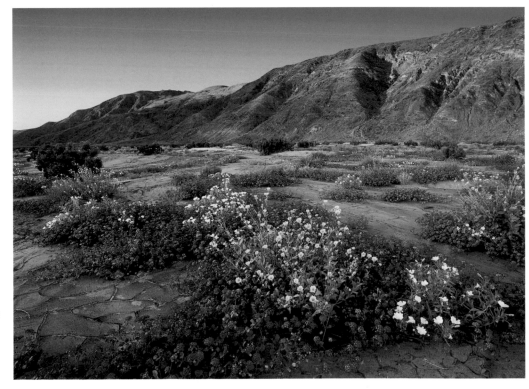

of gorgeous colors and shapes into an effective composition. Minute shifts of camera angle and position generate dramatic changes in the scene. Once the artist in you has it just right, stabilize the camera position with anything handy—a beanbag support works well. Adjust focus, aperture and shutter speed for the best rendering of subject sharpness (check depth of field through the lens at

shooting aperture). Trip the shutter with the self-timer or a cable release to avoid camera-shake. Most of the time color and contrast improve with the use of a matt-white reflector placed on the ground beneath the flowers. A simple sheet of white paper or paper plate work as effectively as anything.

DESIGNER'S TO DO LIST

Here's a quick checklist to run through before you start shooting:

Wildflower Shooting Season Highlights			
When	**Where**	**Shooting Experience**	**More Info**
February	Anza Borrego Desert, CA	Sunflower/verbena expanses in rugged setting	www.desertusa.com
March	Sonoran Desert, AZ	Golden poppies/owl's clover among saguaros	www.desertusa.com
April	Edwards Plateau, TX	Red paintbrush/bluebonnets in hill country	www.wildflower.org
May	Gulf Islands, BC	Blue camas/fawn lilies among oaks and arbutus	www.gulfislandstourism.com
June	Blue Ridge Parkway, NC	Rhododendrons/azaleas in high country forest	www.ncnatural.com
July	Crested Butte, CO	Blue columbine/sunflowers in alpine setting	www.crestedbuttewildflowerfestival.com
August	Mount Rainier, WA	Paintbrushes/bear grass under the volcano	www.nps.gov/mora

• Magnification and focus should reveal petal detail in the closest flower specimens.

• Allow the sky to occupy about the top third of the frame (for an abstract effect, exclude it altogether).

• Simplify your design by limiting picture content to three categories (e.g., sky, land, flowers).

• Eliminate elements that lead the eye out of the picture frame (branches, bright stems).

• Synchronize exposures to capture the scene when the vegetation is motionless.

Don't delay; meadows are waiting in a location near you.

Orange sneezeweed meadow and East Beckwith Mountain, Colorado (far left). The tilt feature of this lens allowed me to achieve nearly full depth of field (middle ground is soft) at a relatively large aperture. This permitted the use of a shutter speed fast enough to arrest the slight motion of the blooms. Mamiya 645 AFD with Phase One P 25 digital back, Hartblei Super Rotator f/4.5 lens, Singh-Ray polarizing filter, ISO 100, f/11 for 1/30 second.

Red paintbrushes at American Basin, Colorado (left). For this photo the camera was placed at ground level to project the blooms against the sky. A small matt-white reflector was positioned below the paintbrushes to brighten shadows. Mamiya 645 AFD with Phase One P 25 digital back, Mamiya-Sekor 35mm f/3.5 lens with extension tube, Singh-Ray polarizing filter, ISO 100, f/16 for 1/15 second.

Twilight Time

Heavenly light when the sun is below the horizon

Joy Fitzharris

When the sun sets, give your eyes a few minutes to adjust to the darkness, and the photogenic drama of twilight will emerge from murky surroundings. Extending for about 30 minutes after sunset and before sunrise, the bright twilight period seems designed especially for the pleasure of photographers, combining the soft, emulsion-quenching tones of an overcast sky with a glowing spectrum of rich and changing hues. It's a great time to shoot the landscape.

SIDELIGHT, SILHOUETTES AND STILLNESS

When you set up at right angles to the sub-horizon sun, landscape contours are modeled by sidelight emanating from the horizon's diffuse glow while shadow-revealing fill light falls broadly from the sky overhead. Twilight is also the time for exploring silhouettes. Backlit features are etched against a palette of electric hues and shifting color. Atmospheric stillness is the third attraction of twilight, offering opportunity to make detailed images

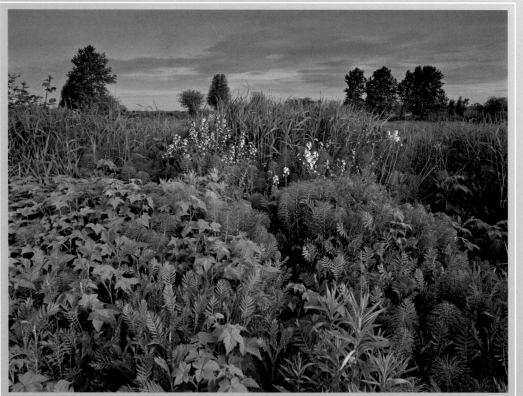

of vegetation at exposure times extending to several minutes.

PREPARATIONS

You should know how to operate your camera in darkness (practise at home). In the field carry a small flashlight to deal with unexpected glitches. Twilight is feeding time for mosquitoes and other pests, so during warmer seasons pack bug repellent. Extra batteries may be needed to keep long, power-draining exposure times from exhausting your camera. Especially in mountainous or rocky terrain, working and hiking in near darkness can be hazardous, making a cell phone good insurance against a mishap. Of course, a tripod and cable release are necessary to keep the camera rock steady during exposures.

RECONNAISSANCE REWARDED

Most crucial for consistent results is to target a setting that makes the most of twilight's soft and colorful light. For conventionally illuminated scenarios (not silhouettes) it's best to anchor your composition to a foreground dominated by bright, sharply defined elements that project both luminos-

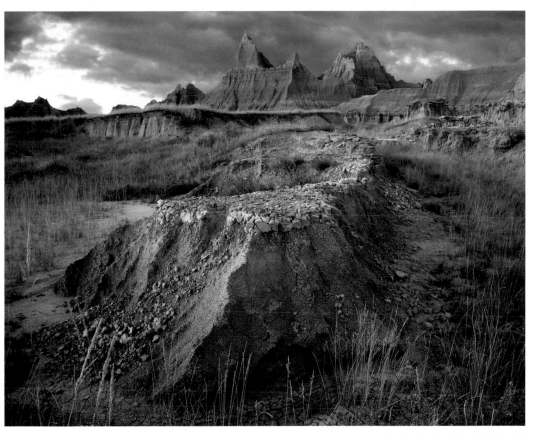

ity and interesting detail (light-colored vegetation, rocks, sand, snow, pools, lakes and wet surfaces) that can reflect the color display of the sky. Be sure to scout your sites early to make the most of twilight's briefly proffered and changing opportunities once the action begins.

FOLLOW THESE STEPS ON LOCATION

• Set up the tripod and attach the cable release.
• Adjust camera angle and lens focal length (zoom

Vampire Peaks, Badlands National Park, North Dakota (above).
I scouted this area earlier in the day to be sure not to waste precious moments during the brief twilight shooting period.

Wallflowers, Nicomekl River Valley, British Columbia (far left).
Rich color and fine shadow detail are generated by twilight's soft warm light just prior to sunrise on a windless morning.

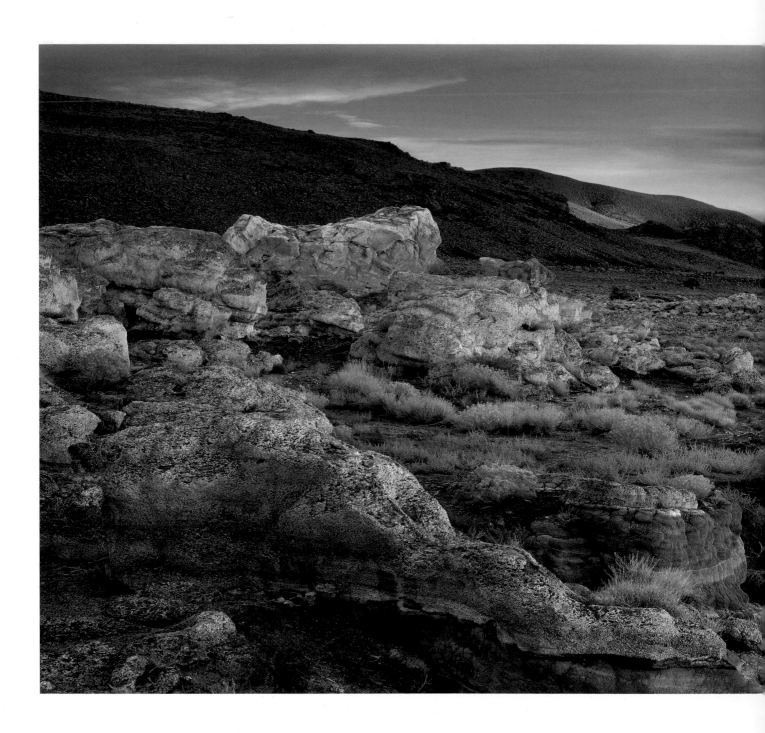

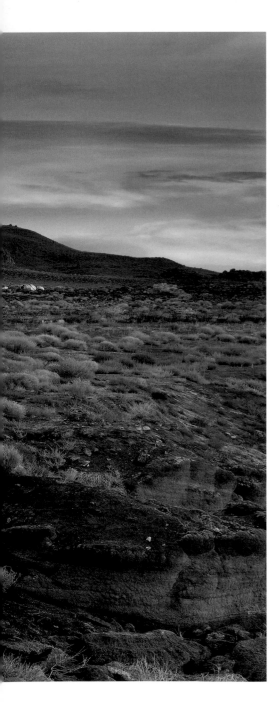

Steps for Superior Silhouettes

1) Be at your shooting site 30 minutes before the sun meets the horizon.

2) Find a view with distinctive elements projecting against the sky (character trees, cacti, rock pinnacles, buttes, mesas, peaks). Sky areas with clouds have the most potential for strong color.

3) Position the camera low to the ground at a vantage point that shows clear separation of all silhouetted components.

4) Adjust aperture and focus distance to bring all silhouettes within depth of field.

5) Base exposure on a close-up (spot) reading of only the most interesting part of the sky (exclude silhouettes).

6) Shoot and bracket with a tripod, cable release and mirror lockup.

lenses are best) and attach filters (split or graduated neutral density filters are usually needed to reduce overall contrast).

• Set camera controls in this order: 1) ISO speed to 200 or 400. 2) Aperture to achieve a depth of field that encompasses all the important features of the scene. 3) Shutter speed for proper exposure.

• Shoot and bracket exposures by one stop over and under the base reading. Check histograms.

• Try new camera positions and framing if time permits.

These pointers should get you well on the way to capturing the heavenly shades of twilight.

Lake Range at twilight near Pyramid Lake, Nevada (left). ISO speed was increased to reduce exposure time to avoid unwanted noise and avoid blur from moving vegetation. Mamiya 645 AFD with Phase One P 25 digital back, Mamiya-Sekor 55–110mm f/4.5 lens, Singh-Ray one-stop split ND filter, ISO 200, f/16 for 1/4 second.

Wide View Panorama

Shooting and stitching multiple captures of a scene

Ancient bristlecone pines, White Mountains, California. *This image, made from three separate digital captures, was constructed on the computer using special software. Mamiya 645 AFD with Phase One P 25 digital back, Mamiya-Sekor 35mm f/3.5 lens, Singh-Ray polarizing filter + one-stop ND filter, ISO 100, f/16 for ¹/₂ second.*

Digital technology makes it easy to produce panorama photographs with almost any camera by stitching a series of images together on the computer. Nature photographers can capture the grand spectacle of wilderness more expressively than ever before, creating ultra-wide, distortion free, highly detailed images with standard camera equipment and appropriate software. Here's how to get started.

SIMPLE EQUIPMENT

You can use any camera, digital or film (if shooting with film you need to have the photos scanned into digital format). Normal to telephoto

lenses produce the most reliable results. A tripod that can be set perfectly level assures easy match-up of the images. Finally, you will need stitching software to combine the images (see sidebar, page 147).

OUT IN THE FIELD

The work that occurs behind the camera is key to making professional panoramas. Do your best here and the computer follow-up will be easy.

• Search for a view that fits the ultra-wide format snugly. The scene should have a single dominant component that will anchor the composition, as well as strong secondary elements that will sustain visual interest over the breadth of the frame.

• Situate the tripod a few meters away from an interesting array of foreground features. (The closer you set up, the more difficult the subsequent match-up of components will be.) Level the tripod (see sidebar this page) to ensure that the pictures line up.

• Select a focal length (normal to moderate tele-photo range is best) that snugly frames both the foreground and the tallest element (e.g., tree, mountain peak) intended for the composition.

• Set depth of field (by adjusting aperture and focus

Joy Fitzharris

Level Your Tripod

For a tripod that has a bubble level fixed in the leg platform. First level the legs by adjusting leg length. Next level the camera on the horizontal axis with a second bubble level mounted in the camera hot shoe. (Tilt up or down to achieve best composition.) You can now rotate through the image series with no further need of adjustment.

For a two-way bubble level on the tripod head or camera hot shoe only. Level the camera only on the horizontal plane after each frame. Use identical overlapping features in the scene to maintain consistent tilt (e.g., make sure the daisy in the bottom right corner of take #1 is similarly positioned in the bottom left corner of take #2).

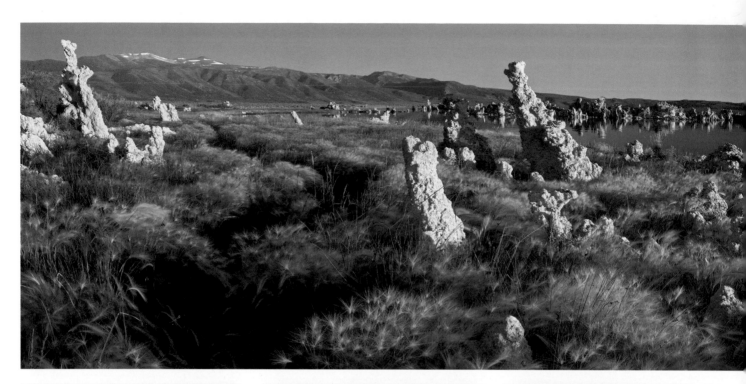

 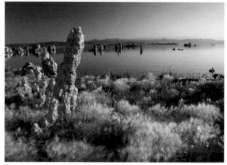

Panorama series (above). These are the three images used in the panorama. They are RAW captures before adjustments were made to color balance, saturation, contrast and sharpness.

distance) to encompass all elements in the composition. (Use depth-of-field preview to analyze the scene at shooting aperture.)

• Set exposure control to manual, metering pattern to center-weighted, and adjust shutter speed to provide best exposure of the most important part of the scene. Use this setting for all pictures in the series.

• Conduct a dry run of the framing sequence from left to right, overlapping each take by about 33 percent. For more resolution and less distortion, shoot the segments in vertical format. (You can vary the amount of overlapping from one frame to the next.)

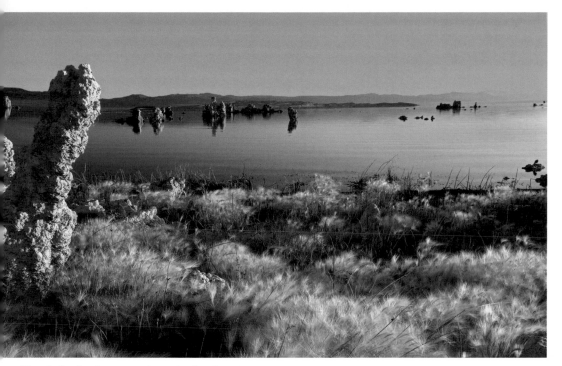

Tufa formations at Mono Lake, California (left). It is especially important to level the camera when working with a wide-angle lens, as was used for this image. I planned the series to keep key scenic features (the tufa formations) away from the seams (the edges of individual frames). Mamiya 645 AFD with Phase One P 25 digital back, Mamiya-Sekor 35mm f/3.5 lens, Singh-Ray polarizing filter + one-stop ND filter, ISO 100, f/16 for 1/8 second.

Software Sources
Internet users can download numerous stitching programs. Many offer a no-charge trial period from several days to several weeks. A simple program that can stitch high resolution images together in a single-line sequence is inexpensive and adequate for most nature photography purposes. Here are a few leads.
- *Both Photoshop CS and Photoshop Elements have stitching programs (simple, but they often can't handle wide-angle capture segments).*
- *Panorama Maker (free trial download), www.arcsoft.com/ en/products/panoramamaker/ (simple and reliable).*
- *For more information on the panorama world in general go to www.panoguide.com.*

Use distinctive features to keep the framing process correctly oriented. Avoid placing critical areas on a seam. Two to five frames usually suffice.

• Once all is rehearsed, make the series of images quickly to minimize cloud movement and changes in lighting conditions between adjacent captures.

BACK ON THE COMPUTER

Most stitching programs are simple to use. You are first prompted for basic information such as the panorama's orientation (vertical or horizontal), picture quality (for print or Web use), lens focal length, output format (TIFF, JPEG, etc.) and auto-exposure correction (yes). Once this is done, you import the photos from your hard drive, place them in the correct order in the stitching production line and process the image. A few minutes later up pops your masterpiece. If areas fail to match up, most programs allow you to manually correct trouble spots and reprocess. Further refining of the panorama as a whole can be carried out in image editing applications like Photoshop.

So widen your horizons and get shooting!

Captivating Clouds

Dynamic landscape imagery hangs in the air

Hellroaring Plateau, Beartooth Mountains, Montana. *Even an ordinary patch of terrain can yield dramatic images under suitable cloud and lighting conditions. Mamiya 645 AFD with Phase One P 25 digital back, Hartblei Super Rotator 45mm f/4.5 lens, Singh-Ray one-stop ND filter, ISO 100, f/16 for 1/4 second.*

Bringing clouds or their effects into the composition is often my primary concern when shooting landscapes. Without clouds, terrain features are starkly modeled with dense shadows robbed of detail, skies lack contrast and character, and sunsets and sunrises are bleached of attractive color. Clouds almost ensure your chances of producing images both dramatic and distinctive, regardless of how many times the scene has been photographed before. As a general rule, skies filled with scattered clouds provide the best opportunities. Here are ways you can use clouds to add zing to your landscape imagery.

As Subjects

At sunset or sunrise clouds may put on a showstopping display of color and form that supersedes all other features before the lens. This high drama is foreshadowed by a buildup of thick cloud (not cirrus) and an area of clear sky at the meeting place of sun and horizon. The fiery hues are best presented by framing that includes token terrain features to add contrast and scale to the composition. If features are silhouetted by backlight, be sure to take a spot-meter reading of the clouds alone. To avoid underexposure of the land in sidelit or frontlit

situations, neutral density filtration or Photoshop (see page 170) will be needed to reduce sky brightness.

AS TERRAIN ENHANCERS

For most landscape photos, clouds, even spectacular ones, are used as counterpoints to the terrain itself. In this event, remember to run the horizon through the picture space approximately one-third from either the bottom or top of the frame. Try to compose the scene to include the best combination of interesting clouds and eye-catching landforms. If shooting under sidelight, a polarizing filter will improve contrast between clouds and sky.

AS SPOTLIGHTS

Broken cloud formations channel sunlight onto landforms for theatrical effects. Timing and preparedness are your best assets when striving to capture a towering terrain feature in the spotlight. Be patient, frame the scene for the strongest composition, set focus and depth of field and be ready to shoot when light flows onto the scene. Once the decisive moment arrives, take a quick spot-meter reading of the land featured in the sun's main beam and fire off a series of bracketed exposures.

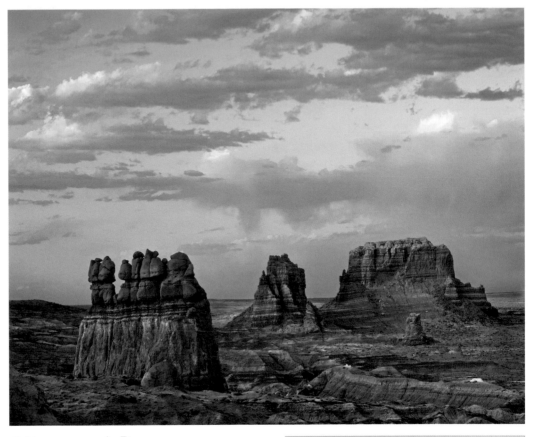

AS DIFFUSERS

Clouds soften the sun's illumination for improved detail in shade and highlight parts of the scene. Broad stretches of wispy cirrus best reveal topographies with varied relief, lighting up peaks and precipices for emphasis while throwing enough light into canyons and valleys for an appreciation of scale and a comparison of terrain. If skies are overcast, I put aside photographing the

Filters Bring out the Clouds
Hazy/cirrus days—blue/gold polarizing filter
Cumulus or nimbus—polarizing filter (+ sidelight)
Stratus banks—one-stop split neutral density filter
Sunset/sunrise clouds—split neutral density filters

Molly's Castle from Goblin Valley State Park, Utah (above). *Clouds not only affect light quality (almost always for the better), they add attractive features that balance the composition while dramatizing the landscape setting.*

Rendezvous with Clouds
Partly cloudy skies are your best bet for compelling scenics. Historic weather patterns are the basis for being at your shooting destination when clouds are also there. In the desert Southwest, for example, summer monsoon season offers a reliable parade of afternoon thunderstorms. Winter in the Pacific Northwest, by contrast, is typified by completely overcast skies lasting weeks at a time. This Internet site, www.ncdc. noaa.gov/oa/climate/online/ ccd/cldy.html, will brief you on seasonal cloud conditions continent wide. More immediate planning should place you on scene during periods of unsettled weather or when storms are gathering or clearing. For these forecasts and reports, consult an internet news site such as CNN (www. cnn.com).

Mount Dana, Mount Gibbs and Mammoth Peak from Tuolumne Meadows, Yosemite National Park, California (right). *Keeping an eye on the horizon where the sun will rise/set, as well as the clouds above potential target landforms, will help you anticipate the show of color and light and place you in the right place at the right time.*

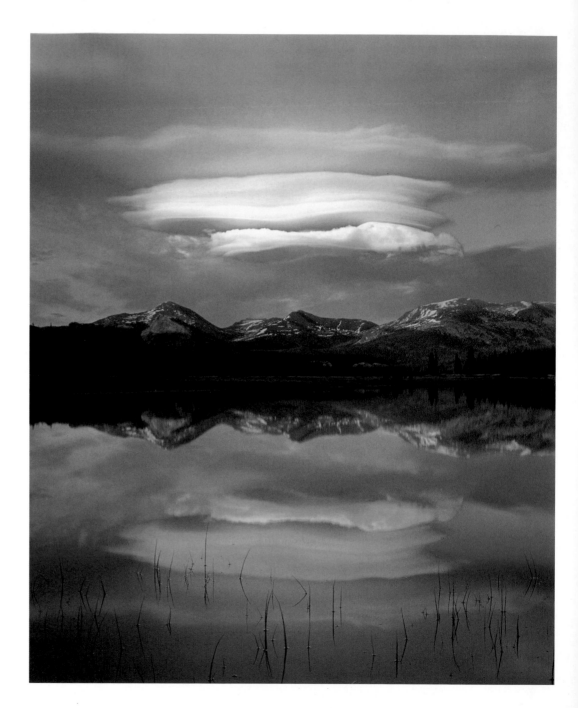

landscape as the scene will lack depth, terrain will appear flattened and key features of the composition will lose emphasis.

As Reflectors

Beautiful reflected effects occur when the sun projects its light from just below the horizon onto a low rumple of cumulus or nimbus to be bounced soft and warm onto the landscape. To the untrained eye, the dimness of such scenes belies their photogenic properties. Expect exposure times lasting from one-quarter second to a minute or longer depending on the f/stop chosen and the sensitivity of the capture medium.

As Atmosphere

Fog and mist create appealing atmospheric effects. They define beams of sunlight as it streaks over and through features of the landscape. For best results, position yourself to catch the scene under backlight from a sun resting low over the horizon.

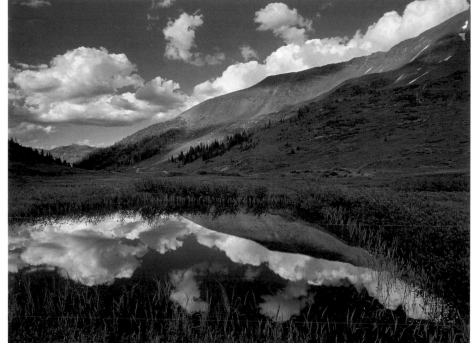

With fog it is possible to include the sun itself in the frame without risking blown-out highlights or lens flare. Fog and mist emphasize depth by accelerating the reduction of clarity in landscape features as they recede into the distance.

So keep your eyes on the clouds and work to incorporate them and their effects into your landscape imagery when possible.

Mount Baldy and Elk Mountains from Paradise Divide, Colorado (above). Here clouds softened the mid-afternoon light and reduced contrast enough for the sensor to record good detail and color in both highlight and shadow areas.

South Llano River State Park, Texas (left). Fog reduces scene contrast (here working as a diffuser and neutral density filter on the sun) and adds atmospheric accents to landscape settings.

Part Five

The Digital Landscape

From Field to Studio
Hardware and software for digital field work

Photographers shooting digital images require equipment additional to the standard camera/lens/tripod kit. On forays lasting more than a day, you need a storage device to clear compact flash (CF) cards for subsequent photo sessions. You also need a computer with image editing software so that you can process, edit and prepare images for printmaking, Web publication and other uses. This section provides basic information for the beginner on professional equipment and procedures.

IMAGE STORAGE IN THE FIELD

Your camera's first level of storage is the in-camera compact flash card. For landscape shooters, who rarely use the motor-driven bursts common in wildlife photography, the best sized cards are in the two or four gigabyte (GB) range (not larger). One card is enough to handle a half-day of steady shooting, provided you delete mistakes as you go along. You can off-load images during the normally quiescent midday period. By carrying a larger number of smaller capacity cards, you don't put all your eggs in one basket and have better protection against catastrophic loss.

Once a CF card is full, you need to clear the captures to a larger storage device. You can off-load files directly to a laptop computer with hard drive capacity or to a stand-alone image tank (a specialized hard

Botanical Beach at low tide, Vancouver Island, British Columbia (below). Although this photograph was recorded on film, once scanned it can be corrected and modified using standard digital imaging techniques.

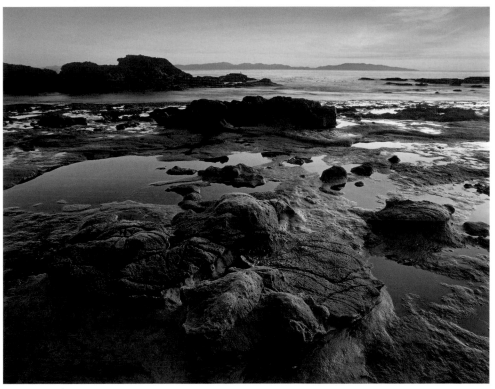

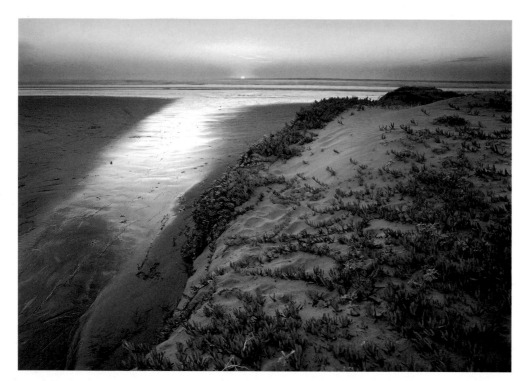

tank for downloading. This approach leaves your entire shoot at jeopardy should the portable drive be lost or damaged, not to mention the battery challenges.

PORTABLE DRIVES

If you are working without a laptop, you need an image storage drive that will allow downloading directly from the CF card. These devices have built-in card readers and simple LCD menus for initiating and monitoring transfers as well as indicating remaining capacity and battery level. Most are equipped with AC and DC hookups and use lithium ion rechargeable batteries. Capacity ranges from 20 GB and up—plenty for a week of backcountry shooting, provided you have enough battery power (about 10 GB of download per charge).

Sunset, Morro Strand State Beach, California (below). A 2 GB compact flash card can record about the same number of high resolution images as two 32-exposure rolls of medium format (645) film. In practice, flash card capacity is even greater because exposure bracketing is not necessary and you can delete inferior imagery from the card as you go along.

drive with a photo storage chip). Ideally, you want both so that your images are recorded in two places should data be accidentally lost from one of the devices. As most scenic shooters have end-of-day access to an AC power source (lodging or vehicle equipped with a DC/AC power inverter), a laptop with peripheral hard drive backup is standard. If you are on an extended shoot with no access to AC power, it's best to pack enough CF cards for the trip. Two gigabytes per day should be sufficient if you delete unsatisfactory images in-camera as you go along. More economical but weightier and riskier are one or two CF cards and a portable, battery-powered image

Digital Tailgate Studio

Laptop computer
(Apple iBook)

Extra hard drive
(Firelite 60 GB)

CF card reader with
Firewire cable

This standard system provides on-the-road Photoshop, plenty of storage and backup security. This portable hard drive conveniently draws power and data from the computer via a Firewire cable. The computer may be plugged into the vehicle's cigarette lighter using an inexpensive DC/AC power inverter.

If you only need backup storage for your laptop computer, any external hard drive will do. For traveling, smaller is always better, and drives that draw both their power and data from the computer via a Firewire or USB cable are the most convenient. A variety of lightweight units is available.

COMPUTER AND SOFTWARE

Post-shooting work begins once the image data is placed on a computer's hard drive. This is where the image is processed (transformed from the camera's proprietary file formats (RAW) to standard TIFF, PSD or JPEG formats that can be adjusted with image processing software and read by other computers. You can tune color balance and saturation, brightness and contrast, dodge and burn, remove imperfections, straighten horizons and make hundreds (if not thousands) of other manipulations with speed and accuracy (see subsequent sections). The standard and best image editing software is Adobe

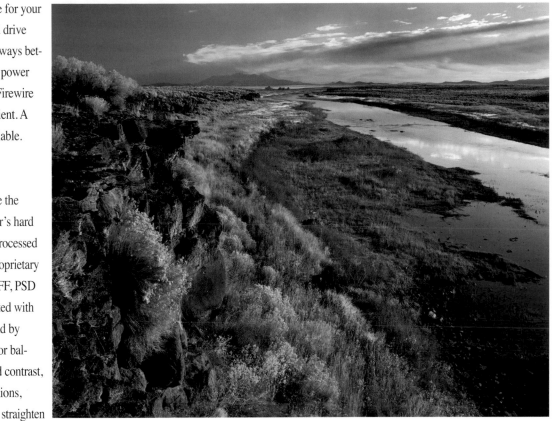

Photoshop (in full or limited versions). There is not much difference in computer brands or platforms, Apple, Dell and Hewlett-Packard being prominent. Due to the large amount of data in a color image, get the fastest processor you can afford, at least one GB of RAM and two high capacity hard drives, one for immediate storage and the other as backup (500 GB minimum/drive). For additional security, you should archive your collection on DVDs or a third drive.

Calibrating Your Monitor
A calibrated monitor is essential for accurate color processing and publication. Monitor performance changes with time, requiring calibration touch-ups about once a month.
• For Windows use Adobe Gamma Utility, found in the Control Panel.
• Mac users go to System Preferences > Displays > Color. More accurate calibration, available through third-party software, is recommended.

Rio Grande and Sangre de Cristo Mountains, Colorado (above).
Adjusting digital color balance, saturation and contrast is based on a consideration of the original RAW file, how you remember the scene and what seems natural. Mamiya 645 AFD with Phase One P 25 digital back, Mamiya-Sekor 35mm f/3.5 lens, Singh-Ray polarizing filter, ISO 100, f/16 for 1/15 second.

The Digital Workflow

Step-by-step from capture to storage

Pedernales Falls, Pedernales Falls State Park, Texas (below). Far from a point-and-shoot exercise, waterfall subjects like this one require special consideration of many of the technical aspects of image making—shutter speed to interpret the moving water, aperture to establish depth of field and exposure to capture detail in both the sky and dark forests.

The advanced automation of a digital SLR makes it easy to pick up and start shooting with no need to set focus, shutter speed or aperture. At the same time the sophistication and complexity of its image recording capabilities require serious photographers to make systematic checks of the many functions to be sure the artistic and technical requirements of the target image will be satisfied. Following are the basic procedures you need to apply to the digital process to ensure consistently good results.

BEFORE LEAVING HOME
• Check batteries of your camera, laptop and portable storage devices. Full batteries will lose power even when not used.
• Conduct memory card maintenance. Off-load valuable images to storage and reformat the cards. Test reformatted cards in the camera.
• Test fire camera at the settings you use most frequently to make sure nothing has gone awry since your last shoot.

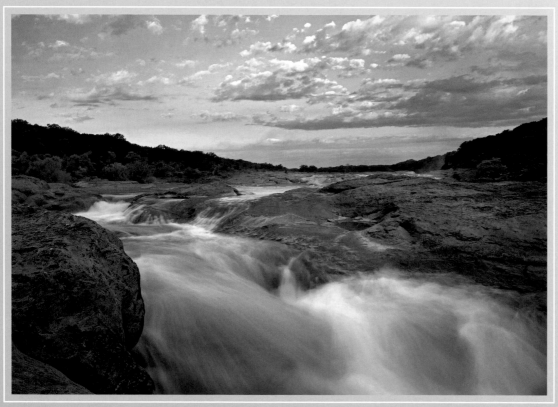

• Check and clean the sensor. Take a photo of the sky then scroll through the image at high magnification looking for crud. If need be, clean sensor according to manufacturer's directions.

• Input basic camera settings:

1) White balance for JPEG only

2) ISO level (set at 400 for no-noise)

3) Exposure mode (aperture priority)

4) Stabilizer mode (off for tripod use)

5) Picture style (landscape)

6) Image format (RAW for best quality)

7) Image size (maximum)

8) Color space (Adobe RGB)

9) Mount your most useful lens (wide-angle zoom)

• Organize your camera bag/vest. Make sure you have all the necessary cameras, lenses, filters, batteries, storage cards, repair tools, cleaning supplies and other items you may use (GPS, etc.).

• Check your laptop, card reader and storage devices.

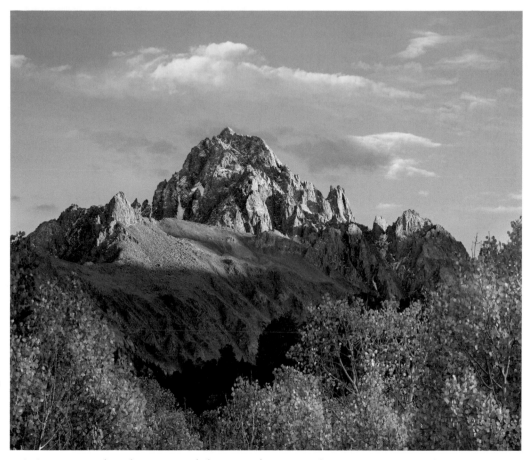

IN THE FIELD

If your preparations at home were thorough, you should enjoy a glitch-free shoot despite the distractions of a new setting and the need to concentrate on issues artistic rather than technical. Follow these steps for a few sessions and they will become routine.

• Position tripod and mount camera.

• Recheck all of your camera settings, modifying those that may not suit the current circumstance (e.g. lens choice, aperture, ISO, metering mode, etc.).

• Make a series of exposures, checking the LCD for satisfactory results. Adjust and reshoot.

• Review the images, deleting those that are badly focused, poorly exposed or ill-conceived.

• Store full CF cards in a secure shirt pocket.

• When done shooting remove the CF in the camera and put it with the other full cards.

• Back up CF cards to computer hard drive or

Mount Sneffels, Colorado. It takes a lot of effort, good timing and a bit of luck to capture beautiful subjects. By making sure all of the technical and logistic issues are fully addressed, you can give full attention to the creative aspects of picture taking. Canon 5D Mark 11, Canon 70–200mm f/4 L lens, Singh-Ray polarizing filter, ISO 400, f/11 for $^1/_{125}$ second.

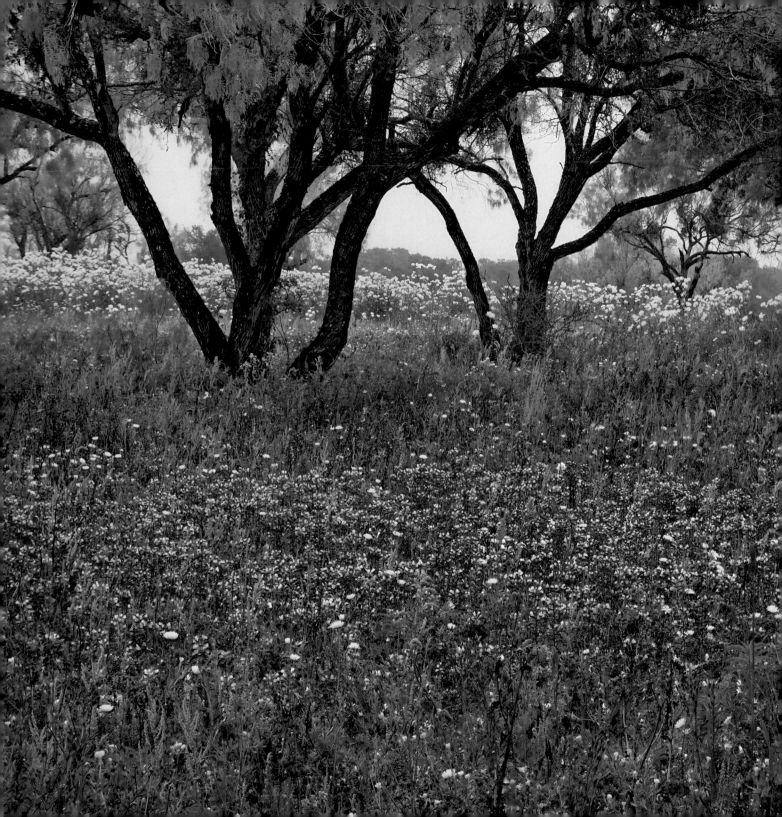

portable storage drive at the first opportunity. Don't clear the cards until you have a second back-up.

AT THE STUDIO COMPUTER

• Create storage folders for the incoming images. You will need one folder for RAW images that will be archived and one folder for processed images that will be edited in Photoshop. The latter may have sub-folders to help organize the files (e.g. Grand Canyon Above Rim, Grand Canyon Below Rim, etc.)

• Import the image files from the CF cards to the folder labelled RAW images using your camera's browser/import application on your computer.

• Back up the RAW files to a high capacity hard drive or burn them to a DVD storage disk. These disks are stable and currently the safest way to archive photos although they take more time and work.

• Do a basic correction of the RAW photos in your browser as you select images for processing. Make simple corrections to cropping, exposure, contrast and color balance. (All or more complex editing can be done subsequently in Photoshop.)

• Process the selected /corrected images, saving them to the appropriate folders.

• Back-up the processed image folders to a separate hard drive.

You are ready to finish your captures in Photoshop or another picture editing application. An outline of basic Photoshop adjustments begins on page 180.

Wildflowers near Pleasanton, Texas.
The explosion of wildflowers in the Hill Country in 2010 was a singular occurance. By developing a routine workflow, you ensure that you're able to capture the images you want and keep them safe.

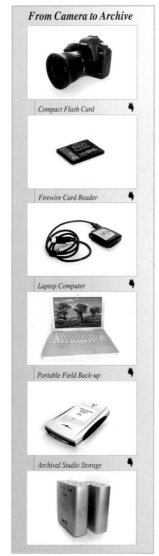

From Camera to Archive

Compact Flash Card

Firewire Card Reader

Laptop Computer

Portable Field Back-up

Archival Studio Storage

The LCD Monitor

Picture making headquarters in the field

The LCD (liquid crystal display) monitor is almost like having a mini-computer with hi-res screen built into your camera. No, you can't edit a photo that you have taken, but you can evaluate your captures instantly in detail, delete the ones that are flawed and take replacement images in the wink of an eye as you go along. The LCD is the most useful tool for improving your photography and getting the photos you want first time out. Here's a rundown of its various functions and how to work them.

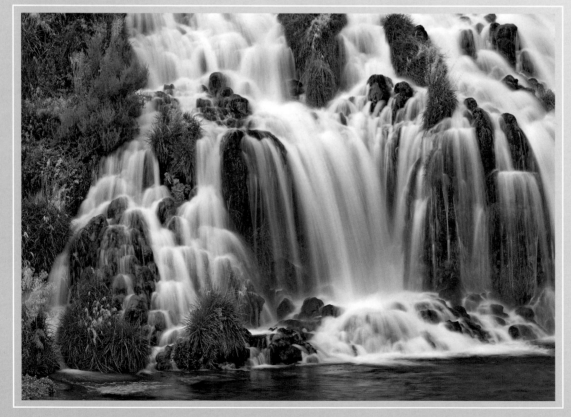

NAVIGATION

It's easy to access the various features of the LCD. All your camera settings can be displayed and set here by navigating through the different menus. One dial is used to select the menu, a second dial to select the menu item and then a button is pushed to choose the menu item option. Once your camera settings are made, your primary work on the LCD will be reviewing the images you have taken.

On most cameras, you activate picture review by pushing a button marked with a solid

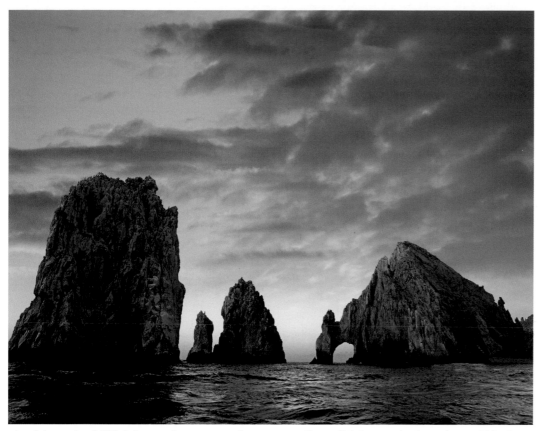

El Arco, Cabo San Lucas, Baja, Mexico (left). Sharpness is a key component of every image. Most of the time we want the scene to be rendered with as much detail as possible. The LCD makes it possible to zoom in to check sharpness at high magnification. I was especially uncertain about the sharpness of this scene captured with handheld camera from a rocking boat. Canon 5D Mark 11, Canon 24–105mm f/4 L lens, ISO 400, f/11 for 1/125 second.

Waterfalls at Niagara Springs, Idaho (far left). The success of this image comes from the soft and silky texture of the water, a design element dependant on shutter speed. The LCD made is easy to evaluate results on the spot and modify exposure times accordingly. Canon 5D Mark 11, Canon 24–105mm f/4 L lens, Singh-Ray polarizing filter, ISO 100, f/16 for 1/2 second.

triangle/arrow head. This brings up the most recently made image and then you can scroll through the captured inages using a thumb dial. Another button, usually marked "Info" can be used to toggle through the diffent methods of reviewing the photo, including a complete listing of the camera settings (ISO, lens, format, image size, etc.), exposure and sharpness.

Review Time

In the menu, set the LCD review time to maximum or even to "hold"which keeps the screen lit up until you slightly press the shutter button. This gives you unrestricted time to evaluate your images, an important task not to be rushed.

Brightness

Set this for maximum. It can be difficult to see the screen expecially under direct sunlight. Get used to peering at the screen under the shade of a hat brim, your cupped hand or shadow of your body. You can buy hoods that help viewing but they're a chore to attach and they add to the bulk of your camera/tripod

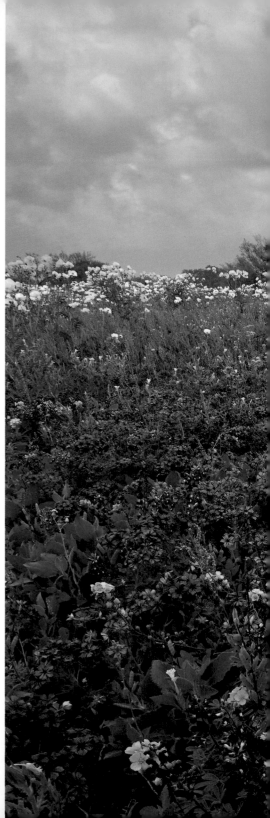

Pointed phlox meadow, Atascosa County, Texas. *The highlight alert feature of the LCD indicated that the sky in this scene was too bright for the sensor to capture. To bring it into range, I placed a graduated neutral density filter on the lens which lent the necessary density to the sky.*

package that can be a drawback when moving through dense brush.

IS IT SHARP?

You needn't guess about sharpness. Want to know if your shutter speed was fast enough to stop the wings of a hovering gull or if your lens is showing too much diffraction at f/32? Check it on the LCD. Most cameras have special buttons for viewing your captures at high resolution. Just punch in the maximum magnification and then scroll through the image looking for trouble spots. Reshoot as required.

HIGHLIGHT ALERT

This feature makes areas of over-exposure blink on and off. It's a little distracting but an over-exposed highlight is lost forever; it's essential to capture all the detail the scene has to offer. Highlight alert tells you exactly where over-exposure problems occur and if they can and should be corrected by filtration, framing adjustment, concept shift or exposure bracketing and computer compositing.

LIVE VIEW

Some cameras offer a live view of what the lens is capturing. It's like having a video screen for your

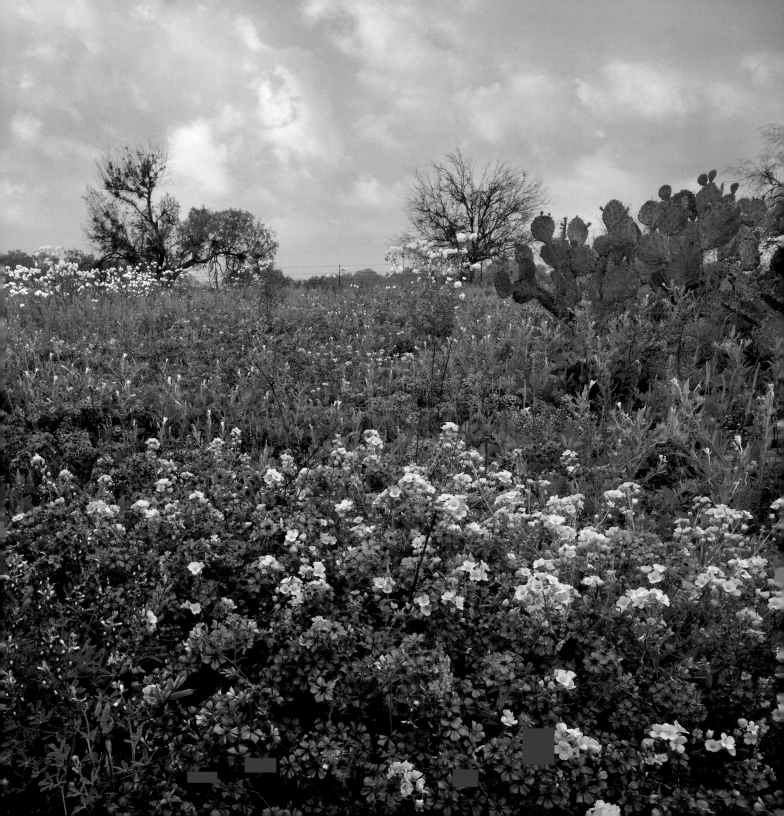

Gulls at El Matador State Beach, California (far right). I made a rapid series of captures then checked the LCD to see how the gulls fit into the design. I kept this take and trashed the inferior ones to save room on the CF card.

Twilight at Cape Haro, Sonora, Mexico (below). This high contrast scene was recorded by a quick series of trial and error exposures while referencing the LCD histogram. Tonal values of the best take were further adjusted in Photoshop.

viewfinder. Whatever you point the camera at shows on the screen in real time. If possible activate both the live view LCD and the standard TTL viewfinder. Use the viewfinder for critical focusing and placement of depth of field. Live view presents the image much as you would see it in a gallery or calendar and so is ideal for judging composition and overall impact of the scene.

The Histogram

The histogram is normally the first item of busi-ness once you make a capture. This handy feature graphs the exposure values of the image. Dark tonal values are shown on the left side of the graph, light tonal values are shown on the right side. Dark forests will have high humping on the left, snowy scenes will have high humping on the right. Because your light meter thinks everything is neutral, your first exposure will tend to be humped in the center, result-ing in gray snow or a coniferous forest brighter than normal. This is the time to make an additional expo-sure or two with the necessary corrections.

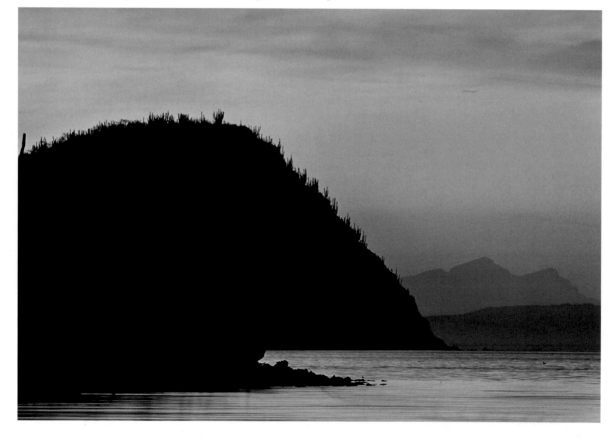

Ideally you will capture all the tonal data in the scene. If you succeed the graph will taper off on both ends and the histogram will show no data at its extreme edges (see illustrations on pages 58 and 165). If even after exposure compensation, you are unable to fit all the scene's tones onto the graph, you need to use a split neutral density filter (see page 62) to reduce scene contrast. Alternatively, you may

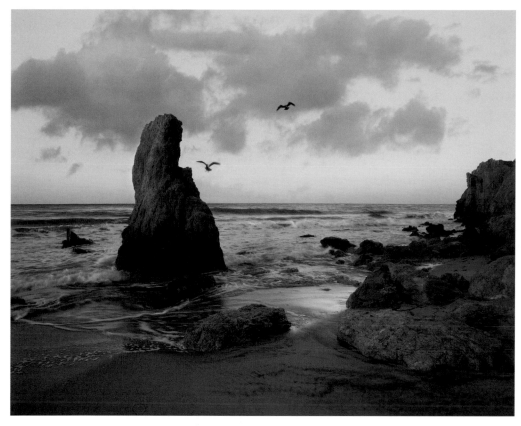

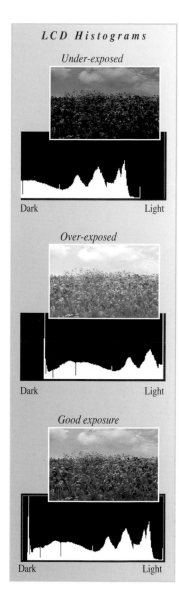

LCD Histograms

Under-exposed

Dark Light

Over-exposed

Dark Light

Good exposure

Dark Light

choose to increase or reduce exposure and take an extra photo or two dedicated to capturing the missing data (usually highlight or shadow areas). Afterward you can combine the best parts of each exposure in Photoshop or another image editing application (see page 170).

FULL SCREEN FOR COMPOSITION CHECK

Toggle through the LCD screen options to see your photo at simple full screen view (no text overlay or peripheral data). This is the best way to check your composition for balance, lighting, distractions and other design considerations.

DELETE / ERASE

Your LCD allows you to review and dispose of unwanted captures—bad exposures, poor focus, cluttered compositions. When the action slows, tidy up your compact flash card. It will reduce editing time in post processing and prolong the time before putting in a new card.

Setting White Balance

Get the best color version when shooting JPEG

Coco Palms at Hinawnan Beach, Island of Bohol, Philippines.
This scene was recorded several minutes after sundown in the violet and magenta tones of twilight. A preset white balance (daylight) was selected in order to retain the rosy palette of sunset.

The sun emits a different color of light than does an incandescent light bulb, candle, TV screen or florescent tube. Furthermore, the reaction of the subject to these colors of light generates varying impressions on the camera sensor. An autumn leaf illuminated by the sun is recorded differently than the same leaf lit by moon light or a flashlight. Our eyes make automatic adjustments to these changes and we seldom notice a shift in color values. But a camera does.

To achieve images with pure, clean colors that accurately record the scene at the time of capture, we make sure that the camera is adjusted for the color of the light (called setting the white balance). When shooting JPEG files, you need to set the white balance in the camera prior to shooting. For RAW captures, color balance is done during RAW conversion and/or in Photoshop.

Light color is described by its so-called color temperature (measured in degrees Kelvin), a term derived theoretically from the color of light given off by a black body radiator

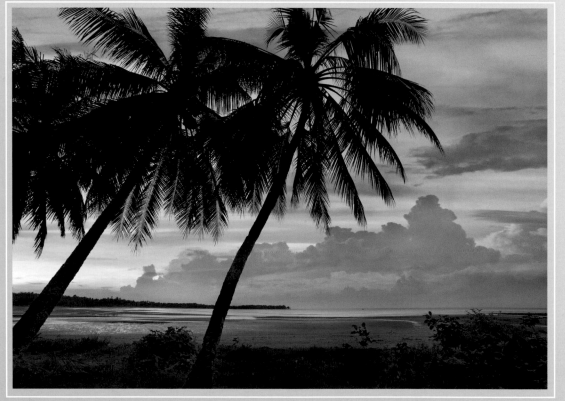

(think of a lump of coal) as it is heated. The hotter the radiator becomes, the cooler the light given off. When it glows red or is "Red" hot, the temperature is lower than when it glows white or blue. For general reference it is enough to know that the warmer the light (from a candle or sunset for example) the lower the color temperature (2,000–3,000K) and the cooler the light (from a clear blue or overcast sky) the higher the color temperature (up to 10,000K).

Generally landscape photographers shoot under but a handful of conditions: sunset/sunrise, overcast, open shade (as in the shadow of a mountain), twilight and midday. To record these conditions accurately in the camera, we need to set the white balance (the sensor's color profile) to render a white object as pure white with no contamination from other colors. Most digital SLRs offer these white balance options.

AUTO WHITE BALANCE

You might think selecting this option takes all the

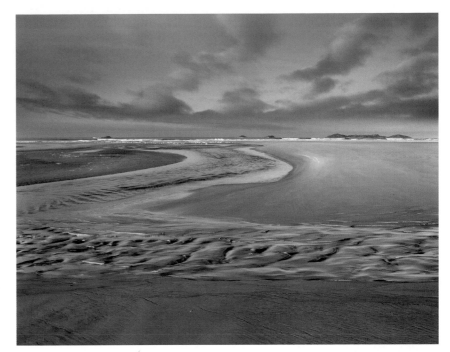

worry out of setting white balance. Unfortunately, auto white balance doesn't work reliably, especially for landscapes. It wants to record all scenes as if they were shot under midday skies. So if you were hoping to record the sumptuous colors of a sunset, you will be disappointed; the mood will be much subdued, whites will be clean and neutral rather than tinted in gold and bronze. Auto white balance is also fooled by scenes that are dominated by one color, such as the red of an autumn maple forest. In such a case, auto white balance will tune out the red bias in its desire for pure white and rob the scene of its distinction.

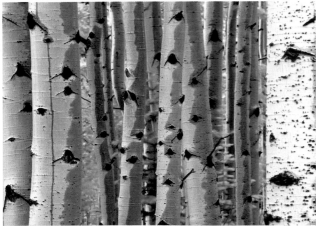

Comber Beach, Pacific Rim National Park, British Columbia (above). RAW file captures will not be altered by white balance settings which only affect JPEG captures. RAW color adjustments must be made with the RAW conversion software of your camera during processing or with image editing software such as Photoshop after processing.

Aspen trunks, Vancouver Island, British Columbia (left). The verdent spring tints that distinguish this image are best recorded using a preset white balnce configured for cloudy days. Auto white balance would calibrate the color space to produce a warmer, more neutral palette.

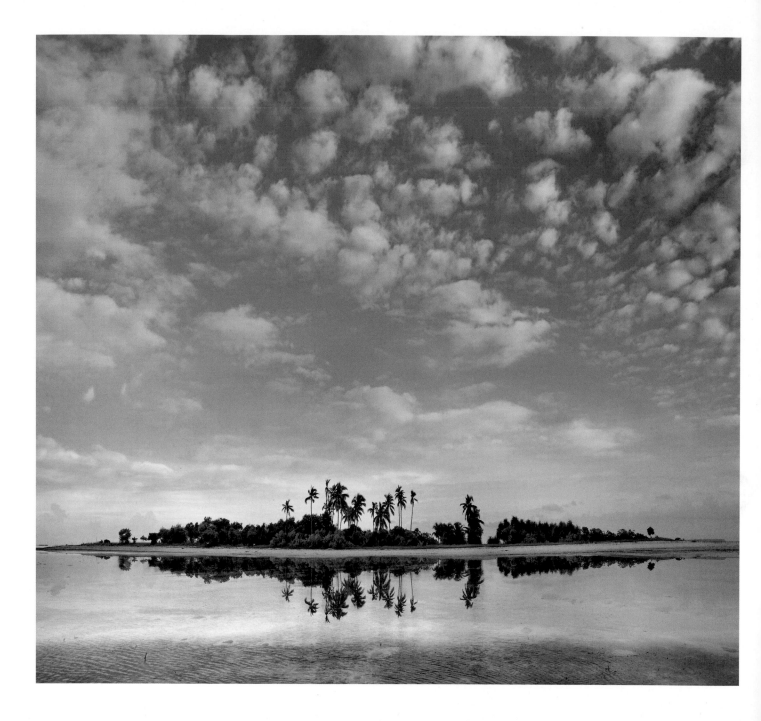

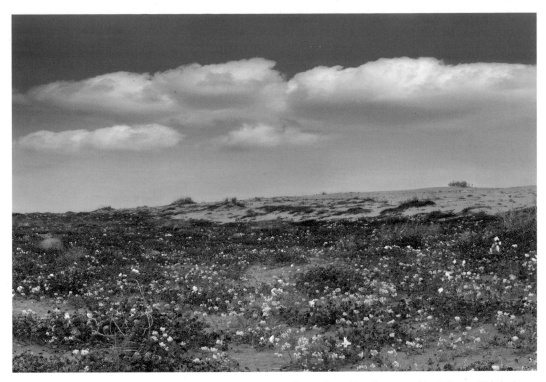

Virgin Island, Bohol, Philippines *(far left). Although this was a sunny blue sky day, the island was shaded by a cloud. The easiest procedure was to make the capture using a preset daylight white balance and then warm up the colors of the island selectively in post processing. Canon 5D Mark 11, Canon 17–40mm f/4 L lens, Singh-Ray polarizing filter, ISO 400, f/11 for 1/200 second.*

Imperial Sand Dunes, California. *(left). A broad and even mix of colors under blue skies makes this scene well suited to selecting a preset daylight white balance. In addition, you could easily make a custom white balance by taking a close-up reading from an expanse of cloud. Tonal values for this image, especially in the sky region, were adjusted in Photoshop to achieve consistant density throughout. Mamiya 645 AFD with Phase One P 25 digital back, Mamiya-Sekor 55–110mm f/4.5 lens, one-stop split ND filter, ISO 100, f/16 for 1/60 second.*

CUSTOM WHITE BALANCE

Top of the line cameras may offer this option. Here you create your own white balance by taking a reading off a neutral subject, usually a photographic white or gray card. This option is useful mainly for catalogue or advertising shooters who must maintain consistant color over a large number of captures. Like auto white balance it will neutralize dramatic lighting situations, particularly late and early in the day.

PRESET WHITE BALANCE

Most digital SLRs offer preset white balance options (florescent, light bulb, flash, etc.) that work better than using the auto white balance. This is the best approach for landscape shooters who usually avail themselves of the following presets:

• Daylight. You will most commonly use this option. It will keep your sunsets glowing warmly and produce natural effects under sunny skies.

• Cloudy/Shade. This setting will retain the warm tints in subjects captured on cloudy days or in the shade. In these conditions, the "daylight" setting will result in a blue cast.

White balance presets will net you excellent quality color that can be further refined in Photoshop.

High Dynamic Range
Capturing detailed highlights and shadows

Red Mountain at Gray Copper Gulch, Colorado. *Sunny midday conditions create subject contrast that is beyond the sensor range of many cameras. Although you can restrain the density of the sky with split neutral density filters, the localized shadows will remain blocked unless the image is captured and processed using high dynamic range (HDR) techniques as was done here.*

Most digital sensors are incapable of capturing the full range of light and dark tones in high contrast lighting situations, midday under clear skies being the most common scenario. To get around this drawback you need to make a range of exposures that captures the full span of light values and then combine the best of these pixels in one image. The common way of doing this is in Adobe Photoshop using the Merge to HDR (high dynamic range) feature.

HDR IN THE FIELD

When making a capture sequence intended for HDR treatment, try to get impressions that place the lightest and darkest regions of the scene in the middle of the histogram— usually 5 or 6 two-stop brackets are adequate to span the scene. Shoot on manual and vary the shutter speed (not the aperture) to avoid altering the depth of field from shot to shot. Turn off autofocus for similar reasons. Shoot from a tripod and trip the shutter with a remote release to avoid jarring the camera and misaligning the captures.

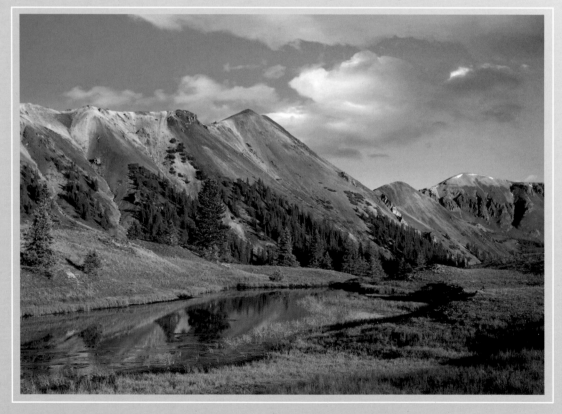

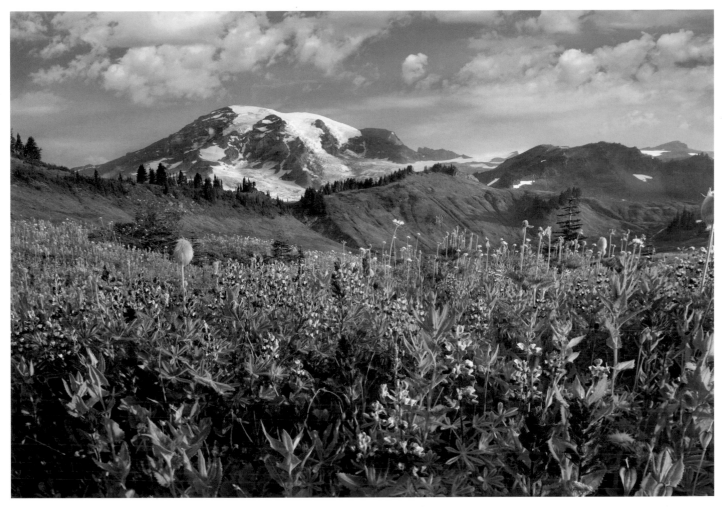

Scenes that have moving elements will have ghost images once processed. These may be difficult to eliminate. Try to make the series quickly and under stable lighting conditions.

HDR AT THE COMPUTER

Simply open Merge to HDR in Photoshop (File > Automate > Merge to HDR) and import the series of images. Experiment with the various options, previewing the results before you begin the merging process which can be time-consuming depending on computer speed. There are lots of HDR blog sites with tips for selecting and implementing appropriate options depending on the scene type.

Paradise Meadows and Mount Rainier, Washington. A snowy mountain scene under sunny skies is normally beyond the range of the sensor. By taking a sequence of varied exposures that cover the full range of tones and then combining them in Photoshop, you can record detail throughout the frame.

Bracketing Exposures for High Dynamic Range (HDR) Compositing

 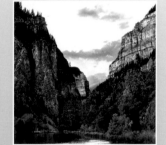 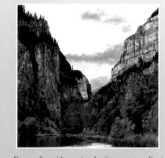 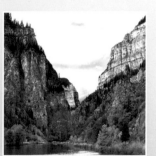

Expose for highlights (meter reading - 4 stops) Expose for midtones (meter reading - 2 stops) Expose for midtones (evaluative meter reading) Expose for shadows (meter reading + 2 stops)

MAKING SIMPLE COMPOSITES

It's easy to make simple composite images manually. When photographing scenes, the terra firma part of the composition often can be captured within the sensor range (about 6 stops) but the sky is much too bright. Without altering framing, make one capture for the land and another for the sky. You can judge the exposure effects accurately enough by reviewing the results on your camera's LCD screen. Once you have both files in Photoshop, you will find it a relatively easy matter to select the blown-out sky from your base image, feather the edge a bit and then paste the properly exposed sky in its place. The results tend to look more traditionally photographic than images created in Photoshop HDR which can sometimes look painterly or even cartoon-like.

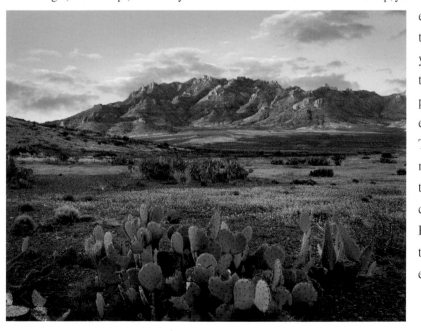

Glenwood Canyon, Colorado. With its deeply shaded canyon walls and bright sky this scene cried out for HDR treatment. Four captures, monitored with the histogram, covered the range of tones. The water's glinting reflections required minor touch up in Photoshop. Canon 5D Mark 11, Canon 24–105mm f/4 L lens, ISO 400, f/11 for 1/2 to 1/125 second.

Florida Mountains, Rock Hound State Park, New Mexico (left). Two exposures were made: one captured the full range of tones of the land and the other took care of the sky. Framing remained constant to facilitate compositing in Photoshop. The properly exposed sky component was selected and pasted into the landscape capture. This technique preserves the natural relationship of local tonal values, particularly regarding contrast.

Sharpness Front to Back
How to extend depth of field while avoiding diffraction

Georgian Bay, Killarney Provincial Park, Ontario. *Depth of field was carefully positioned to make sure all components were sharply rendered, easy to do with this framing because the foreground elements were not greatly magnified. Pentax 645NII, Pentax 45–85mm f/4.5 lens, one-stop split ND filter, digital scan from Fujichrome Velvia, ISO 50, f/16 for 1/30 second.*

One of the biggest headaches for landscape photographers is getting everything recorded in fine detail. Although small apertures deliver lots of depth of field, they also result in soft images due to diffraction (the random scattering of light rays as they pass over the edges of the diaphragm blades). Because smaller apertures have a higher edge-to-picture area ratio, they are not as sharp as photos made at larger apertures. So how do you attain full depth of field without losing sharpness to diffraction?

IN FOCUS SOFTWARE

The solution is to make a sequence of captures at decreasing focal distances using your lens' sharpest aperture and then combine only the in-focus regions using software such as that provided with Photoshop CS4 (File > Automate > Photomerge),

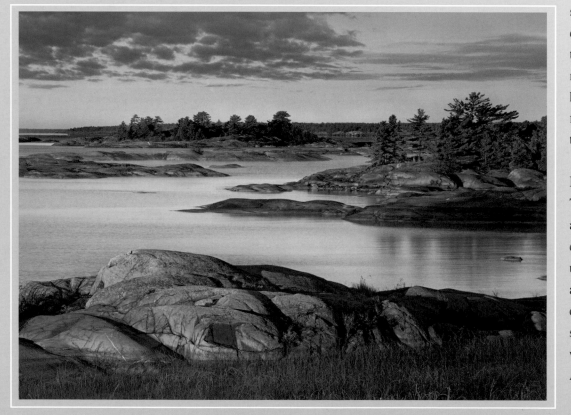

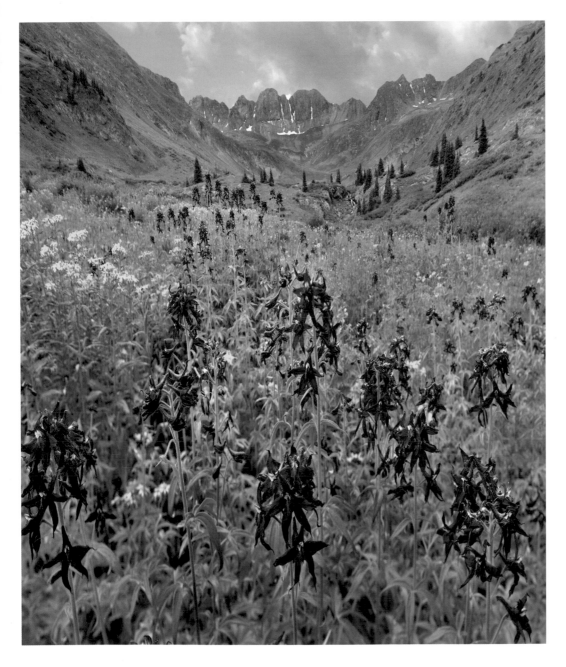

Purple larkspurs at American Basin, Colorado. *The front to back sharpness in this image was achieved by tilting the depth of field to match the subject plane using a tilt/shift lens. Even so sharpness was not sufficient to encompass all the picture elements, evidenced by the soft focus in the vegetation immediately behind the foreground blooms. Using a smaller aperture would have yielded more depth of field but also more softness over-all due to diffraction. Focus merging software would be needed to achieve full depth of field at the lens' optimum aperture. Canon 5D Mark 11, Canon 24mm f/3.5 TS-E L lens, 2-stop neutral density filter, ISO 400, f/11 for 1/88 second, tonal values adjusted in Photoshop.*

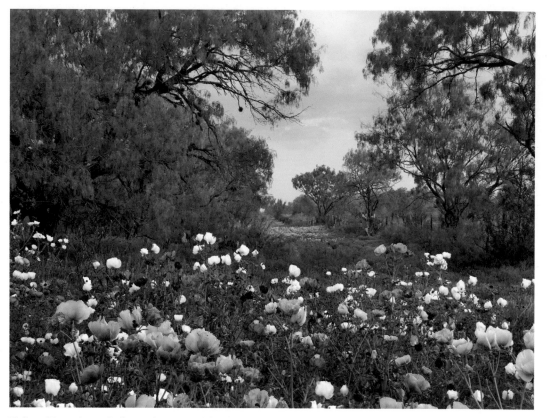

Helicon Focus (www.heliconsoft.com) and Combine ZM (hadleyweb.pwp.blueyonder.co.uk). The software made by Helicon Focus completes the blending process with little or no need for retouching.

SHOOTING THE PARTS

Generally the more parts you feed into the blend, the better the results. Keep these factors in mind when capturing your series.

• Shoot at your lens' sharpest aperture (about f/5.6 to f/8 with 35mm format DSLRs, smaller apertures with larger formats). Search the web for a relevant lens test if you are not sure.

• Avoid wind-blown foliage, crashing waves and flowing rivers as motion will confuse the software.

• Begin the sequence focused at infinity (spot focus on the edge of a cloud) and then focus closer with each capture until the nearest design elements are sharp. Six captures are usually sufficient when shooting at f/8 on 35mm DSLR format. Rehearse the process to get a feel for how much you should refocus with each subsequent take. To make the

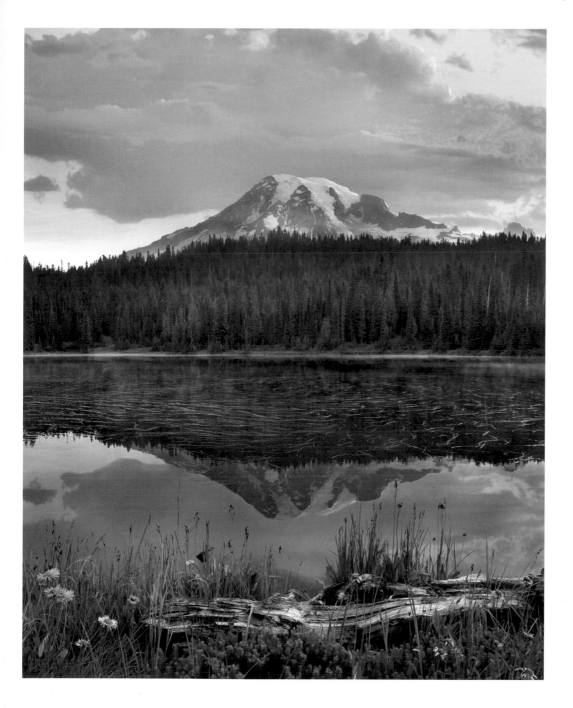

White prickly poppies near Christine, Texas (far left). *Before making the capture sequence, practise making the focus steps so that they can be done quickly to minimize changes in lighting conditions or movement due to wind. Begin the series by carefully focusing on the most distant elements (usually clouds) then wrack forward in equal increments until the closest picture element is rendered sharply. The larger your aperture, the more components you will need. Six or seven captures at f/8 (35mm DSLR) will usually yield good results.*

Reflection Lake, Mount Rainier National Park, Washington (left). *The stillness of twilight is one of the best times for making focus-merge images. The lack of wind allows all components, even delicate vegetation and pooled water to be composed accurately by the software. Canon 5D Mark 11, Canon 15–40mm f/4 L lens, ISO 800, f/8 for 1/15 second, tonal values adjusted in Photoshop.*

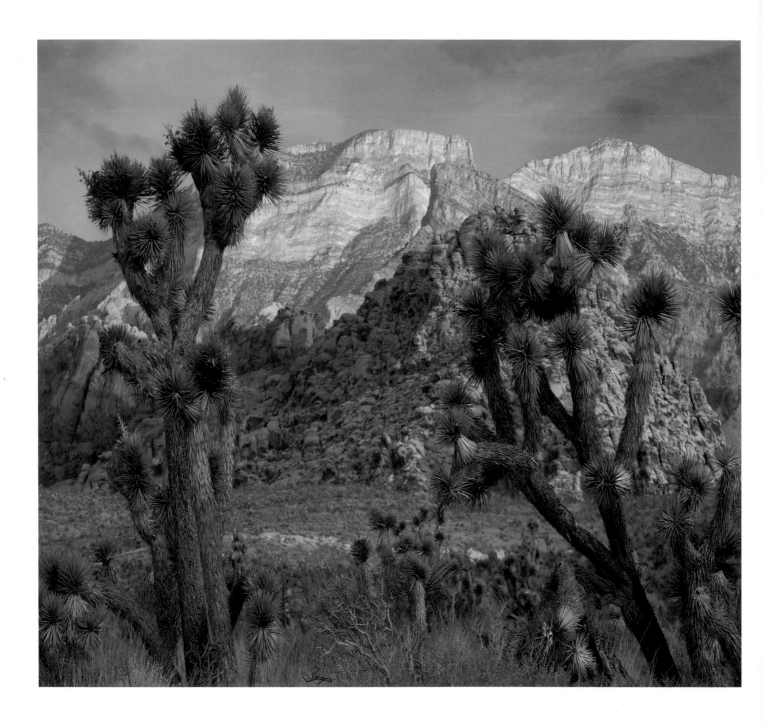

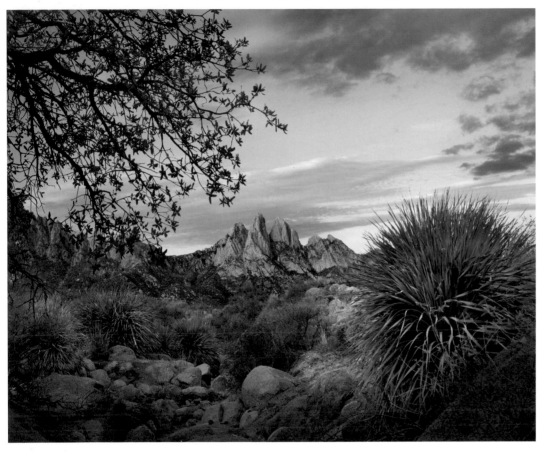

Organ Mountains near Las Cruces New Mexico (left). Compositions such as this, with the sensor surface oriented perpendicular to the scene's featured components (rather than tilted to align with them) and having key design elements both in the near foreground and at infinity can only be rendered with maximum detail by using focus-merge techniques.

Joshua tree and Spring Mountains at Red Rock Canyon Conservation area near Las Vegas, Nevada (far left). A telephoto perspective calls for a small aperture to bring all elements within the depth-of-field zone. Unfortunately, long lenses have poor resolution at such apertures due to diffraction. With focus merge, you can use the telephoto's best aperture (usually one stop smaller than maximum) and still bring all parts of the scene into sharp focus. Here the series does not fully encompass some mid-range features. This could have been avoided by making more captures and finer focusing.

series easy to identify on your storage device, take a close-up reference shot of your hand immediately before and after the sequence.

WORKING THE SOFTWARE

Process the series using identical parameters. Open the software and import the images. If using Helicon focus software, select these manufacturer-suggested settings as a starting point: blending method B, radius 3, smoothing 1 and Lanczos 3

for the interpolation method. If necessary you can touch up problem areas in Photoshop or by using tools supplied with the blending software.

This method of attaining optimum sharpness even allows you to achieve deep focus of parallel subject planes (see illustration page 176), a situation that even tilt/shift cameras and lenses cannot overcome. More information on the latest software versions can be found on the internet.

Preparing Images for Presentation
Professional art print, website or print media display

Yellow monkey-flowers at Lake Kaweah, California. This image was converted from RAW format to Adobe RGB 1998, a large color space standard for commercial and fine art inkjet printing. Mamiya 645 AFD with Phase One P 25 digital back, Mamiya-Sekor 55–110mm f/4.5 lens, Singh-Ray polarizing filter, ISO 100, f/16 for ¹/2 second.

This section deals with the basic computer work necessary to prepare digitally captured images for presentation. The information is just as useful for photographers working from film images that have been scanned for digital refinement. All references to actual software steps refer to Photoshop CS. This is not a comprehensive treatment but rather an introductory look at some of the Photoshop features most useful in preparing digital images for publication or presentation, both commercial and private.

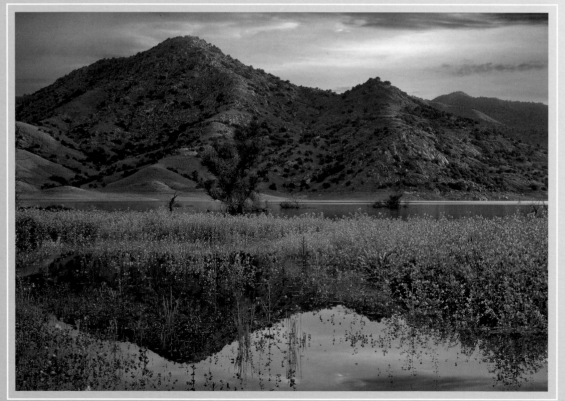

RAW MODE

Most professional photographers capture images in RAW mode. This saves all the data in its original state—there is no in-camera processing of the image, no sharpening, no tweaking of color or contrast. To work with RAW image files (captured in formats specific to each camera model), you must convert them to a standard lossless (no image data lost in compression) format—either TIFF or PSD (Photoshop format). This is accomplished on a computer

with appropriate software. Photoshop CS usually does an adequate job and offers conversion for most camera models.

FROM CAMERA TO COMPUTER

You should convert your RAW files to TIFF or PSD format (not JPEG, which loses data in compression). Before you open the files in Photoshop, you must set the working color space (Edit > Color Settings > Settings). The larger the color space, the more data is retained from the original RAW file and the more options you have for subsequent use.

THREE COLOR SPACES

Following are the color spaces most useful to landscape photographers:
1) For immediate conversion you should choose **ProPhoto RGB**. This provides the largest color space, or gamut (range of color/tone variation), and is well suited for fine art printing. This space retains all the data you need to reconvert for other uses.
2) Next in line is **Adobe RGB (1998)**, a space designed for conversion to CMYK color mode, which is used for high quality commercial printing (like this book). This is the color space you need for submitting RGB images for editorial consideration in magazines, calendars, etc.

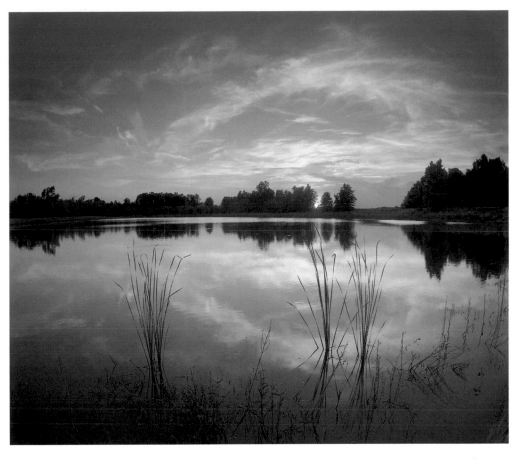

3) The third and smallest of the essential color spaces (there are many others) is **Adobe sRGB IEC61966-2.1**. This space has a color gamut designed for web-posting and is the standard to which most computer monitors are designed and factory set.

Keep in mind that once you convert and save the image to a smaller color space, you cannot recapture the lost data. Consequently, it's wise to archive your RAW files for future uses not yet anticipated.

Sunset at Carlyle Lake, Illinois (above). When converting an image from one color space to another, be sure to safeguard a copy in the largest color space in a lossless file format such as TIFF or PSD (not JPEG) for future use. Mamiya 645 AFD with Phase One P 25 digital back, Mamiya-Sekor 35mm f/3.5 lens, Singh-Ray polarizing filter + two-stop ND filter, ISO 100, f/22 for 1/2 second.

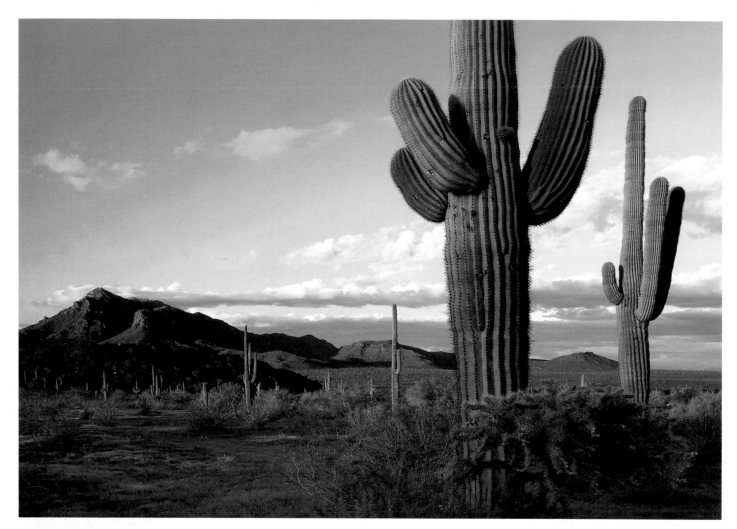

FINE-TUNING THE IMAGE

When a RAW capture first opens in its new color space, it will look dull and not very sharp. Not to worry—Photoshop's numerous controls can quickly bring the scene back to its original state. The adjustments of the image's basic characteristics of color and brightness are interrelated and normally require back-and-forth tweaking before the desired result is achieved.

ADJUSTING BRIGHTNESS

The first correction is usually made to image

brightness (Image > Adjustments > Levels). In practice this is a fine-tuning of your in-camera exposure and makes judging subsequent changes to other aspects of the image more accurate. If you verified your exposure against the camera's histogram at the time of shooting, a minor adjustment is normally all that is needed. Use an expanse of blue sky, patch of grass, green leaf or other common feature as reference. If the scene is low in contrast (e.g., landscapes shot under overcast conditions with skies cropped out), you may wish to increase contrast for more brilliant color. This is done by adjusting the input sliders to more closely bracket the histogram (see sidebar, page 165).

ADJUSTING THE LEVELS CURVE

You can make changes to specific ranges of the tonal scale using Curves (Image > Adjustments > Curves). Holding down the Control key (Windows) or the Command key (Macintosh) click the region of the image you would like to adjust. A control point appears on the curve. Using the arrow keys, you can

move the point upward to lighten or downward to darken the area clicked in the image. You can use the same dialog box to adjust individual RGB tonal values.

ADJUSTING COLOR SATURATION

Usually, the next step is adding more color saturation (Image > Adjustments > Hue/Saturation). Again, choose a generic color-pegged feature to serve as reference (blue skies, green foliage) and make a master correction to all colors simultaneously. Strive for a natural impression and avoid pumping colors excessively. Save adjustments to

Saguaros and Picacho Mountains, Arizona (far left). Image editing software allows you to correct lens distortions such as these inward leaning saguaros. Mamiya 645 AFD with Phase One P 25 digital back, Mamiya-Sekor 35mm f/3.5 lens, Singh-Ray polarizing filter, ISO 100, f/16 for 1/2 second.

Bahia Honda Key, Florida (below). Crooked horizons can be fixed in a jiffy—at the loss, however, of peripheral image features. It's usually best to get it right in the camera.

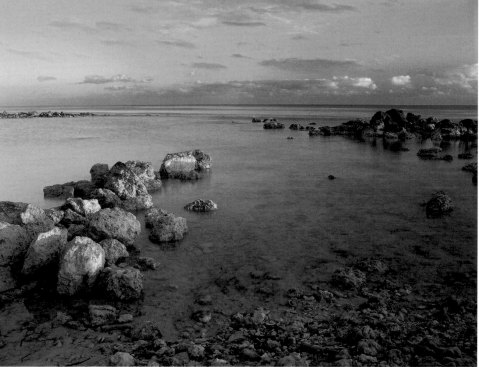

Adjusting Low Contrast Files

Low contrast scenes record without vibrant color and show a histogram bunched in the middle. Move the sliders inward to closely bracket the curve. This separates tonal values and increases contrast.

Histogram Before *(for image above)*

Levels

Channel: **RGB**

Input Levels: 0 1.00 255

Move sliders inward to edge of curve.

Histogram After *(for image at left)*

Levels

Channel: **RGB**

Input Levels: 0 1.00 255

New histogram with expanded tonality and increased contrast.

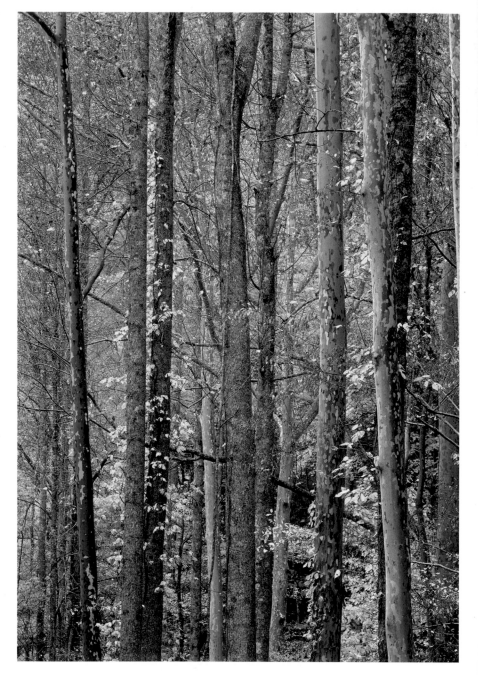

hue and individual color saturation for the final stages of editing.

ADJUSTING COLOR BALANCE

Now you are ready to take a closer look at overall color balance. As I shoot outdoors almost exclusively, the camera's white balance is by default set for "daylight" (rather than "auto white balance"). Except for scenes recorded at twilight, color balance usually requires only minor adjustment. Again, use universal features as reference.

ADJUSTING CONTRAST

One of the most important qualities of an image, contrast is the degree of difference between adjacent colors. The term is used to describe both the scene being photographed and the resulting image. High contrast scenes and imagery exhibit great differences between the brightest and darkest color tones whereas low contrast versions show little difference. Normally, landscape photographers prefer to retain an accurate record of the setting being photographed, and contrast

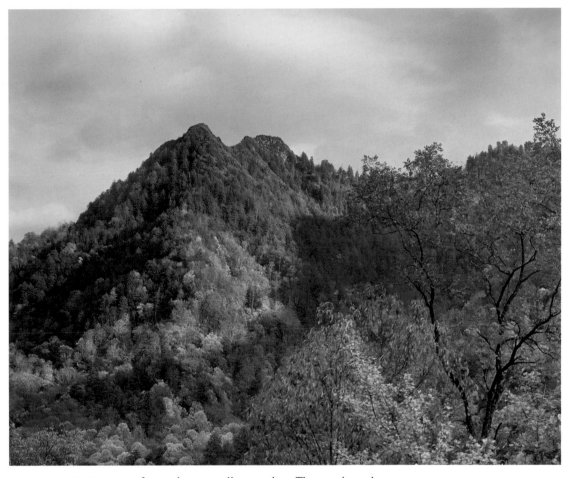

Chimney Tops, Great Smoky Mountains National Park, Tennessee (above). When making color adjustments to a landscape image, I normally start by adjusting the blue of the sky, which displays a universally consistent hue (dependent on time of day). Next I attend to the greens, striving for a hue that appears fresh but not oversaturated. Other colors are keyed to these two.

Gaps in the Histogram

Gaps in the histogram indicate loss of color data—usually due to high contrast. Sometimes you want "contrasty images" (Web use); at other times subtle variation in color tone may be preferred (art prints).

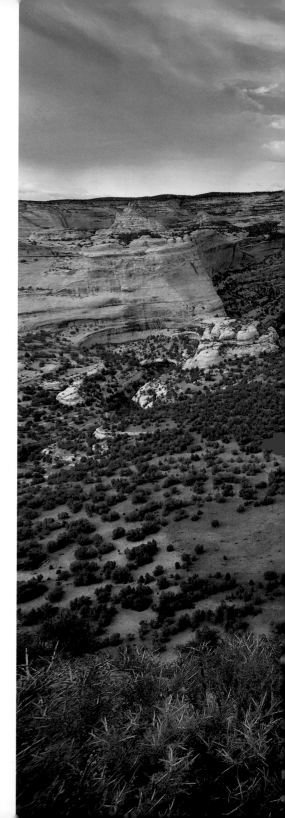

Making Selections

You can apply Photoshop filtration to any area of the image by isolating it with one or more of the selection tools—magic wand, lasso and marquee. This is especially handy for adding density to skies —much as you would with an on-camera split ND filter. You can also use this method for patching in density that the filter missed due to an uneven horizon. Once you make the selection, it must be feathered (Select > Feather) to achieve a seamless transition. Selections can be used for making specific changes to any image feature. Convert the selection to a mask for even more editing options.

Yampa River, Dinosaur National Monument, Colorado (right). When shooting digitally, you needn't correct all contrast issues in-camera using neutral density filtration. Provided the image data fits comfortably within the histogram, you can adjust specific areas for more accurate color and detail in Photoshop. Here density and color was restored selectively to the sky and river once the image was on the computer. Mamiya 645 AFD with Phase One P 25 digital back, Mamiya-Sekor 35mm f/3.5 lens, Singh-Ray polarizing filter, ISO 100, f/16 for ½ second.

adjustments are made in order to present as much color information as possible while retaining a faithful rendering of the original scene. Split neutral density filters are crude methods of modifying scene contrast (usually by adding more density to skies) when the image is captured. Photoshop provides numerous ways to continue this process in a much more precise and selective manner.

• **Standard overall adjustment.** (Image > Adjustments > Brightness/Contrast). Use this adjustment for minor tweaking. Compare your before and after histograms to see how much data you may have lost (evidenced by gaps in the histogram). Data loss should be avoided.

• **Shadows/highlights.** (Image > Adjustments > Shadow/Highlight). Use the sliders to darken highlights and brighten shadows. It's easy to overdo it,

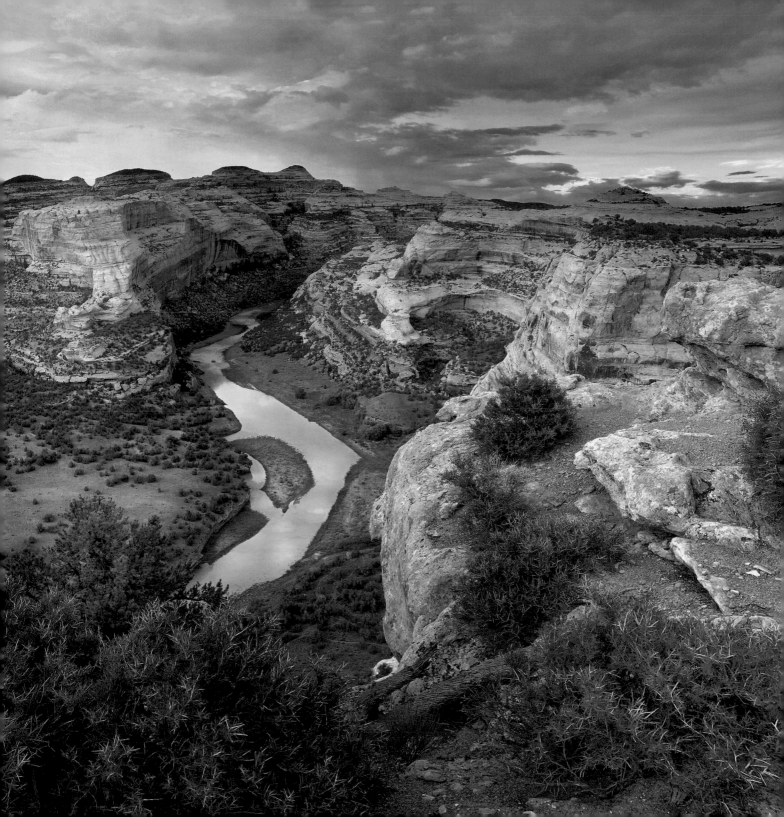

Boulder Mountains and Summit Creek, Idaho (below). When adjusting snowy images, I first tune overall color, working to give a natural hue to skies. Then I selectively move the whites toward a more neutral tone as they are often overly blue. This is easy (Image > Adjustment > Selective Color > Whites). Mamiya 645 AFD with Phase One P 25 digital back, Mamiya-Sekor 55–110mm f/4.5 lens, Singh-Ray polarizing filter, ISO 100, f/16 for $^1/_{15}$ second.

so examine affected areas at 100 percent magnification for unwanted noise and fogging (shadows) and unnatural color shifts (highlights).

• **Midtone contrast.** (Image > Adjustment > Shadow/Highlight > Show More Options > Midtone Contrast). This adjustment is sometimes handy for punching up midtone color in images where highlight and shadow areas are already near their limits.

• **Dodge and burn tools.** These are mouse controlled and work just like in your old darkroom,

only with far more precision and easy redo.

• **Selective contrast adjustment.** Sometimes the image only needs adjustment in a certain area. Photoshop provides tools to isolate these regions so that the rest of the image will not be affected. Use any of the methods described above to modify the selected area (see sidebar, page 184).

RETOUCHING

Once you are satisfied with the image's brightness, contrast and color, you need to repair small imperfections, usually a result of dirt on the camera's imaging sensor. Examine and retouch at 100 percent magnification. You may also wish to remove unwanted image features such as trash, footprints and telephone wires. The tools and techniques are similar in both cases.

• **Healing brush.** This tool allows you to paint pixel samples from one part of the image to another. It matches the texture and lighting of the sampled area to the spot being repaired, resulting in seamless blending. This tool is especially

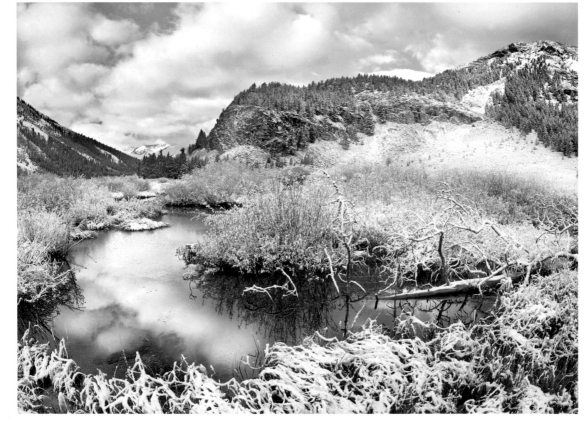

useful for working with scanned transparencies, where it is important to match grain structure.

• **Clone stamp tool.** This tool also copies pixels from one area to another, but, unlike the healing brush, it does not modify the sample to blend into the new position. It is used for bigger jobs such as repairing skies that have been darkened excessively by filtration or lens vignetting or for removing a road sign or streak of flare.

FILE FORMATS AND RESOLUTION

At this point you are ready to size and save the image to a file format for specific use. Here are the basic guidelines for standard types of presentation. When downsizing, be sure to keep a copy of the high resolution file.

Web site/computer monitor. Size the image at 90 pixels per inch (for high quality monitors) or 72 ppi at the dimensions you wish displayed.

Art print from inkjet printer. Size the image at 225 pixels per inch at the print dimensions.

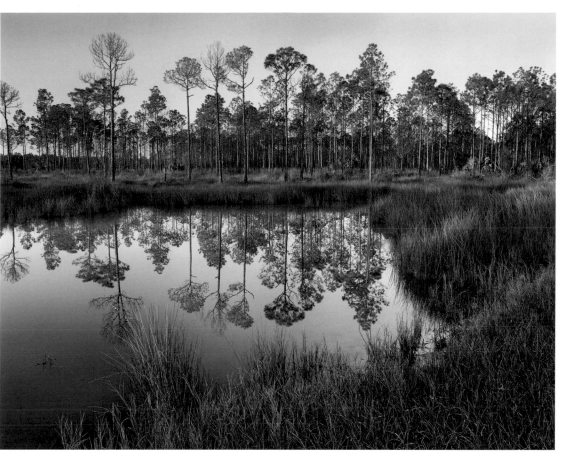

Books, calendars, magazines. Size the image at 300 (or more) pixels per inch at the size of page reproduction. This is the standard requirement for editorial use.

ADJUSTING SHARPNESS

The final stage of image preparation before output is sharpening. Sharpening does not add more detail or resolution. It increases contrast between adjacent pixels so existing detail is more succinct. How much

Pinelands at Piney Point near Hagen's Cove, Florida (above).
This image was sized to 300 dpi at the size it appears here. Then I sharpened it with the Unsharp Mask filter while judging the results on screen at 50% magnification—a good approximation of the detail that will be apparent once the image is printed.

North Clear River Falls, Colorado
(below). The Smart Sharpen filter
is a good choice when sharpening
photos with dense shadows—areas
which tend to become "noisy'" when
sharpened. This filter allows you to
selectively reduce sharpening effects
in these parts of the image.

Sharpening Artifacts
Sharpening is primarily a matter of find-
ing the line between sharp and oversharp.
Here's what to avoid.

Halo. Reduce pixel radius.

Noise. Adjust shadow fade amount (Smart
Sharpen) or raise threshold (Unsharp Mask).

Pixel clumping. Reduce amount and
increase threshold (Unsharp Mask).

you sharpen an image depends on its
ultimate use and reproduction size.
Sharpening causes a loss of image
data and cannot be reversed once the
file is saved. For best results, each
image should be custom sharpened
based on its inherent characteristics

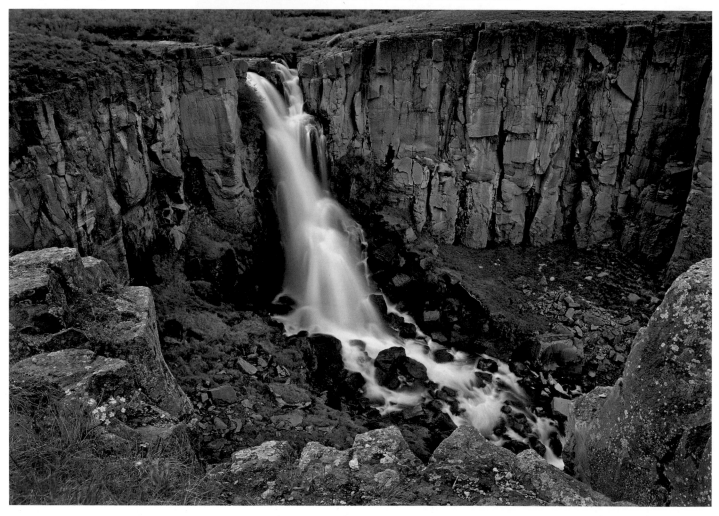

and intended use. The biggest pitfall is oversharpening, evidenced mainly as halos appearing around object peripheries, noise in dark areas and clumping of pixels (see sidebar opposite).

Photoshop's best sharpening tools are Smart Sharpen (Filter > Sharpen > Smart Sharpen) and Unsharp Mask (Filter > Sharpen > Unsharp Mask). Smart Sharpen's distinctive feature is providing control of sharpening in highlight and shadow areas. Here are some tips on using these two filters.

• Analyze the effects at 100 percent magnification.

• In Smart Sharpen, set the "Remove" option to "Lens Blur" (allows more sharpening with less halo than the "Gaussian Blur" option). The "Motion Blur" option is used for imagery made with a handheld camera, a practice generally eschewed by landscape shooters.

• As a starting point for both filters, set "Amount" to 150 percent and "Radius" to 1.0 pixels. Generally, the larger the final image presentation size, the larger the radius setting (up to 2.0 pixels for 11 x 14 inch art print or calendar image). For Web presentation, 4 x 6 inch prints or quarter-page reproduction, set the radius at about 0.3 pixels as a starting point.

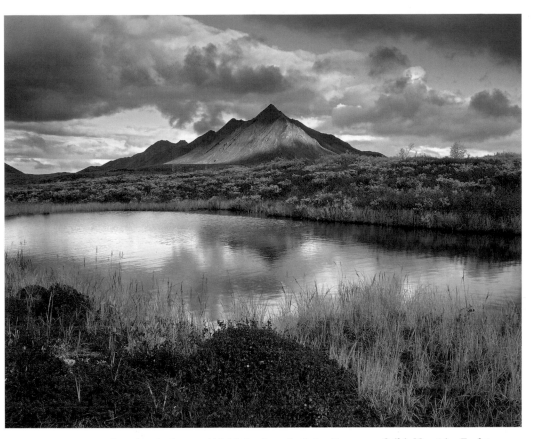

• Examine shadows and highlights for noise/halos. In Unsharp Mask, raise threshold if sharpening artifacts appear. Similarly, in Smart Sharpen, fade sharpening for relevant area (shadows or highlights). Click the Advanced button to access these controls.

There's a new world of photography to further explore in Photoshop, but that's the subject of another book. Meanwhile, good luck with your shooting!

Ogilvie Mountains, Tombstone Territorial Park, Yukon. To increase sharpness in this image, I sharpened subject details with the Unsharp Mask filter. I then selectively adjusted contrast (Image > Adjustments > Curves) of the foreground vegetation to give it more brightness. For this I Power/Clicked (Macintosh) on the area and then toggled upward with the arrow key.

Resources
Helpful books, special equipment and informative websites

Newsletters, Organizations

North American Nature Photography Association (www.nanpa.org). Provides education and inspiration, gathers and disseminates information and develops standards for all persons interested in the field of nature and wilderness landscape photography.

Photograph America Newsletter (www.photographamerica.com). Produced by Robert Hitchman, these periodic guides provide in-depth information for landscape and nature photographers about travel logistics and specific scenic shooting sites. Contact the publisher for a full list of back issues.

Books

Focus on Digital Landscape Photography, George Schaub, Lark Photography Books, New York. 2010.

National Audubon Society Guide to Nature Photography Digital Edition, Tim Fitzharris, Firefly Books, Richmond Hill, Ontario, 2010.

National Audubon Society Guide to Photographing America's National Parks Digital Edition, Tim Fitzharris, Firefly Books, Richmond Hill, Ontario, 2009.

PC Photo Digital SLR Handbook, Rob Sheppard, Lark Books, New York, 2008.

Michael Freeman's 101 Top Digital Photography Tips, Michael Freeman, Ilex Publishing, East Essex, 2008.

Websites

There are many websites dedicated to digital landscape photography. Here you can find lots of helpful, up-to-date information. These sites are good starting points for further exploration.

Popular Photography (www.popphoto.com). Best source for archived lens tests and equipment reviews.

Outdoor Photographer (www.outdoorphotographer.com). An online collection of *Outdoor Photographer* magazine's current and past issues.

The Luminous Landscape (www.luminous-landscape.com). This essential site by Michael Reichmann provides authoritative reviews of equipment as well as tutorials on advanced techniques of special interest to digital landscape photographers.

L.L. Bean's Park Search (www.llbean.com/parksearch). Search America's parks (all state and federal including national forests, wildlife refuges and BLM lands) by region, name, activity or service. Provides information on facilities, natural features and attractions.

National Park Service (www.nps.gov). Provides information about U.S. national parks, including natural features.

Parks Canada (www.pc.gc.ca/eng/index.aspx). Provides information about Canadian national parks, including natural attractions.

Equipment

Kirk Enterprises (www.kirkphoto.com). Source for Kirk ball heads.

Really Right Stuff (www.reallyrightstuff.com). Source for Really Right Stuff ball heads.

Singh-Ray Filters (www.singh-ray.com). Top quality, professional-level filters.